CATS

ROCK

FELINES IN CONTEMPORARY ART
AND POP CULTURE
EDITED BY ELIZABETH DALEY

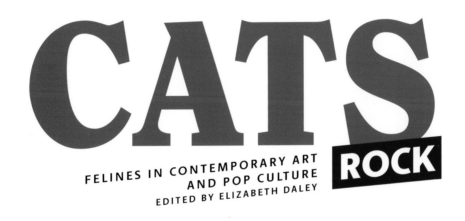

CATS

ROCK

FELINES IN CONTEMPORARY ART
AND POP CULTURE

EDITED BY ELIZABETH DALEY

CERNUNNOS

TABLE OF CONTENTS

LEFT PAGE
Jeff Koons - Cat on a Clothesline (Yellow)
Polyethylene, 123 x 110 x 50".
1994.

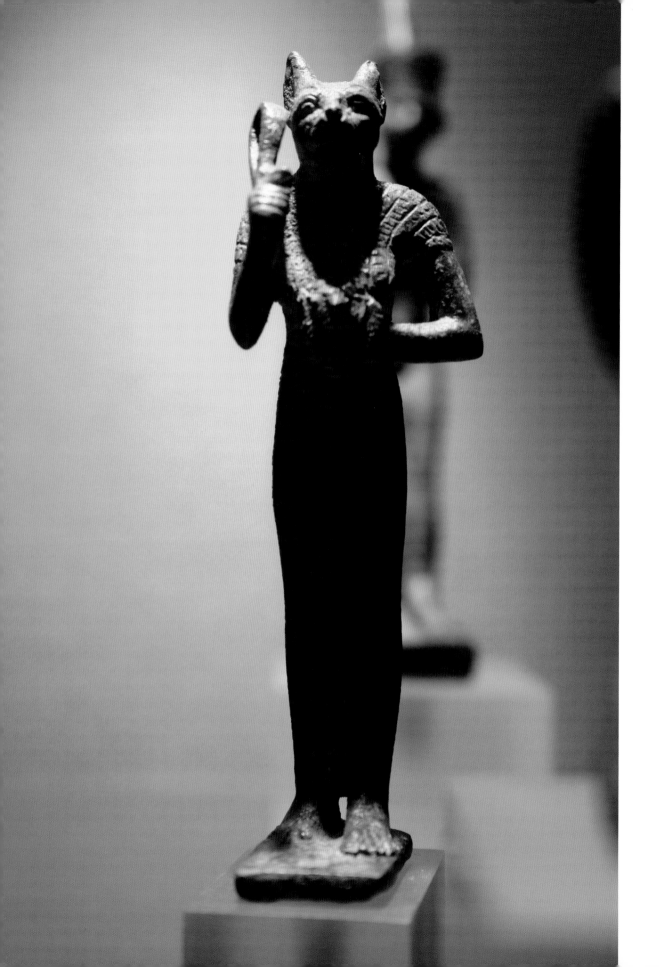

CATS ROCK, BUT WHY?

"There you have the despotic character of men. They do not like cats because the cat is free and will never consent to be a slave. He will do nothing to your order, as the other animals do...A hen would obey your orders if you could make her understand them. But a cat will understand you perfectly and not obey them."

Philosopher Jean-Jacques Rousseau as quoted in *The Journals of James Boswell: 1762-1795*

What is it about the cat that has so beguiled artists for generations? They are not the most docile of pets. They are equipped with sharp claws, which they do not hesitate to use on furniture and humans alike. They march to the beat of their own drums, rarely aim to please as dogs do, yet they are among the most popular household accessories globally.

It is not certain when the first cat was domesticated. However, it is thought that along with civilization came the opportunity for felines to chase rodents from our grain supplies, earning them prized meals and occasionally, prized places in society. Depictions of felines occur in cave paintings, but domestic cat imagery is thought to have been popularized in Egypt just after 1500 B.C.[1]

Images of cat goddess Bast appear potentially as early as 2500 B.C.[2] Her worship likely lasted for more than 2000 years, similar in length to Christianity. She spawned many artistic renditions and in depictions she appears on two legs, with a cat head and a human female body. Egyptians also decorated mummified cats to be sacrificed in her honor.

For as much acclaim as cats received in the times of Bast, they became objects of derision and torture during the rise of Christianity, as they represented both the pagan past and female power and potential. Those who associated with cats often met bad ends, including accusations of witchcraft and death by fire.

As early as 1211, Gervase of Tilbury wrote: "women have been seen and wounded in the shape of cats,"[3] implying a type of suspicious magic transpired between cats and females. Since at least the 15th century, live cats, thought to be demonic, were thrown from towers in Belgium during a cat parade to ward off evil.[4] As part of pagan tradition in Scotland, at least until the middle 17th century, the tradition of Taghairm called for one cat to be roasted continuously. If it lived for four days, legend was that the animal abusers would be granted wishes.

LEFT PAGE: Einsamer Schütze, *Statuette of Bastet*, Egyptian Museum of the University of Leipzig. ab. 2000 BC.

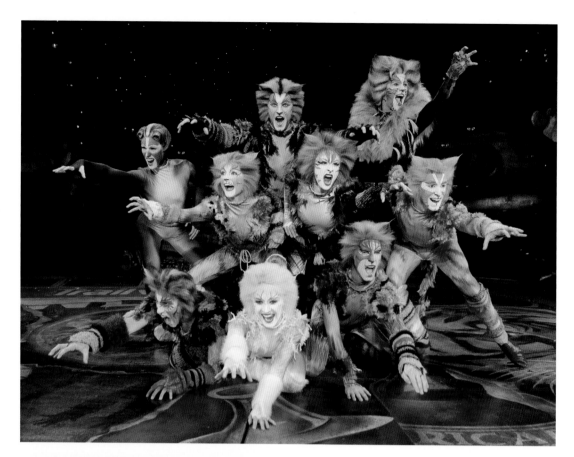

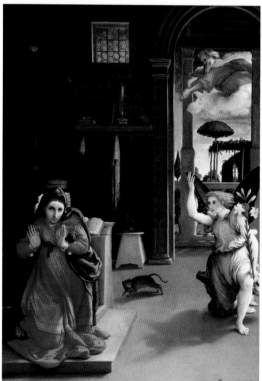

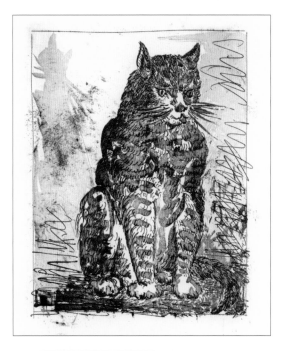

Across cultures, cats were eaten and used in potions since the first century—it's no wonder that even today, they remain so standoffish. It is perhaps a self-preserving instinct.

This is not to say that cats did not enjoy respect in some cultures. In China, they were appreciated for their skill at killing mice and depicted lovingly at least as early as the 10th century. Cats were included in Renaissance paintings of religious subjects and as cats made their way into homes across the world during the 18th and 19th centuries, they increasingly became subjects of artistic work. They represented evil, femininity, domesticity, luck and at times, just cats. They went from material—used for their fur coats and flesh, to being respected family members.

Artists like Théophile-Alexandre Steinlen (1859-1923), Lila Cabot-Perry (1848-1943) and Balthus (1908-2001) found cats compelling enough to include them in work ranging from commercial to surreal and even in portraiture. Meanwhile, cats were "familiar" pets of artists including Henri Matisse (1869-1954), Pablo Picasso (1881-1973) and Tsuguharu Foujita (1886-1968) who were often accompanied by cat companions. Across time and throughout the world artists have been inspired by the feline form. Even former United States President George W. Bush has tried his hand at painting cats, with varied success.

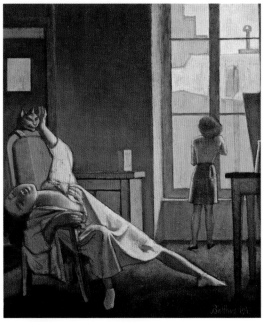

LEFT PAGE, TOP: *Cats*, the Musical, Belk Theatre, 2010. LEFT PAGE, BOTTOM LEFT: Lorenzo Lotto, *Recanati Annunciation*, Oil on canvas, 65 x 45". 1534. LEFT PAGE, CENTER RIGHT: Noritaka Kikuchi, *Majo to Hoki to Kuroi Neko*, 2014. LEFT PAGE, BOTTOM RIGHT: Charles Marville, *The Mummified Cat of Saint-Germain-en-Laye*, 11.2 x 11.4". ab. 1862. RIGHT PAGE, TOP: Pablo Picasso, *Le Chat* (*The Cat*), Aquatint with drypoint on paper, 14 x 11". 1936. RIGHT PAGE, CENTER: Balthus, *The Week with Four Thursdays*, Oil on canvas. 1949. RIGHT PAGE, BOTTOM: Google, *Noto Emoji Kitkat*, 2014.

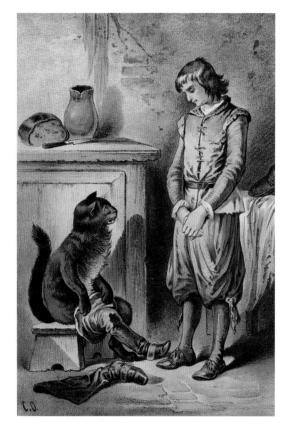

Cats undoubtedly hold tremendous sway in popular culture. The musical *Cats*, which featured actors in Broadway's most artistic costuming, remains among the longest running shows in Broadway history. The book *Millions of Cats*, written and illustrated by Wanda Gág in 1928, is the oldest American picture book still in continuous print.[5]

Today, the cat has taken over not only our homes, but also our visual culture. The image of the cat appears frequently in online videos and reaction GIFS, becoming her own form of universal communication. She allows us to connect with those who do not speak our language and even with children who do not yet write.

From highbrow to lowbrow, from outsider art to emoji, the cat is queen. In all her mystery, she captures our imagination like few other animals. Her history as an object of sexualization, derision and affection, as well as her natural agility and grace, make her the perfect pet and muse for the artists featured in this book.

Meow, without further ado, we present *Cats Rock*, a collection of contemporary art by living artists obsessed with felines.

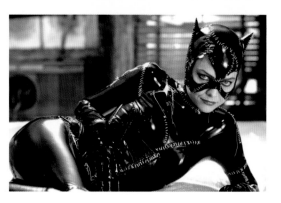

LEFT PAGE, TOP: Carl Offterdinger, *Puss in boots*, end of XIXe. LEFT PAGE, CENTER: Foujita, *Cat*, 11 x 15". 1927. LEFT PAGE, BOTTOM: Frame of Michelle Pfeiffer is Catwoman in *Batman Returns*, Warner Bros. 1992. RIGHT PAGE: Théophile Alexandre Steinlen, *La Tournée du Chat Noir* (*The Black Cat Tour*), Lithography, 24.4 x 15.7". 1896.

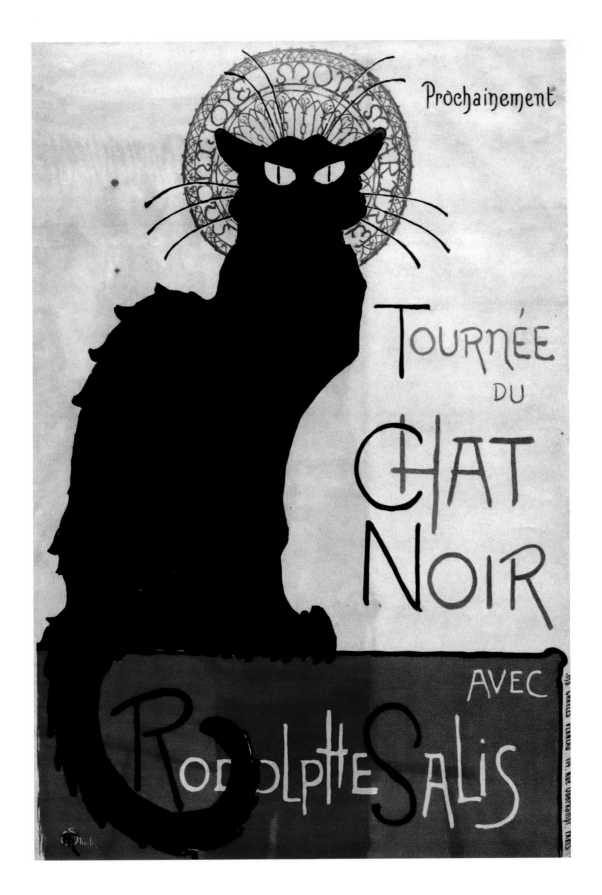

CATS
AS
CATS

Carli Davidson
Shake Cats 21 (detail)
2015

"Thou art the Great Cat, the avenger of the Gods, and the judge of words, and the president of the sovereign chiefs and the governor of the holy Circle; thou art indeed...the Great Cat."

INSCRIPTION ON A ROYAL TOMB IN THEBES.

The beauty of felines has been celebrated for millennia in art. Since the days of the ancient Egyptians, when sacred cat gods adorned tombs, cats have been revered for their singular grace and mystery. The first live cat show was held at London's Crystal Palace in 1871, to great public acclaim. It was so popular that the city reportedly had to run extra trains to the event. However, even before cats were accepted as household pets, writers and artists were inspired by their smooth moves and quirky ways. It seems that since there was art, cats were depicted. They adorned illuminated texts in the Middle Ages showcasing their antics. They were illustrated in tile by Romans in the First Century and were even pets to some early saints. In Chinese and Japanese art, cats appear as early as the 10th century. In Chinese art, they signify longevity, as the word for cat is a homonym for octogenarian. Cats have been painted into depictions of the Last Supper and with Adam and Eve in the Garden of Eden. Even Leonardo da Vinci took notice of the cat, studying its form in sketches. Like many of the artists who came before them, these artists pay homage to the great cat in all her natural forms: silly, graceful and cute. In these works, the cat is beloved for being just exactly who she is: a cat.

ANITA WONG

Anita Yan Wong, M.F.A., M.A., is an American Chinese Impressionist painter best known for her distinct dynamic brushwork and style. She uses traditional techniques to create unique and thoroughly contemporary paintings. Yale University's *China Hands Magazine* described her paintings as "traditional art form that questions the modern minds." Her work is featured internationally in traditional and general interest magazines alike including *NY Arts*, *Works & Conversations*, *Widewalls* and a cover story of *Art Dependence Magazine*. She won first place in wall art from "Design Within Reach" in the Design Philadelphia Awards. Wong has taught at the School of Visual Arts, Temple University, Maryland Institute College of Art and is currently teaching in the University of California at Berkeley Extension fine art department. Through the years, Wong has taken part in many non-profit artistic projects around the world including the Baltimore International Rhythm Festival, the Academy of Natural History Museum insects show and ActionAIDS. She has collaborated with the Millennium Alliance for Humanity and the Biosphere at Stanford University, with the goal of preserving Lingnan Guo Hua and the beauty of the natural world.

anitayanwong.com

RIGHT PAGE

Splash Two
Ink on rice paper,
12 x 16". 2018.

Jumping Kitten Two
Ink on rice paper,
27 x 54". 2018.

Ink Kitten One
Ink on rice paper,
12 x 16". 2018.

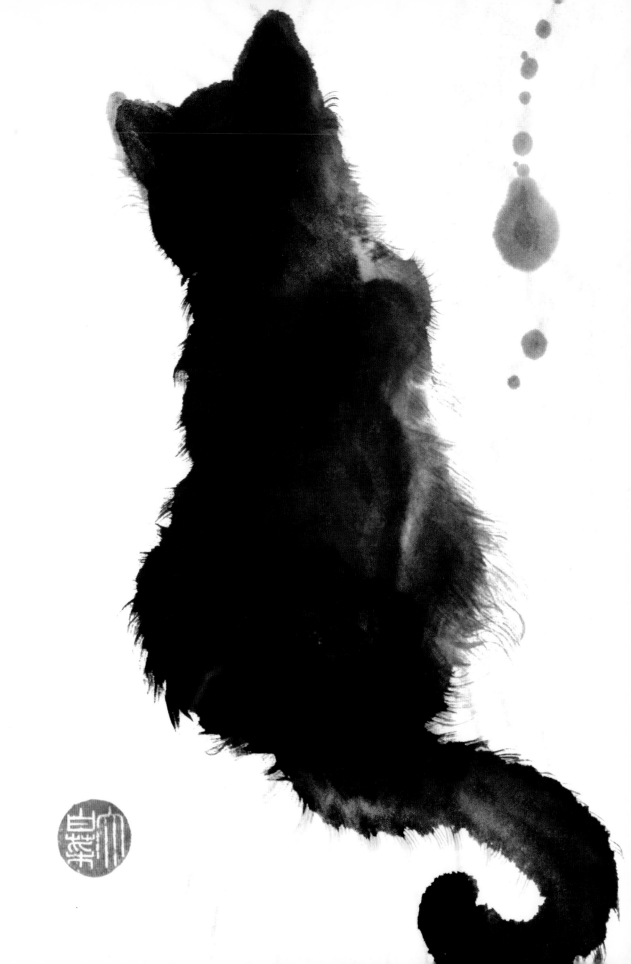

When and why did you start incorporating cats into your work and what do you feel they bring to it?
I always included big cats in my work, but I seriously incorporated house cats into my art creation around 2017-2018 when I met the neighborhood cat, Tux. He appeared one time when I took a walk, and he started taking a walk with me every day. I am inspired by Tux every time I see him, so I created the painting series *Jumping Kittens*, using black sumi-e ink, inspired by my black furry friend Tux. I feel cats bring energy to my projects, movement to my brushwork and calmness to my life.

Is there any work of art featuring cats that has inspired you? Where did you encounter it, and how did it make you feel?
I have always been inspired by the Chinese tiger paintings. I love the "mogu" (boneless style) tiger paintings from Gao Qipei (1660-1734), Hu Zaobin (1897 –1942) and Gao Qifeng (1888-1933). I also love the house cat paintings from the Japanese Meiji period. In particular, I like Shunso Hishida, who painted cats in his own way by combing "morotai" style (using color wash, instead of line drawings that were typical of traditional Japanese paintings in the 19th century) and line drawing. I first encountered these paintings in art books and Asian art museums. I admired the works by these artists because many of them may have never encountered any photographs of cats, but they painted cats livelier than a real cat! To me, these cat paintings are very anti-realism in their own unique style. The works not only captured the cat as an animal, but also the human imagination and our interpretations of cats in the past.

What process do you go through to create your work? What inspires you?
As artists, we seek perfection. I begin my works by researching and brainstorming subjects, painting techniques, meanings, etc. I then create when I feel completely inspired by the subject. The process of creation is very fast for me, sometimes 15 minutes to half an hour per painting. I take a break when I don't see the results I want—a complete break for my hands, without creating any art physically. Instead, I just think. I think and work on the art piece in my mind. I guess one is always working as an artist, either with your hands or your mind. Nature and animals inspire me the most. I like the unexpected, the happy little accidents and the little imperfections that create the perfection in nature. I find these qualities in my paintings as well.

What might people be surprised to know about you (or your work)?
It is hard to verbally identify who I am. I speak three languages. I have lived in Beijing, Hong Kong, London and the United States. I found myself and my identity through my art. It unconsciously captured my lived experiences from each location and my true identity as a person. My ultimate dream is to develop unique styles of contemporary traditional art that speaks to both Eastern and Western viewers. I am amazed by the beauty in both Eastern and Western art, but find it very challenging to combine them. I don't want to force or rush into a style because of some trend. I want to create something that I'm happy with, a painting style that identifies who I am.

What question do you wish I had asked you?
What would you do if you had nine lives like a cat?

What is your answer to that question?
I would be happy to gain eight more lifetimes to paint. There is so much I want to create and so little time. I am afraid of not having enough time to fulfill my dreams and visions in art. I am afraid of not having enough time to create all the things I want to create in life. Life is short and there is so much beauty contained in it. I love what I do and I love living because of being an artist.

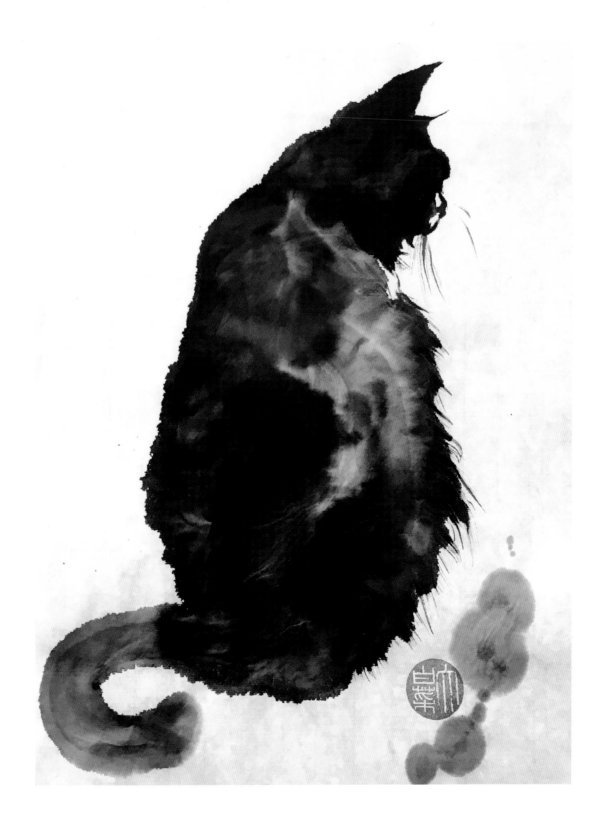

Ink Kitten Two
Ink on rice paper,
12 x 16". 2018.

CARLI DAVIDSON

Carli Davidson is an internationally recognized photographer, director, and animal trainer. Her photo and video work has been featured in publications such as *Vanity Fair*, *The New York Times*, *Rolling Stone*, *WIRED*, and *Slate*. Her client work, which often focuses on animals, includes Pfizer, Purina, National Geographic, Nike, Wellness, and MARS. She has been a global ambassador for Nikon Cameras and teaches and speaks around the world about photography techniques. Her book *SHAKE* is a critically acclaimed *New York Times* best seller, and her work has won numerous awards including the PDN Faces Portrait Photography Contest and the PDN Photo Annual. Davidson has always been drawn to working with animals both in the studio and in care and rescue settings. She worked at zoos and wildlife rescues for over a decade, training everything from primates to crocodiles. Her passion for animal welfare has driven her career and she continues to work closely with animal rescues both as a photographer and as a dog foster and trainer for animals that need extra guidance before finding homes.

www.carlidavidson.com

Shake Cats 25
Photography. 2015.

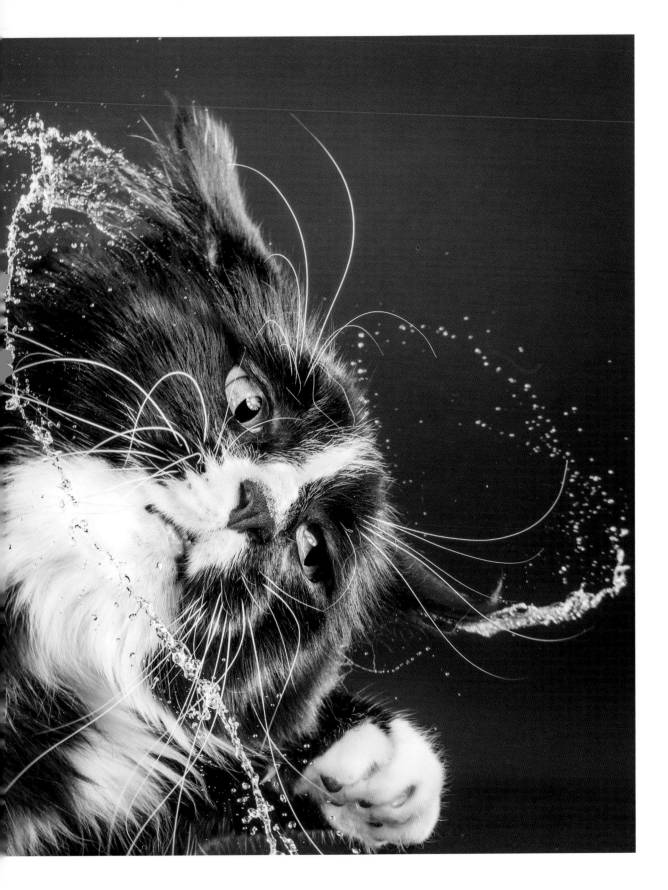

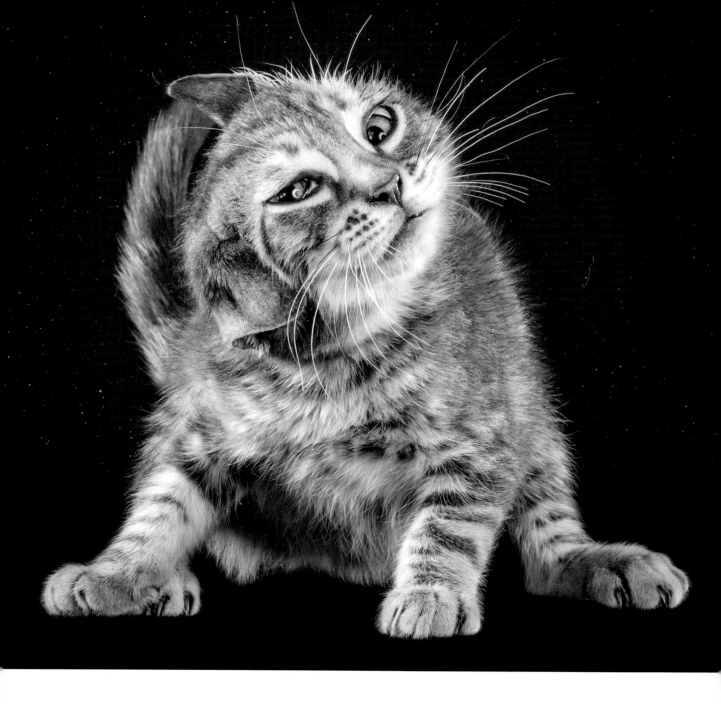

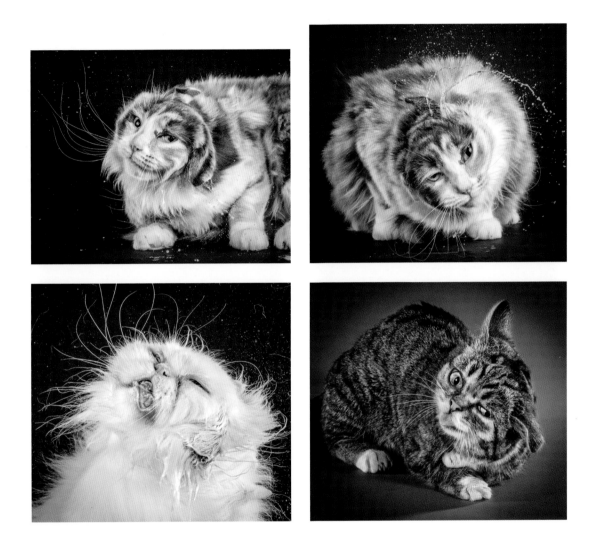

Shake Cats 9
Photography. 2015.

Shake Cats 31, 32, 34, and 4
Photography. 2015.

When and why did you start incorporating cats into your work and what do you feel they bring to it?

I began working with cats creatively as a child. My cat, Hulk Hogan, was a huge influence and a huge cat. I walked confidently into the pound at five years old and simply asked for the largest cat they had, since I really wanted a tiger. He was the kind of friend every kid wants: strong and confident, an avid hunter (provider) and my emotional caregiver.

I photographed him and drew him often. I was sure he was the most stunning creature on the planet even as he grew old and drawn out. I better appreciated the complexity of the human form and the changing body because of him.

Is there any work of art featuring cats that has inspired you? Where did you encounter it, and how did it make you feel?

I spent a lot of time the last few years with Holly Andres who is a brilliant photographer who uses her cats as muses as well. Seeing how much she was enjoying her cat projects inspired me to find a way to incorporate cats into my work more often.

What process do you go through to create your work? What inspires you and how do you capture your images?

I generally have an "ah ha" moment upon seeing something that inspires me. For the *Shake* series, it was my mastiff getting slobber on the ceiling of my house and my curiosity as to how it was propelled so far from his face. It was a man playing fetch with his dog in a wheelchair that got me started on interviewing and documenting the stories of people who adopt and care for dogs with additional needs. I then become obsessed with the project. When I get obsessed, pretty much everything else in my life falls away and I produce, shoot and retouch full time while documenting my own narrative. It's the indulgence of art at this point: both creating and spending time with my muses.

What might people be surprised to know about you (or your work)?

I'm a grungy aging punk. I grew up in the New York and Olympia, WA scene, living in communal houses and destroying my ears with loud music from the age of 15. I was kicked out of two schools and worked lots of dead-end service jobs before finding my legs in photography. I wasn't assuming I'd ever be a success story. Nowadays I spend most of my non-shooting time training for backpacking trips. Disappearing into the wilderness is how I foster my creative energy.

Do cats hate water as much as they are rumored to?

Some cats LOVE water. I had a cat that used to jump into the shower with me. I had another cat who hunted bullfrogs and would come home soaking wet with headless frogs all the time (this was back in the early 90s before I stopped letting my cats outdoors to hunt). Also full disclosure, I never pour water on any of the cats I shoot. Instead, I have a vet tech on set cleaning their ears, so that's the liquid that you see. We also do nail trims to help out owners while in the studio. A lot of people struggle to clip their cats' nails.

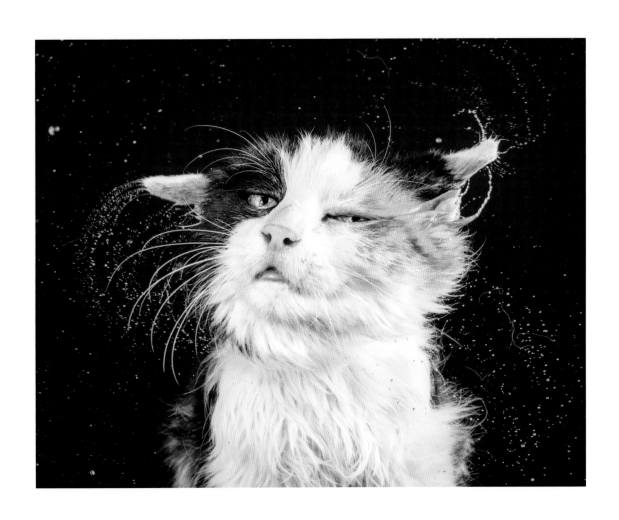

Shake Cats 22
Photography. 2015.

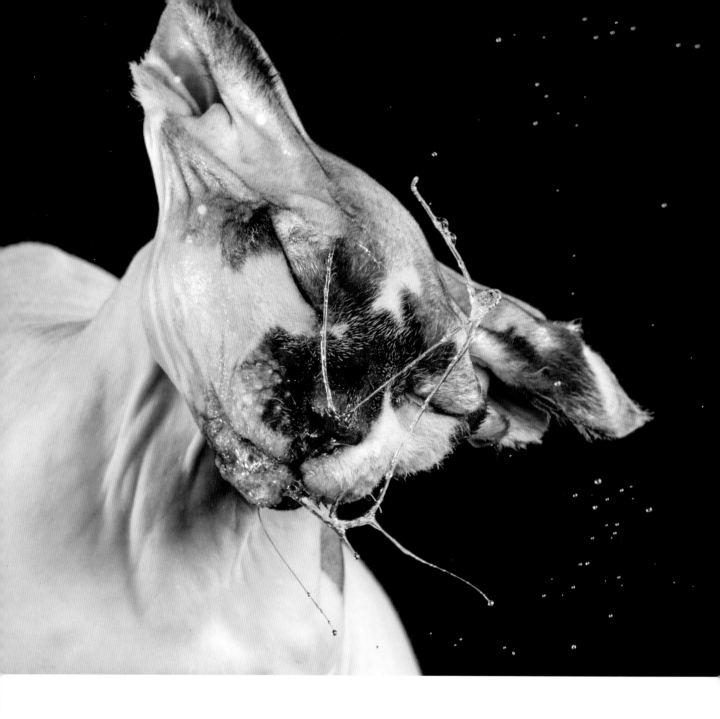

Shake Cats 14 and 13
Photography. 2015.

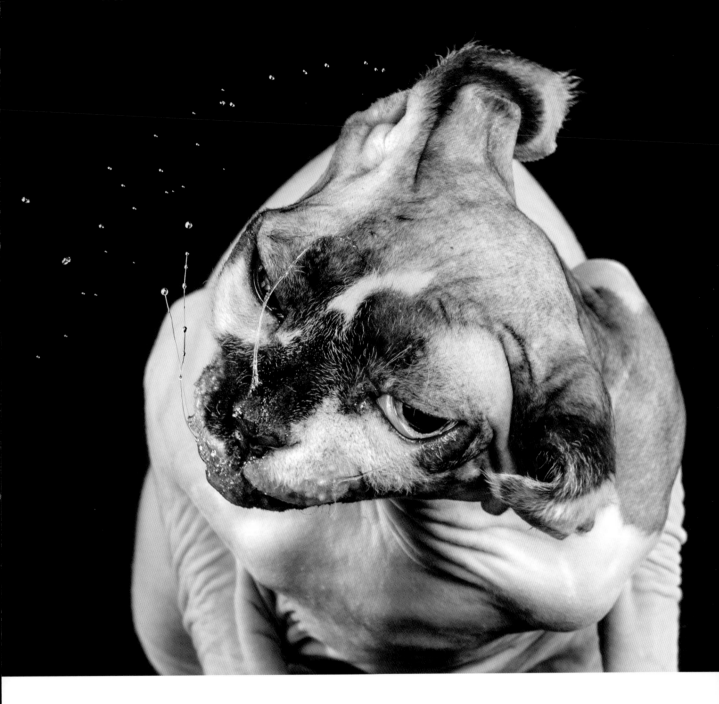

JOAN LEMAY

Joan LeMay is an American, born in 1979 in Houston, Texas. She is a portraitist and illustrator interested in pattern, gesture and Byzantine halos. She loves painting people, animals, plants and things in equal measure. She employs a kind of anthropomorphic approach to portraiture, packing referential objects, color-based symbolism and other subject-specific elements into the busy backgrounds of her work in order to reflect the soul and life of the person or creature depicted. She is currently focusing on work that celebrates what soothes and inspires us and what inspired her in childhood: over-the-top portraits of beloved TV and pop culture personalities, food, fellow artists, and depictions of medications. LeMay has exhibited her work worldwide for over a decade, created artwork for albums and films, and done illustration work for multiple outlets. She constantly takes portraiture commissions for pets, people and things, and continues to paint and illustrate for herself and others from her studio in Portland, Oregon.

Instagram: @joanlemay

Dolly Parton the Cat
Gouache on paper, 16 x 16".
2018.

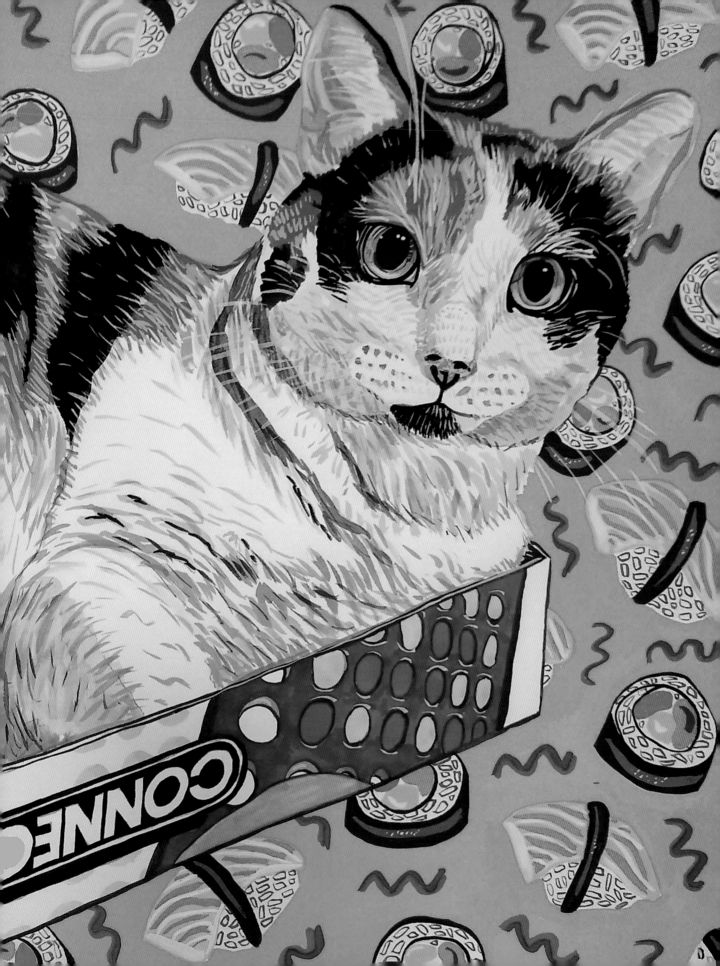

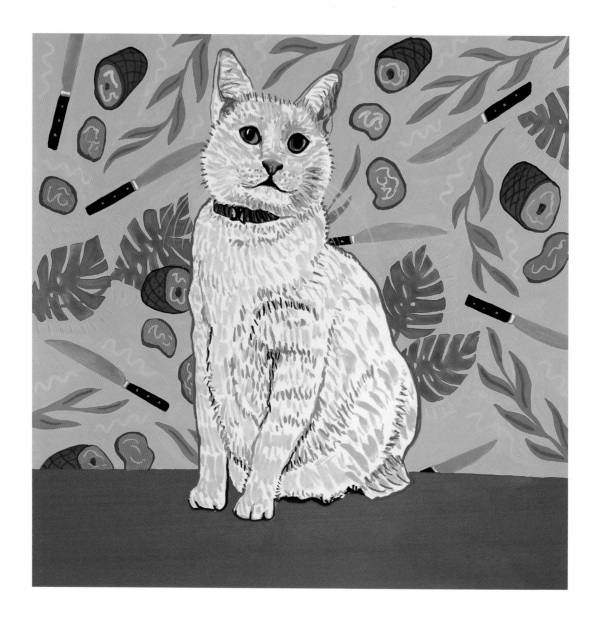

THIS PAGE

Carl the Cat
Gouache on paper, 12 x 12".
2018.

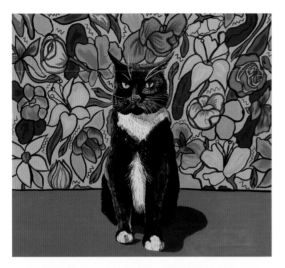

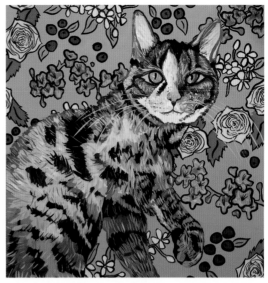

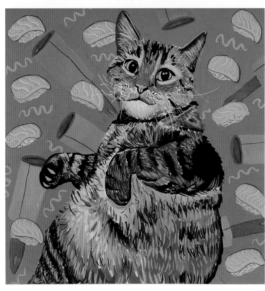

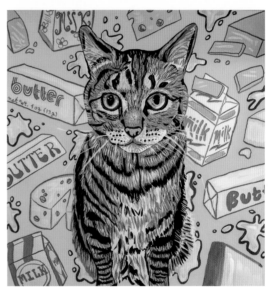

TOP LEFT

Tom For Amiee and Michael
Gouache on paper,
12 x 12". 2017.

TOP RIGHT

Lola Blueberry Kaufmann
Gouache on paper,
18 x 18". 2017.

BOTTOM LEFT

Tokaji
Gouache on paper,
16 x 16". 2018.

BOTTOM RIGHT

Ladybird the Cat
Gouache on paper,
12 x 12". 2018.

When and why did you start incorporating cats into your work and what do you feel they bring to it?

I've always had pretty bad asthma and have always been allergic to cats. This is terrible, because I LOVE CATS. Painting them for people helps me to be closer to them without having to reach for my inhaler. One of the first instructional art books I had as a kid was a "learn to draw cats" book. Once I started doing commissioned pet portraits for people, I found that my favorite pet to paint was, in fact, a cat. I especially love painting people WITH their cats. It changes the whole mood of a piece.

Is there any work of art featuring cats that has inspired you? Where did you encounter it, and how did it make you feel?

I feel that pet portraiture as a practice doesn't get its due, even though everyone loves paintings of animals. Once I started doing a lot of pet paintings, I began to seek out cats painted by some of my favorite artists—Alice Neel's *Victoria and the Cat* from 1980 has to be my favorite cat painting of all time. I first encountered it while doing a Neel deep-dive, and boy, it just filled me up with joy.

What process do you go through to create your work? What inspires you? How do you decide on the backgrounds?

Nearly all of my cat paintings are commissions. I like to learn all about the cats in question from their people—what they like to eat, what their personalities are like, what their typical day is. I work from as many photographs as my clients can get me, and I create the backgrounds based on what the cat is into, so that the entire piece is about the very essence of the cat and its very favorite things. Sometimes, the background will be about the person the cat lives with. It will include favorite colors of theirs, or birth flowers, or state flowers.

What might people be surprised to know about you (or your work)?

Although I have been painting for a long time, I've only just started painting full-time, and I'm in my early forties. I was a music (and sometimes comedy) publicist for 17 years before this, and also an interior decorator. It's never too late to work your ass off towards doing your dream thing.

What question do you wish I had asked you?

What's the biggest cat you have ever painted for someone?

What is your answer to that question?

I once painted a cat named Simon for a family who wanted to have Simon REALLY take over their living room. The piece was nearly seven feet tall and five feet across. I painted it in acrylic on canvas.

RIGHT PAGE

Arlo the Cat
Gouache on paper, 12 x 12".
2018.

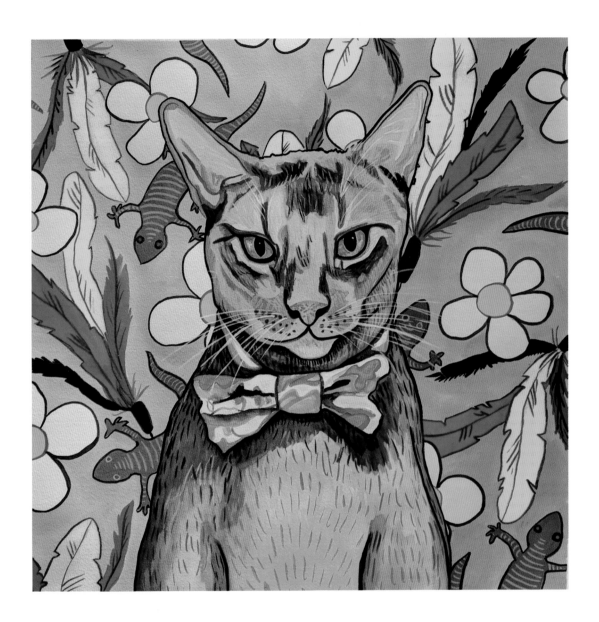

KELLAS CAMPBELL

Kellas Campbell grew up in Winnipeg,
Manitoba and outside Chicago, Illinois.
Her trusty cat, Charlie I, was by her side
throughout. She lives in Edinburgh, Scotland,
with her rescue cats Charlie II and Noir.
Campbell learned to draw from her mother,
Helen, a commercial artist.
When her mother was hospitalized in 2004,
Campbell returned to drawing. She started
with frogs and other creatures from *National
Geographic* magazines in the ICU waiting
room. Although Helen was unable to fully
wake up from a coma, whenever Campbell had
a drawing to show her, she opened her eyes
and appraised it silently. Helen died in 2004.
A year later, Campbell adopted her cat muse
Charlie II, and began drawing her.
When Campbell moved to London, she took
her drawings to a local frame store, as putting
them on the wall made more sense than
storing them in boxes. The store owner asked
if he could try selling them, and so her career
as an artist began. She sells prints and accepts
commissions at her website.

www.kellascampbell.com

THIS PAGE
Charlie Sleeping
Ink, charcoal and pencil,
16 x 12". 2014.

RIGHT PAGE
Joschi
Ink, charcoal and pencil.
2018.

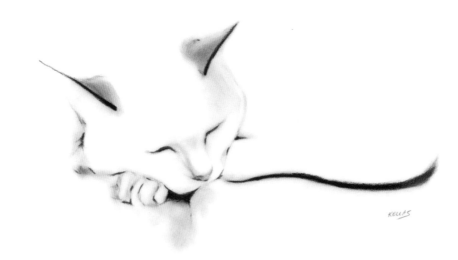

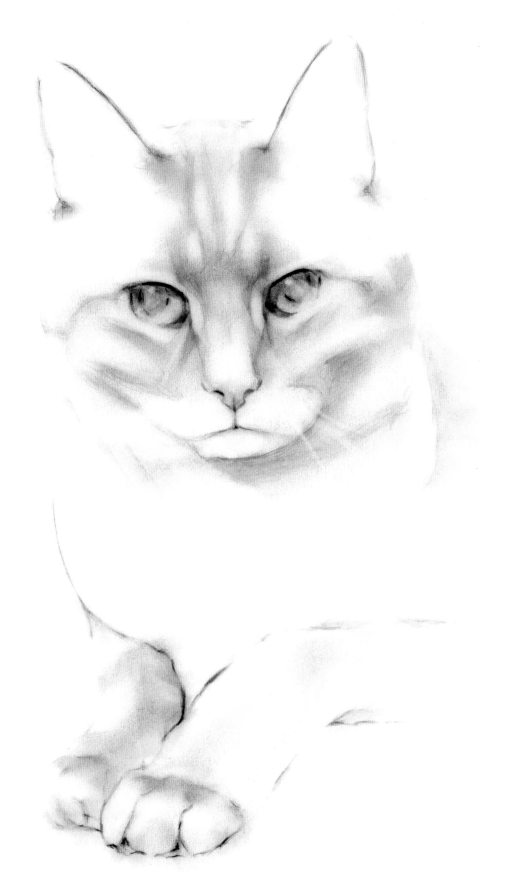

JOSCHI
BY
KELLAS

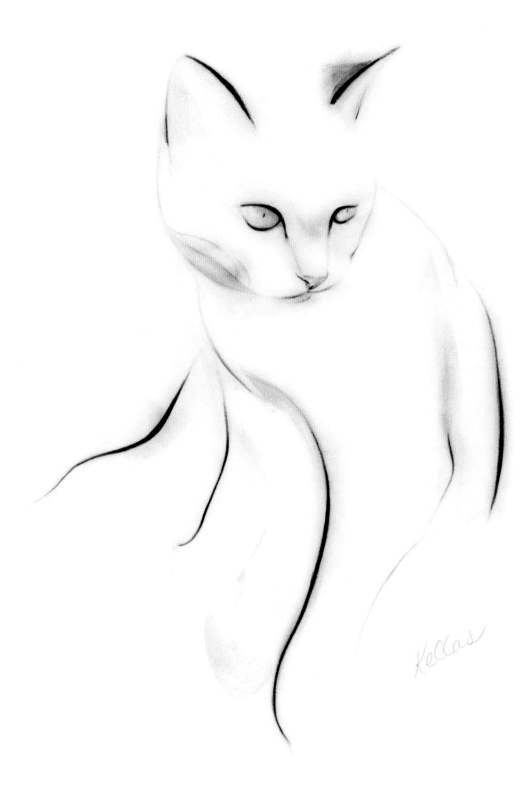

When and why did you start incorporating cat imagery into your work and what do you feel it brings?

As a way to get over my mom's death, I kept a blog called Single with Cat (a title that got old when I got old and adopted more cats). One day, someone wrote me saying he'd accidentally come across it while googling himself. We never figured out why my blog showed up, but we ended up friends. He was a country singer in West Virginia and also an artist. I was working for an aerospace company; my mom, who taught me how to draw, was the only other artist I'd ever known, so it was quite interesting to talk with him. He made his own pens from reeds growing near his house and mailed me a few, along with a bottle of sepia ink. I used one to draw a picture of Charlie, my cat, and when I showed it to him, he reacted so positively that it encouraged me to keep drawing her. I've been drawing her, and other cats, ever since.

Is there any work of art featuring cats that has inspired you? Where did you encounter it, and how did it make you feel?

My mom painted my childhood cat and me when I was seven. It hangs in my living room. I love it because it reminds me of Charlie the First and my mom. She graduated in Commercial Art from what was then the Corcoran School of Art in Washington, D.C. I grew up in Winnipeg, Manitoba. The art gallery there has an amazing collection of Inuit art, and we also had sculptures and prints in the house, including one of a bird by Benjamin Chee Chee, which has just reemerged from storage and which I love.

What process do you go through to create your work? What inspires you?

Well, my cat inspires me, because she is everything I am not. She is mysterious, quiet, patient and always decorous. As far as process, I start out drawing in pencil quite lightly. Then, it's a matter of erasing some lines and darkening others. And knowing when to stop.

What might people be surprised to know about you (or your work)?

My cat, Charlie, is actually not all white.

LEFT PAGE

Gentle Time Before Sleep
Pencil on paper,
11.69 x 16.54". 2015.

MARTIN WITTFOOTH

Martin Wittfooth was born in 1981 in Canada and was raised in Finland. He now resides in New York and Savannah, Georgia. He received his M.F.A. from The School of Visual Arts in New York City and has exhibited extensively in galleries and museums throughout North America and Europe. His work has appeared in numerous publications, including cover features in books and magazines such as *New American Paintings*, *Hi-Fructose*, and *American Artist*.

www.martinwittfooth.com
Instagram: @martinwittfooth

It seems a lot of your work explores tensions between the manmade and the "natural." Can you speak a bit about how you might use animals and cats in particular in your work?

By creating allegories with animal protagonists and narratives, my paintings speak in a symbolic vocabulary that is universal. There are inherent connotations in various animal forms that viewers understand and respond to instinctively. This allows these figures to suggest themes and ideas that pertain to our human condition. In a sense, I aim to present portraits of us all in these pieces, though a recognizable "I" or "we" is not present. The settings in which the paintings take place and the artifacts found within them often suggest that we were there, and what we see is playing out on a stage that we've built. I've often employed the image of the domestic cat in my work as an icon imbued with an added layer of familiarity by its very nature: that of a being whose story we've written since it stepped out of the wilderness and into our homes. It is (as we are), "other" to its wild origin, yet still carries a reminder of what was.

What, if anything, do you hope viewers take from seeing your work?

I hope my work serves as a prompt to reflect upon the status of our world and the imperative for change. In a present hell-bent on plowing into the future with an ever-increasing appetite for a quick fix, I hope that my paintings might offer a pause. I hope something in what I've presented captures a viewer's attention for long enough to offer a moment of contemplation on the past and what we might learn from it and on our current condition, and what might be done going forward.

RIGHT PAGE

Pandora
Oil on canvas, 60 x 42". 2018.

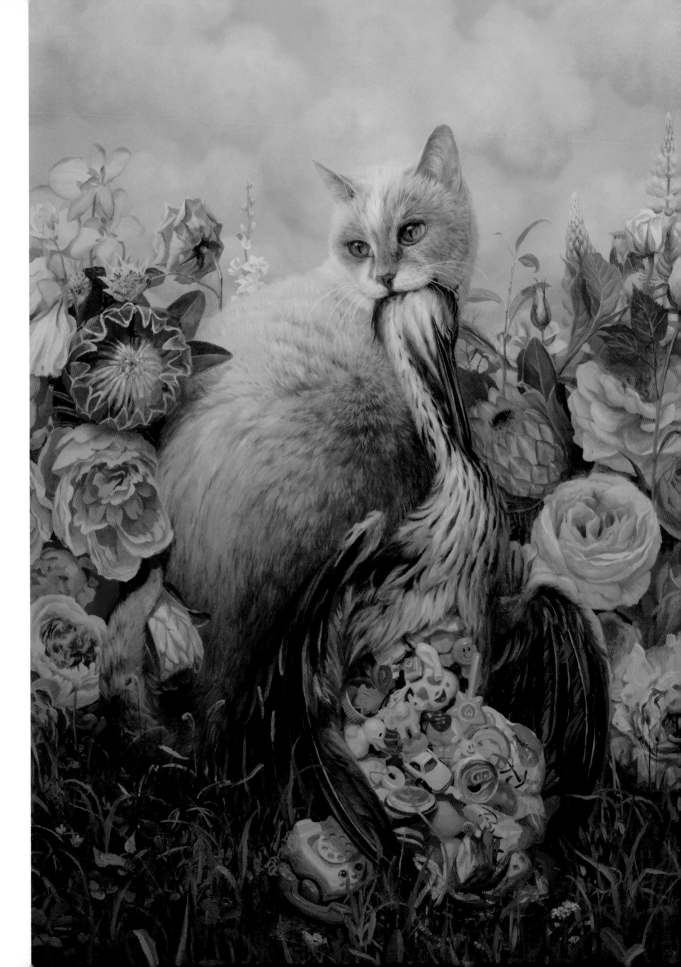

What is the relationship between the beauty of the natural world and the beauty of the manmade? Is there a relationship?

I am very interested in this question. Our species has departed materially, psychologically, and spiritually from our natural origins enough that the dividing line between us and nature is seen as common fact. For me, this topic is worth building my entire painting career around. Stripped down to its essence, all that is "manmade" is of course natural, as all things derive from the same prime source. Yet clearly we are a species apart. At some point, we delineated ourselves as the "Us," and the wild world as "Them." This distinction is both fascinating and troubling to me. Someone once said my work is "a meeting place of hope and horror." I find this duality to be beautiful, as it takes in the full view of our shared condition.

What would people be surprised to know about you?

The three dogs, cat, and snake that my wife and I share our home with regularly appear in my paintings.

What inspired your painting of the cat attacking the bird and can you talk about the work and what is inside the bird?

This painting was included in a 2018 series of works titled *Domestic Katabasis*, in which I looked at the relationship between the domesticated and the wild - the meeting of two worlds that we've dug a valley between, where one side no longer recognizes the other as equal, as borne of the same earth. The painting presents us with saccharine, cute colors and an environment of playful naivety - the objects spilling out of the bird are plastic children's toys - while the overarching narrative is that of a tragedy.

MIDORI YAMADA

Midori Yamada is an illustrator and painter living in Chiba, Japan. Midori started illustration work while in art school, and currently draws illustrations for books and magazines.
In addition, she has regularly held solo exhibitions of cat works since 2009.
The main subjects of her work are cats, plants, girls and fish. In most cases, she draws with pens, and paints with acrylic and watercolor.
Yamada's work can be found on her website where you can inquire more about her work.

www.midoriyamada.net

THIS PAGE

Get off the Tree
Pen, watercolor,
6 x 4". 2017.

RIGHT PAGE

13
Ink bottles, acrylic, pen,
8 x 5". 2014.

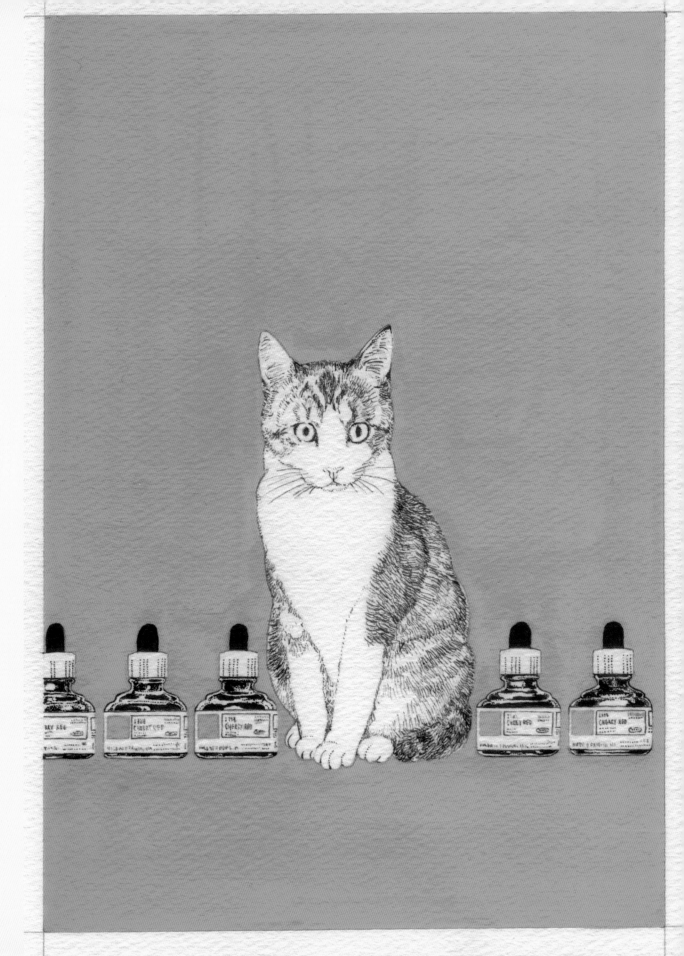

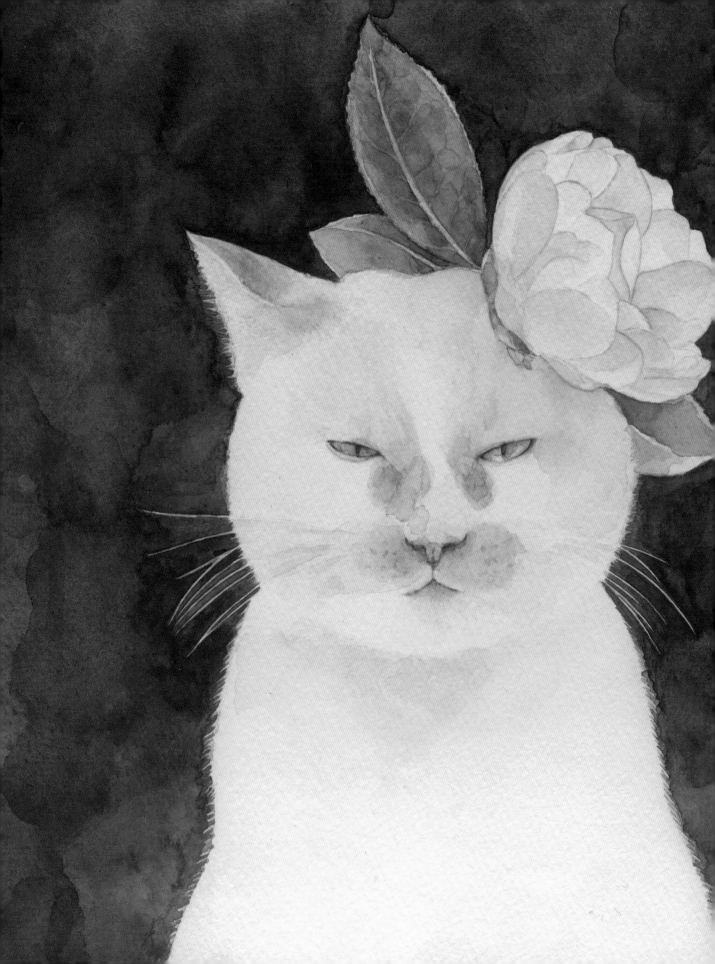

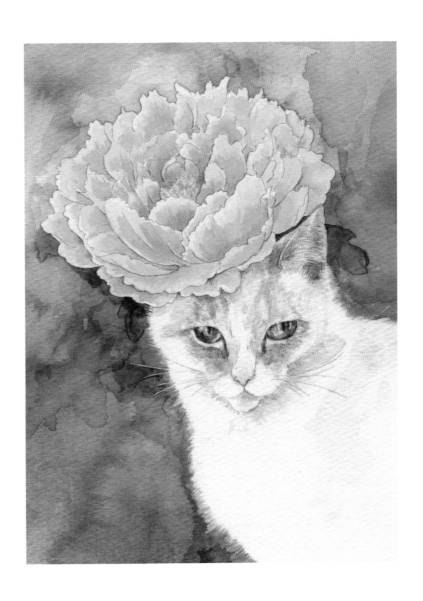

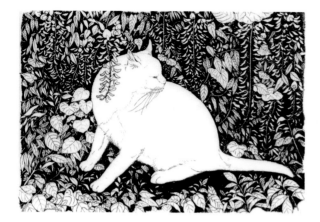

TOP

Wisterias of May
Pen, 6 x 4". 2018.

BOTTOM

Hydrangeas of June
Pen, 6 x 4". 2018.

RIGHT PAGE

Trumpet Vines
Watercolor, 10 x 8". 2011.

When and why did you start incorporating cats into your work and what do you feel they bring to it?
I began incorporating cats into my work for the first time in 2009. That's when I held a cat painting exhibition at my parent's pottery shop. My parents always lived with many cats and loved them very much. At the request of my parents, I began to draw cats.

Is there any work of art featuring cats that has inspired you? Where did you encounter it, and how did it make you feel?
I enjoy the Japanese ukiyo-e artist Utagawa Kuniyoshi (1798-1861). Ukiyo-e is a genre of Japanese art consisting of woodblock prints and paintings prominent in the 17th and 18th centuries. The term translates to "picture[s] of the floating world". Kuniyoshi has painted many cats in that style. They are famous in Japan and we have the opportunity to see them in various places. The cats he drew are not all realistic, some are kind of deformed, but they are very attractive as the cat's specific gestures are properly represented.

What process do you go through to create your work? What inspires you?
I especially like drawing plants and cats, so my parents' cats who play freely in the mountains around my home are always sources of my inspiration.

What might people be surprised to know about you (or your work)?
About my work, people might be surprised that I use coffee for sepia expressions. The works drawn in coffee are (probably) as durable as watercolors and have a very nice smell.

What question do you wish I had asked you?
A question about what the internal and external attractiveness of cats is for me.

What is your answer to that question?
Even though cats are extremely close to me and I can feel their attraction, I do not know what they are thinking. I find this alluring. As for their external attractiveness, I think that the delicate pink color in their nose, paw pads and ears is externally attractive. I am careful to express these charms in my own pictures.

THIS PAGE

On the Rock he likes
Pen, watercolor,
4 x 4". 2017.

ROBBIE CONAL

Robbie Conal grew up in New York City. His parents were union organizers who considered the major art museums to be his day care centers. He attended the High School of Music and Art, received his B.F.A. at San Francisco State University and his M.F.A. at Stanford University. Angered by the abuse of political power by U.S. President Ronald Reagan's Administration in the 1980's, he began making satirical oil portraits of politicians and bureaucrats, turning them into street posters. His irregular guerrilla army of volunteers has helped him poster the streets of major cities around the country. Over the past 30+ years, he's made more than 100 street posters satirizing politicians, news and entertainment media, and global capitalists. Conal has also made celebratory oil portraits of personal heroes Nelson Mandela, Gandhi, The Dalai Lama, Martin Luther King, Jr., Charles Darwin, Mark Twain, Marie Curie—and many CATS! Conal's work has been collected by and featured in exhibitions at: The Metropolitan Museum of Art in NYC, LACMA, MOCA in Los Angeles and the San Jose Museum of Art. He's been a cartoon character on *The Simpsons*. His art was featured in the 2015 Venice Biennale and the international street art exhibit, *Ca$h,*

Cans, & Candy in Vienna, Austria. Most recently Robbie premiered *Cabinet of Horrors*, a solo exhibit at Track 16 Gallery in LA, skewering Trump and his cronies. Conal has authored three books: *Art Attack: The Midnight Politics of a Guerrilla Poster Artist*, 1992 (HarperCollins), *Artburn*, 2003 (Akashic Books), and *Not Your Typical Political Animal*, featuring his cat, dog, bird, and other animal portraits, which he co-authored with his wife Deborah Ross, in 2009. (Art Attack Press). He lives in California with Deborah and two kittens, Ella and Louie.

Instagram: @robbieconal
www.robbieconal.com

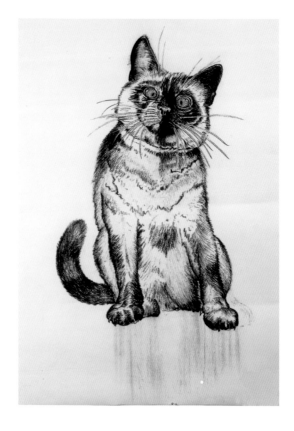

THIS PAGE

Smilla
Compressed charcoal and
colored pencil on paper,
29 x 23". 2000.

RIGHT PAGE

Self Portrait with Smilla
Compressed charcoal
on paper, 29 x 23". 2000.
Collection of Deborah Ross.

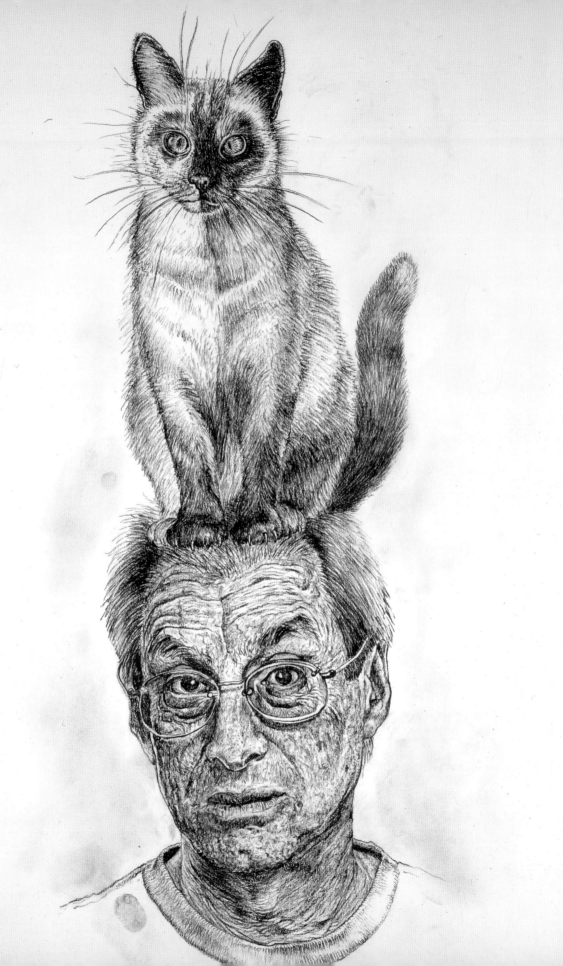

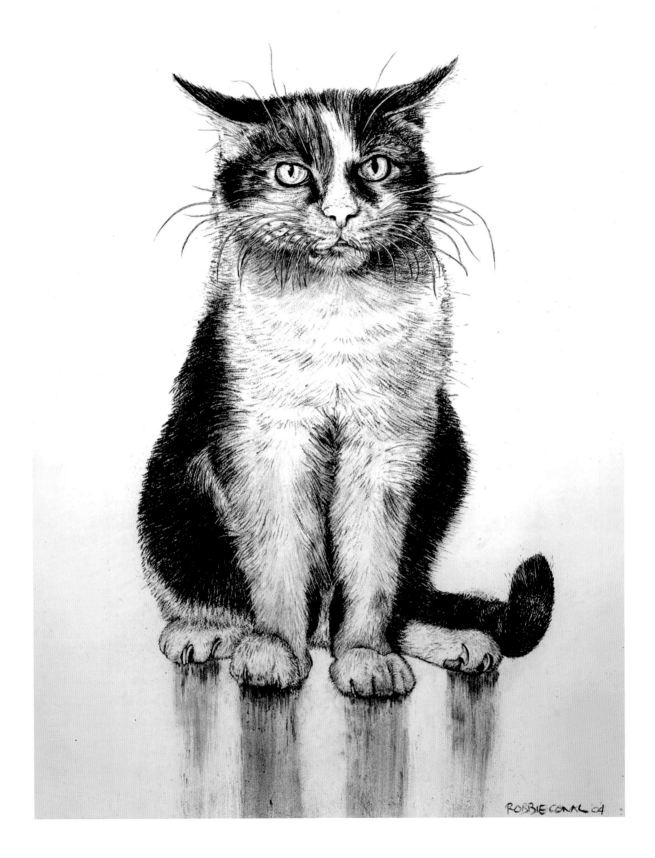

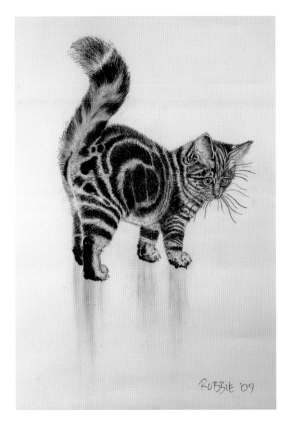

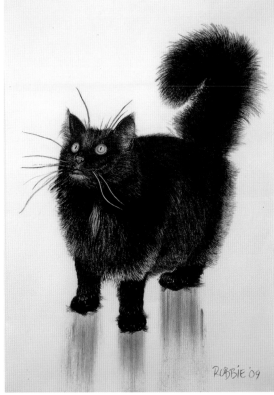

You're known for your street art, have you ever taken cat art to the street?

Not yet. Though I have ideas about that. One is a drawing of our late great tabby, Bodhi, up on his hind legs, right forepaw raised, making a power paw fist, with the text: "SMASH THE POWER OF THE CATAPALIST STATE!" However, there's actually NO good reason why cat posters shouldn't be plastered over every public space!

When did you start depicting cats and why?

I was raised by Siamese cats in an apartment on the upper "left" side of Manhattan in New York. I was an only child. My parents were very busy. It was mostly just me and the cats. They took very good care of me. I've been drawing since I was a toddler, so, naturally, my first subjects were cats. Been drawing them ever since.

How does your cat art relate to the rest of your work? Does it?

I guess you could say it's become the antidote to my over 30 years of adversarial portraiture. For example, for me, making the cat drawings is the opposite experience of doing my latest *Cabinet of Horrors* series of paintings and posters of all the odious Trumpsters—which, sadly, I've been stuck on for the last few years. The *Self-portrait with Smilla* is an homage to a great drawing—by the maniacally wonderful Belgian artist, James Ensor—of a woman sleepwalking through the woods with a freaked out black cat on top of her head. I know the feeling.

What would people be surprised to know about you?

That I'm a stone cold optimist. I just love people (almost as much as cats).

LEFT PAGE
Sebastian
Compressed charcoal on paper, 29 x 23". 2004. Collection of Deb Lacusta & Dan Castellaneta.

LEFT
Bodhi
Compressed charcoal & colored pencil on paper, 29 x 23". 2009.

RIGHT
Goddess
Compressed charcoal & colored pencil on paper, 29 x 23". 2009. Collection of Deborah Ross.

TRAIN

Train is an illustrator from Taiwan.
In 2018, Train left life as an office worker
for an electricity supply company and
started persuing art full-time. Train regularly
pays close attention to animal and social
issues, hoping to draw more people's attention
to those topics through illustration. Train is
skilled at drawing animals and flowers, and
also enjoys drawing interaction between
people. Train dreams of publishing picture
books one day.

Facebook: @trainillustration
Instagram: @hellotraintrain
www.behance.net/tongdong

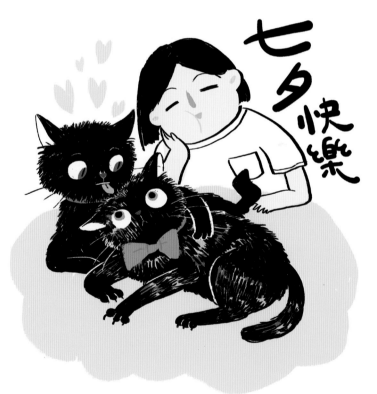

ABOVE

Happy Chinese
Valentine's Day
Digital painting,
10 x 10". 2018.

RIGHT PAGE

Happiness
Digital painting,
13 x 13". 2017.

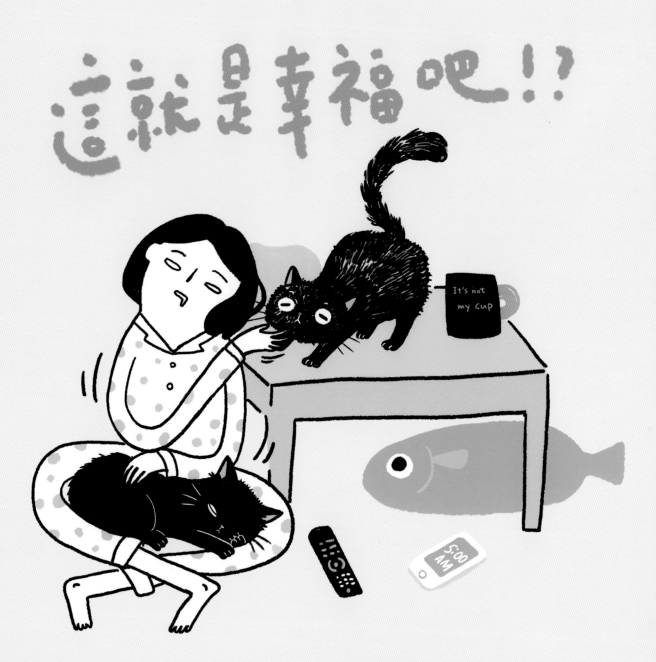

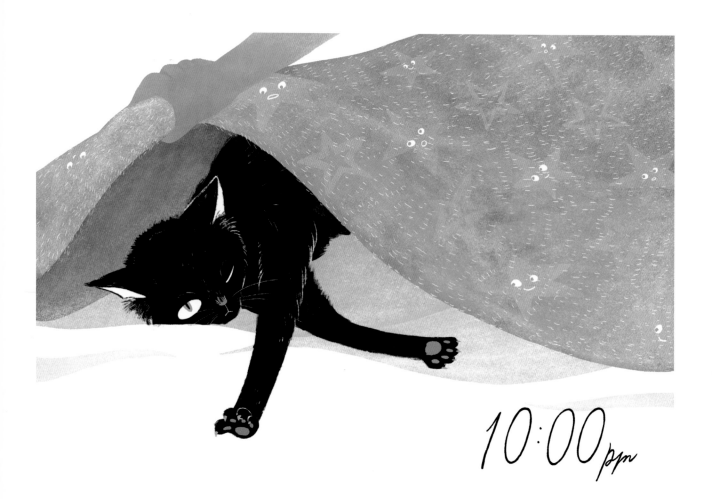

THIS PAGE

In bed at 10pm
Digital painting,
8 x 12". 2019.

RIGHT PAGE

Wake up at 3am
Digital painting,
8 x 12". 2019.

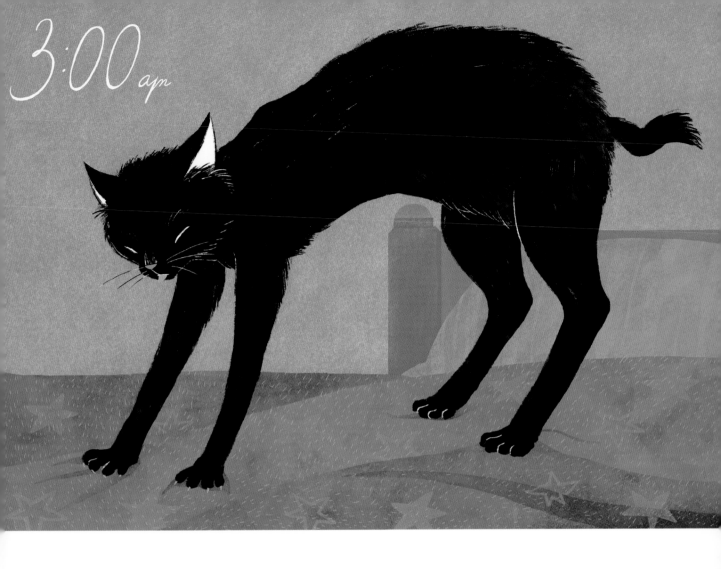

3:00 am

When and why did you start incorporating cats into your work and what do you feel they bring to it?

Cats have affected my life ever since I adopted two of them. From observing their behavior, they have gradually made their way into my paintings. Almost any time I create I want to paint them. Cats bring me different attitudes towards life: they are idle, elegant and free. They give me strong personal principles and make me more determined to follow the road of illustration.

Is there any work of art featuring cats that has inspired you? Where did you encounter it, and how did it make you feel?

I really like the artist Kamwei Fong (see page 344) of Malaysia. In his paintings, I can see the mysterious and playful side of a black cat, like a little devil who appears by your side. In addition, he paints cat hair very well, and I have since begun to try and show cat hair in different ways.

What process do you go through to create your work? What inspires you?

Most of my images are inspired by poems or articles. When there is a passage that makes me feel deeply or moved, I hope to show the atmosphere of that work in my pictures. When the inspiration comes, I will start looking for other works to reference and think about how to present the ideas visually.

What might people be surprised to know about you (or your work)?

I hope people can see the positive power of cats and their charming sense of delicacy in my paintings.

What question do you wish I had asked you?

You can ask me how to treat cats.

What is your answer to that question?

A cat does not need to explain its reasons to you. When a cat wrecks your home, you just smile and say how cute it is.

What role if any do cats have in your culture and do you have any personal relationship with cats?

This may vary according to the personality of cats. With my cat Jazz, I think he would be my sexy and charming lover. His eyes and lips are really beautiful. With Spot, she would be a little princess who is fond of spoiling and shy, and I would be her father who dotes on her.

RIGHT PAGE

Jazz and Spot Design
Digital painting,
5 x 5". 2017.

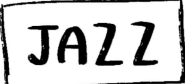

JAZZ

斑斑

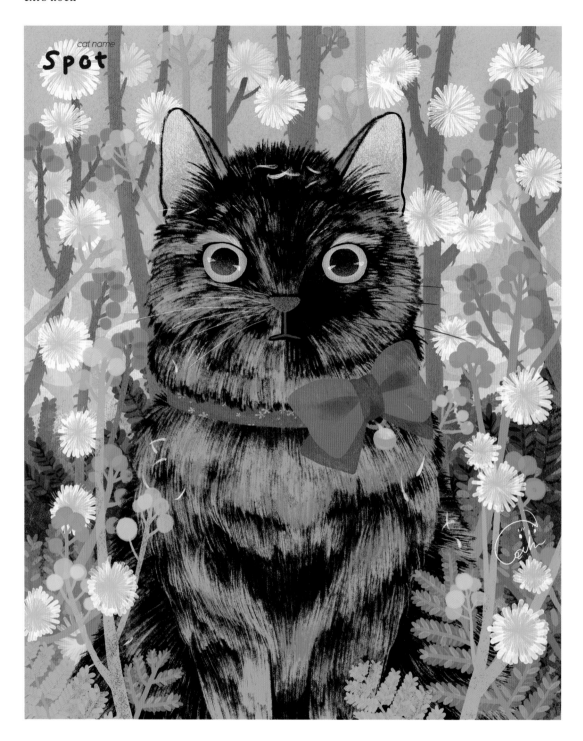

cat name
Spot

THIS PAGE

Spot
Digital painting,
13 x 17". 2019.

RIGHT PAGE

Jazz
Digital painting,
13 x 17". 2019.

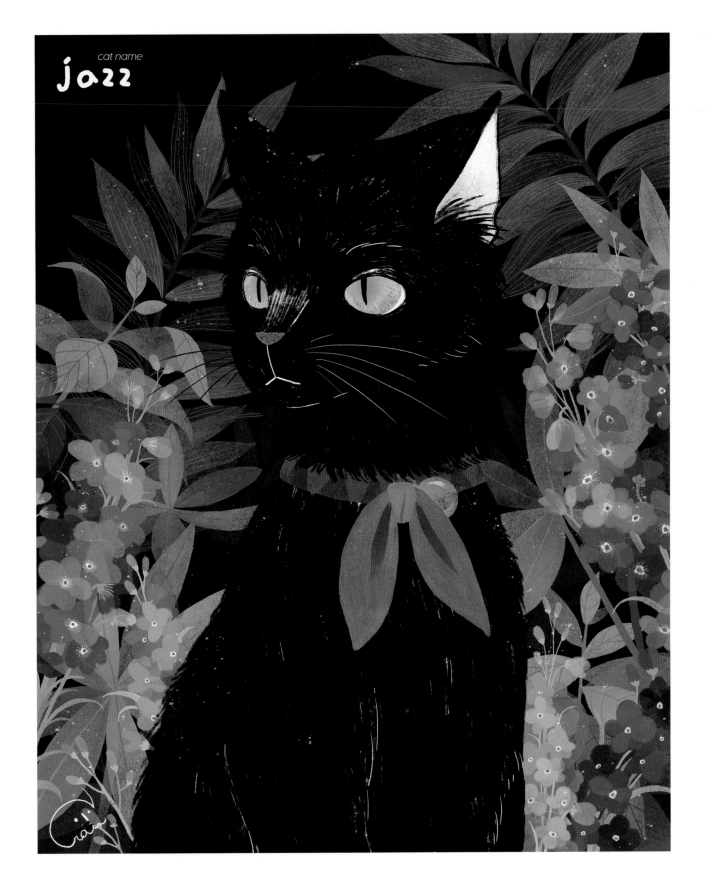

cat name

jazz

STEVE TABBUTT

Steven Tabbutt was born in Maine and currently lives and works in NYC. He graduated with a B.F.A. in Illustration (minor in Painting) from the Savannah College of Art and Design, and an M.F.A. in Illustration as Visual Essay from the School of Visual Arts in New York. He has exhibited work with galleries nationally and internationally, in New York, Paris, London, Brussels, and Tokyo. His fine art is represented by the Yukiko Kawase Gallery. His illustration is represented by Morgan Gaynin Inc. His clients include: *The New York Times*, Rizzoli Publishing, Penguin Group USA, The National Academy of Recording Arts and Sciences (Grammy Awards), *Wired UK*, Scholastic, Launch Agency, *Playboy*, *Hour Detroit*, *Texas Monthly*, and *The Wall Street Journal*. Some of Steven's awards include a silver medal from the New York Society of Illustrators, a gold medal from Spectrum Fantastic Art, two bronze medals from the LA Society of Illustrators, a silver medal from Illustrative Berlin's Young Illustrators Award, a gold, silver and bronze from *3X3* magazine, and a gold and two silver medals from *Creative Quarterly*. The Savannah College of Art and Design awarded him their Distinguished Alumni Award in 2011. He currently has one cat named Tuna.

www.steventabbutt.com

The Grey Rabbit
Mixed media and acrylic
on paper, 12 x 15". 2009.

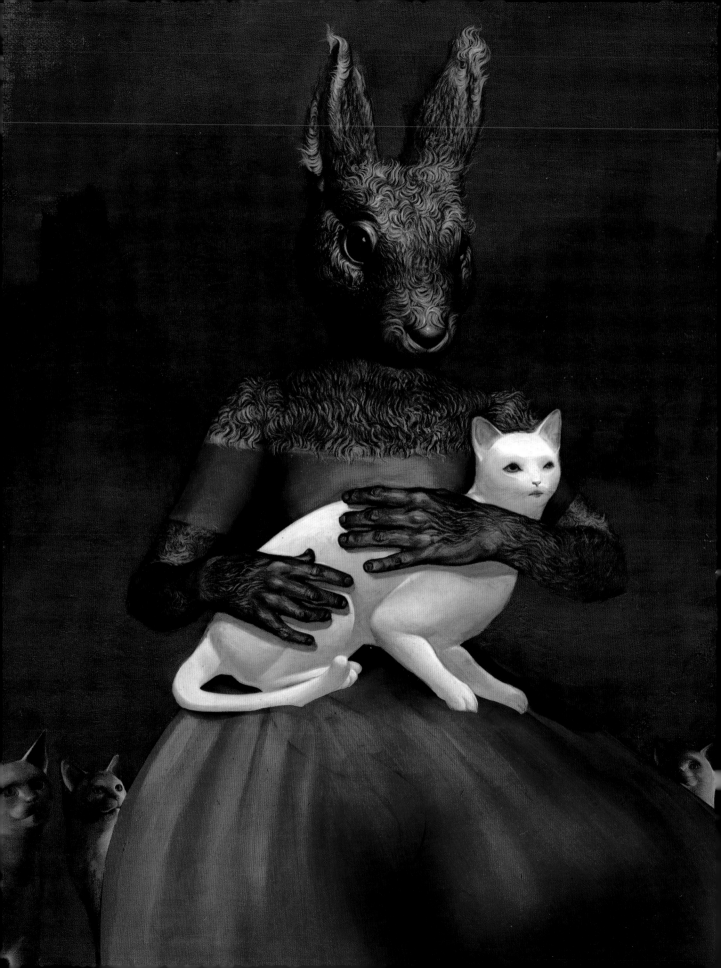

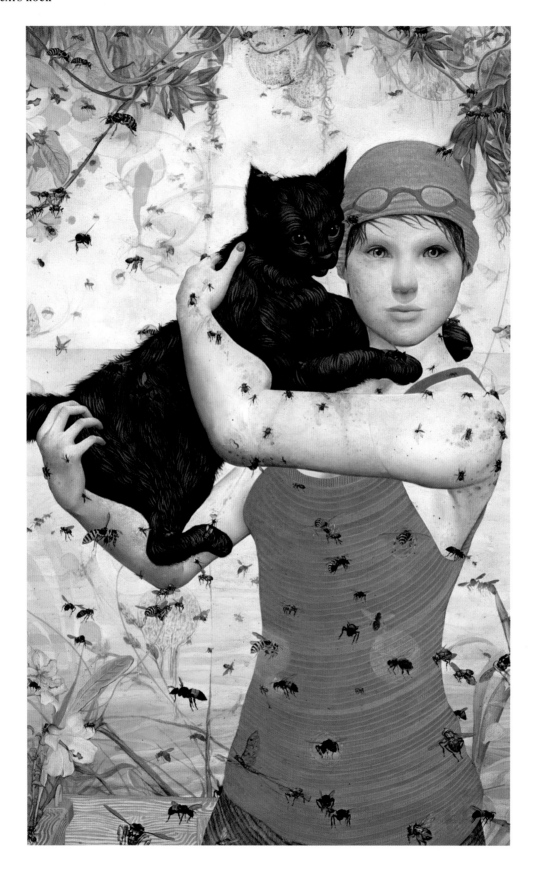

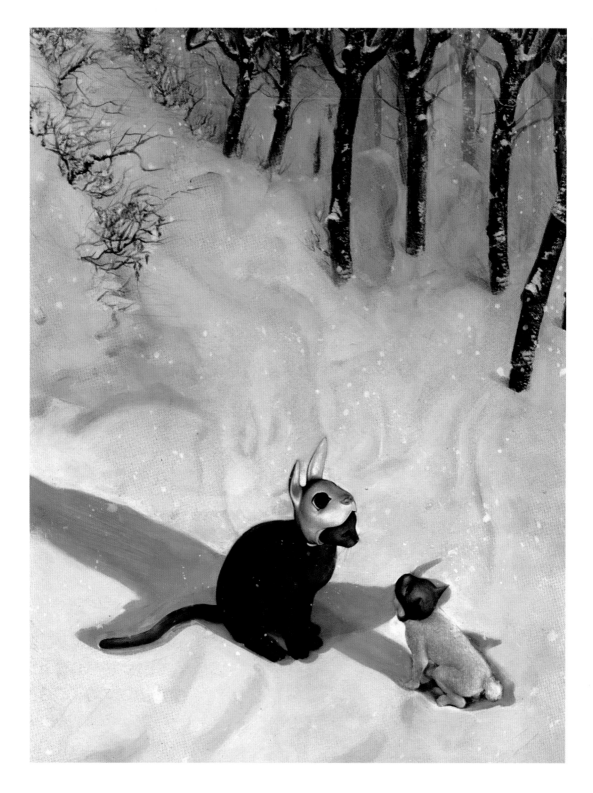

LEFT PAGE

Infest
Mixed media and acrylic
on paper, 11.5 x 18.5". 2011.

THIS PAGE

The Incident
Mixed media and acrylic
on paper, 11 x 14.5". 2009.

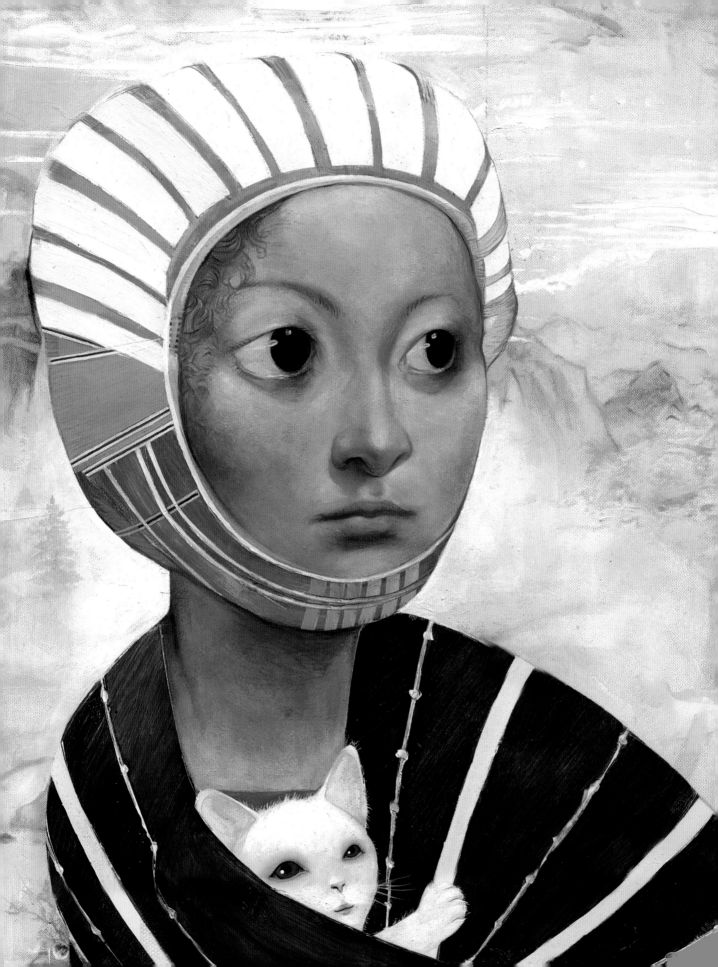

When and why did you start incorporating cats into your work and what do you feel they bring to it?
Cats have always been a major part of my life and have been featured in my work since my childhood. I have always been fascinated by dichotomies. I often incorporate cats because of their dual nature. Cats are incredibly vulnerable and sweet animals but, at the same time, they are somehow also very brutal and stoic.

Is there any work of art featuring cats that has inspired you? Where did you encounter it, and how did it make you feel?
There are several paintings featuring cats that I love, such as Lucien Freud's *Girl with a Kitten*. Though I am mostly drawn to the cats depicted in art during the Renaissance that I have encountered in museums and seen in books. They always leave an impression on me because they often seem to have very bizarre, unnatural faces. I find them terrifying and hilarious at the same time.

What process do you go through to create your work? What inspires you?
I start with a feeling that I want to express and then I obsess about what it is about that feeling that is instinctively compelling me to want to put it on paper. I then do as many sketches and color studies as it takes until I feel I have captured that feeling. After I have my composition and color scheme worked out, then I begin my very labor-intensive process of creating my final. My favorite medium to use is acrylic paint, but I often combine it with a multitude of mediums depending on what piece I'm creating. I mostly work on paper because I like the way the surface feels. I often spend a lot of time building up a textured surface with several layers of dry brushing using acrylic paint. I then usually put on the final touches using colored pencil and pastel. I am inspired by all sorts of things such as fashion, nature, and music, but my motivation always stems from a desire to express a feeling that I am unable to express in any other form.

What might people be surprised to know about you (or your work)?
My dad was a career Marine so I spent most of my childhood living in the South on military bases.

What question do you wish I had asked you?
What were the names of the three cats I have personally owned?

What is your answer to that question?
Snickles was my first cat, she lived with me in Savannah, Georgia. Lulu was my second cat, she moved to NYC with me. My current cat is named Tuna. She is a very confident orange tabby who always gets her way.

The Diver
Mixed media and acrylic
on paper, 12 x 15". 2008.

ZANE YORK

In Zane York's work, focus falls mostly to oddities, animals, and entomology. They are not necessarily pretty things, not necessarily ugly things, but intensely visual things. Themes of mortality, anthropomorphism, perceived beauty, and transience always seem to be played out. The complex and conflicting state of these subjects provide his motivation; a bird's skull, all at once, is evidence of grand design, profane existence, and memento mori. York Received his B.F.A. from the University of Wisconsin Oshkosh and his M.F.A. from the New York Academy of Art. He is represented by Causey Contemporary in New York and Gallery Fledermaus in Chicago. He has had numerous solo exhibitions with his galleries, as well as at the Dubuque Museum of Art, and the Arsenal Gallery in Central Park. His work has been exhibited in New York, Chicago, Los Angeles, Denver, Melbourne, St. Barthelemy, Florida and France. Zane maintains his studio in Greenpoint, Brooklyn, and is on the faculty at the New York Academy of Art.

www.zaneyork.com

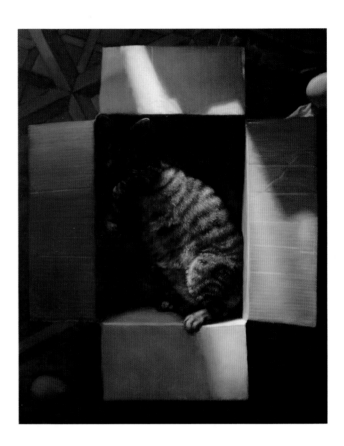

THIS PAGE

Cat in Box
Oil on panel, 10 x 8".
2011.

RIGHT PAGE

Cat on Chair
Oil on panel, 14 x 10".
2013.

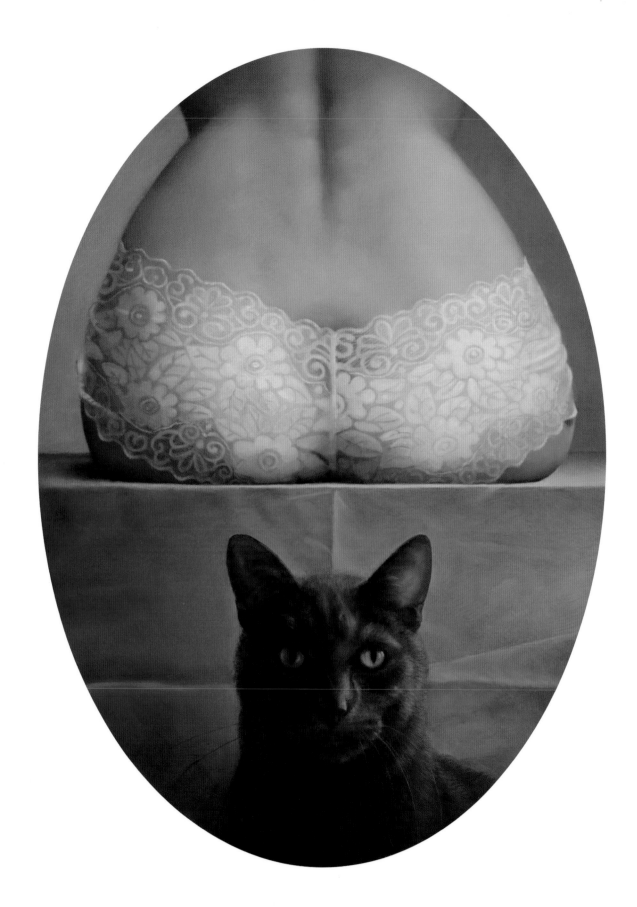

When and why did you start incorporating cats into your work and what do you feel they bring to it?

Cats have long found their way into my work. My paintings typically deal with our interrelationship with the natural world, and the "domesticated" cat seems like a natural intermediary - half wild, half tame. It took me a while to understand why I find cats such potent characters. Ultimately, I realized that they are a near perfect vessel for the viewer. We all know cats, we love them, we ascribe human feelings and emotions to them; we empathize with them. Unlike portrayals of humans in paintings, the viewer doesn't struggle with objectivizing or subjectivizing the cat. They comfortably place themselves within the experiences of a feline protagonist. With cat as vessel, the viewer can feel the anxiety, the threat, the fear or the joy more directly without the hazard of overwriting another human's experience.

Is there any work of art featuring cats that has inspired you? Where did you encounter it, and how did it make you feel?

Any works that include cats have an immediate interest to me. I remember seeing Da Vinci's sketches of cats - in his investigations he captures their feeling through gesture. Cats are a great humanizer. Goya includes cats in his paintings and they often feel like a reprive from the serious, dark, political, or otherwise intense subjects he paints. Chardin's cats are lovely. He understands the animal spirit and utilizes them in a primal fashion that enhances the temporal effect created by his still lives. Grant Wood often painted cats and each one was handled uniquely in each separate painting. They almost seem like a guidepost for the artist's approach to each subject he was depicting. Throughout art history, cats have been a potent subject for instilling profound content in a painting. They are familiar yet a mystery, exotic yet ubiquitous, tame yet wild. With that potency, it is no surprise that there are so many examples of cats in the history of art.

THIS SPREAD

Ascension
Oil on canvas on panel,
70"-diameter. 2014.

NEXT SPREAD

Cat in Sink
Oil on linen, 8 x 10".
2018.

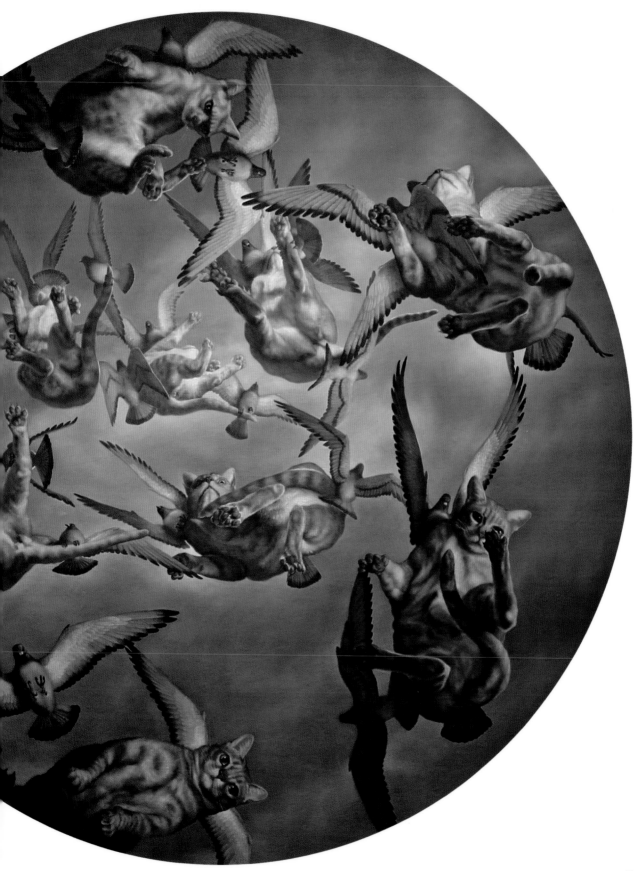

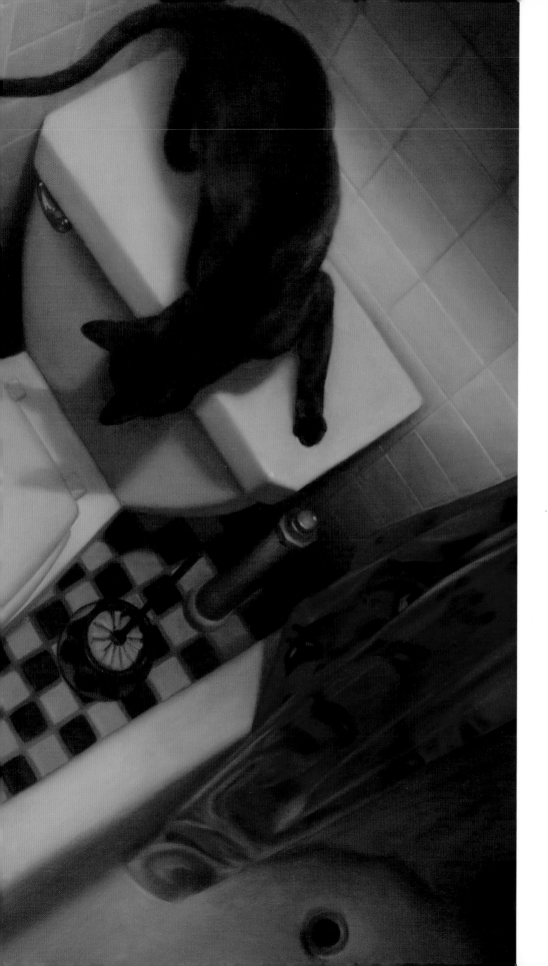

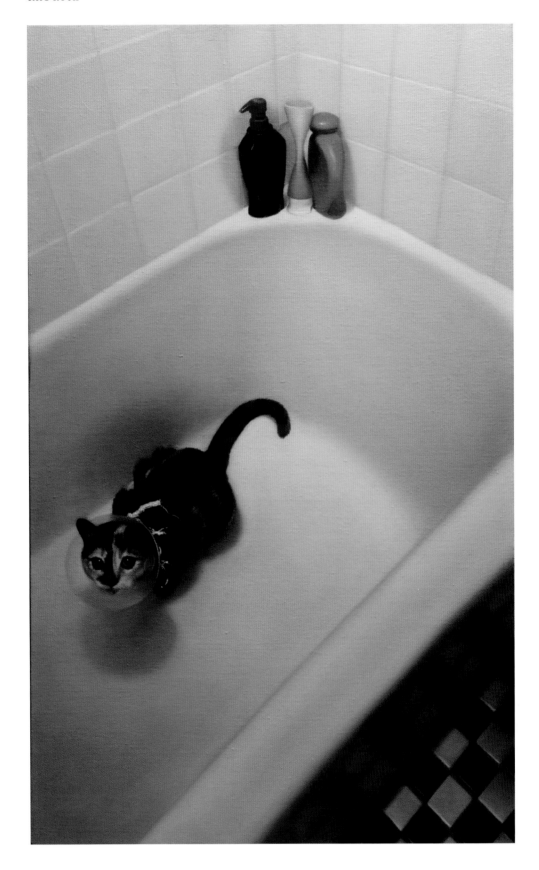

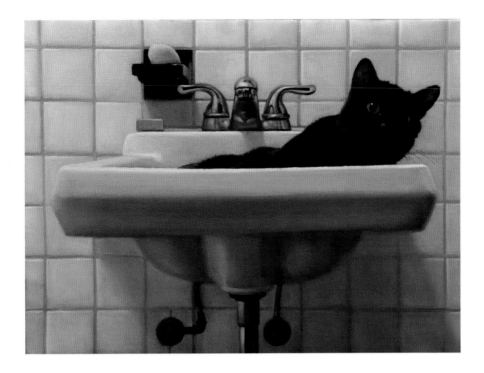

What process do you go through to create your work? What inspires you?

My work is typically a distillation. Themes, visuals, and concepts float around in my head, often for years, before I understand why an idea, the seed of a painting, is meaningful and worth pursuing. Imagery and ideas that appeal to me do so in a very intuitive manner. I know they have a level of profundity, even if I don't know why. Once I start to understand why, I begin painting. After conception, my process itself is quite cerebral. I plan for many variables, and leave areas for exploration. I think both are important for crafting a painting. There is an intensely personal interaction in the studio between artist and canvas - one that yields a result that is more than idea and paint. Hopefully pathos, revelation, deep understanding, and a feeling of gravity are captured within the oil and pigment.

What might people be surprised to know about you (or your work)?

I like to believe an artist's work is a fair representation of their understanding of and interests in the world. In this, I believe my work gives an accurate account. I personally find myself occupied with bigger concepts, but there is always levity. By default, I smile. It might be out of place in certain situations, but I am very amused by the absurdity of life and enchanted by the beauty of its contradictions.

What question do you wish I had asked you?

With cats being central to meme culture and a mainstay in social media, we are bombarded with cats being represented as cute and comical - a carefree escape. Your work seems less invested in that aspect of cat culture, why?

What is your answer to that question?

I think many artists are pursuing the link between cats and contemporary social media, and many of those works are incredibly interesting. While I certainly enjoy a good cat meme, it is not central to my interest in cats. My entry point into painting cats stems from my direct experience with my pets. Most cats seem to like my company, and I tend to get very involved in understanding them. I try to gain a sense of their personality, their behavior, and perhaps catch a glimpse of their soul. I find it amazing that we are able to bond so closely with these half-wild creatures. It is such an intimate experience and being their steward creates such a loving bond. I look to capture the intensely personal aspect of our relationship with cats, as I find that is often when we are most fundamentally human.

LEFT PAGE

Cat in Bathtub
Oil on linen, 36 x 24". 2013.

THIS PAGE

Cat and Cicada
Oil on linen, 36 x 48". 2007.

CATS

AND

THE FEMININE

Adipocere
Four of Swords
2018.

"Woman is a cat to bite with teeth."

FROM A LATE MEDIEVAL POEM ENTITLED: "THE VICES OF WOMEN."

It is hard to write about cats without discussing their association with all things feminine. Even before the term "pussy" became slang for female genitalia and the expressions "cat fight" or "catty" referred to (primarily) female aggression, before the trope of "crazy cat lady" or "sex kitten" made it into popular culture, cats were associated with women. The ancient Egyptian cat goddess Bast was linked with fertility, protection and childbirth. However, these positive associations weren't eternal. With the rise of Christianity, pagan rituals including cat worship, once practiced by Egyptians, became illegal. While maintaining their feminine associations, cats also became associated with shape shifting and trickery. As a result, cats were routinely tortured and women who kept cats too close were punished for witchcraft. Such torment befell cats and women for hundreds of years—from the Middle Ages in Europe to the Salem witch trials in the Massachusetts Bay Colony in 1693.

Even well into the 1800s, when cats became increasingly popular pets, they were still entangled with femininity. In "Passional Zoology" (1852) Alphonse Toussenel wrote: "An animal so keen on maintaining her appearance, so silky, so tiny, so eager for caresses, so ardent and responsive, so graceful and supple...; an animal that makes the night her day, and who shocks decent people with the noise of her orgies, can have only one single analogy in this world, and that analogy is of the feminine kind."

In art, women and cats are familiar bedfellows, as in the work of Mary Cassatt (1844-1926) or Edouard Manet (1832-1883). Cats and women were also famously brought together in Japanese art of the Edo period.

Today, as in the past, cats are often used to signify feminine duality. Perhaps the best example can be found in the Batman franchise, which features the character Catwoman, a former kind-hearted cat lady turned villainous sex kitten. In *Batman Returns* (1992), before she becomes Catwoman, Selina Kyle (Michelle Pfeiffer) is shown living in a pink apartment adorned with remnants of her childhood. The only messages on her voicemail are from her mother and her only co-occupants are cats. "Honey I'm home," she announces, entering her apartment. "Oh, I forgot. I'm not married," she says in a monotone. She then transforms into a frightening possessed woman, feverishly stitching a black patent leather cat suit, after destroying everything that might be considered "sweet" in her apartment.

In *Catwoman* (2004) with Halle Berry in the title role, the character is portrayed less as a misfit and more as a liberated woman. In this film, when Catwoman realizes her powers she goes to investigate them at the home of a professorial cat lady. The older woman shows Catwoman ancient texts and tells her she is not alone. "Catwomen are not contained by the rules of society. You follow your own desires. This is both a blessing and a curse," the woman says, queering the feline character. "You will often be alone and misunderstood, but you will experience a freedom other women will never know. You are a cat woman: every sight every smell every sound incredibly heightened. Fierce independence, total confidence, inhuman reflexes...accept it child. You spent a lifetime caged. By accepting who you are, all of who you are, you can be free and freedom is power."

It's no wonder that this trope of cat lady lends itself well to queer interpretations, particularly in contemporary art. The cat lady is essentially a queer character: one who defies social norms of marriage and children in favor of a life spent devoted to her pets and her own desires. She is the modern witch, a self-sufficient character of great mystery, except to her familiars. The idea of the cat lady is so powerful that it extends of course to the cat man. As cats are traditionally associated with femininity, men who have cats as pets, such as Jon from the comic strip *Garfield*, (1978) are often viewed as less masculine or suspect in popular culture. Jon has a hard time getting a date and is notably unassertive, allowing his cat to run the house. As characters like Jon show, the cat man fails to perform masculinity in the "proper" way. He has a difficult time serving as the master of his domain. He is literally "pussy whipped."

The artists in this section explore the relationship between felines and the feminine, expanding upon one of the most enduring and compelling themes in cat art since the times of ancient Egypt.

MARK RYDEN

Blending themes of pop culture with techniques reminiscent of the old masters, Mark Ryden has created a singular style that blurs the traditional boundaries between high and low art. His work first garnered attention in the 1990s when he ushered in a new genre of painting, "Pop Surrealism," dragging a host of followers in his wake. Ryden has trumped the initial surrealist strategies by choosing subject matter loaded with cultural connotation. Mark Ryden received a B.F.A. in 1987 from Art Center College of Design in Pasadena. His paintings have been exhibited in museums and galleries worldwide, including a career-spanning retrospective *Cámara de las maravillas* at The Centro de Arte Contemporáneo of Málaga, as well as an earlier retrospective *Wondertoonel* at the Frye Museum of Art in Seattle and Pasadena Museum of California Art. Ryden was recently commissioned to create the set and costume design for a new production of *Whipped Cream*, put on by the American Ballet Theatre with choreography by Alexei Ratmansky. *Whipped Cream* is based on *Schlagobers*, a two-act ballet with libretto and score by Richard Strauss first performed at the Vienna State Opera in 1924. Mark Ryden currently lives and works in Portland, Oregon.

www.markryden.com

THIS PAGE

Hoop Cat
Graphite on paper, 8 x 8". 2002.

RIGHT PAGE

Amanda
Oil on panel, 12 x 9". 2016.

NEXT SPREAD

Schrödinger's Cat - Superposition (No. 134)
Oil on panel, 7 x 16". 2018.
In 1935, Erwin Schrödinger, an Austrian physicist, devised a hypothetical thought experiment to illustrate the paradox between the strange behavior of tiny particles at the subatomic quantum realm and the world of everyday objects that are made of those subatomic particles. He imagined a cat in a box with a Geiger counter that, upon detecting the radioactivity of an atom decaying, would trigger a hammer that shatters a vial full of poison. The cat's fate was linked to this subatomic event. In quantum mechanics, until we look in the box, the cat is in a superposition of being both dead and alive at the same time. It is our act of looking that causes the superposition to collapse into one outcome or the other. This raises many questions: Who observes us to determine whether we see a dead cat or a live cat? The cat itself has an observation of the event, which gives her a place in it. Does the universe split into infinite alternate worlds, with every possible outcome of every event?

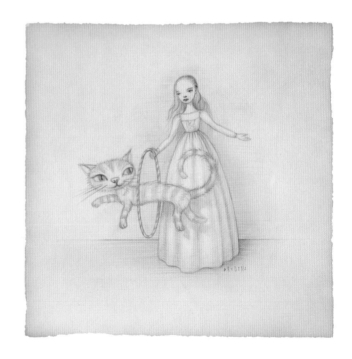

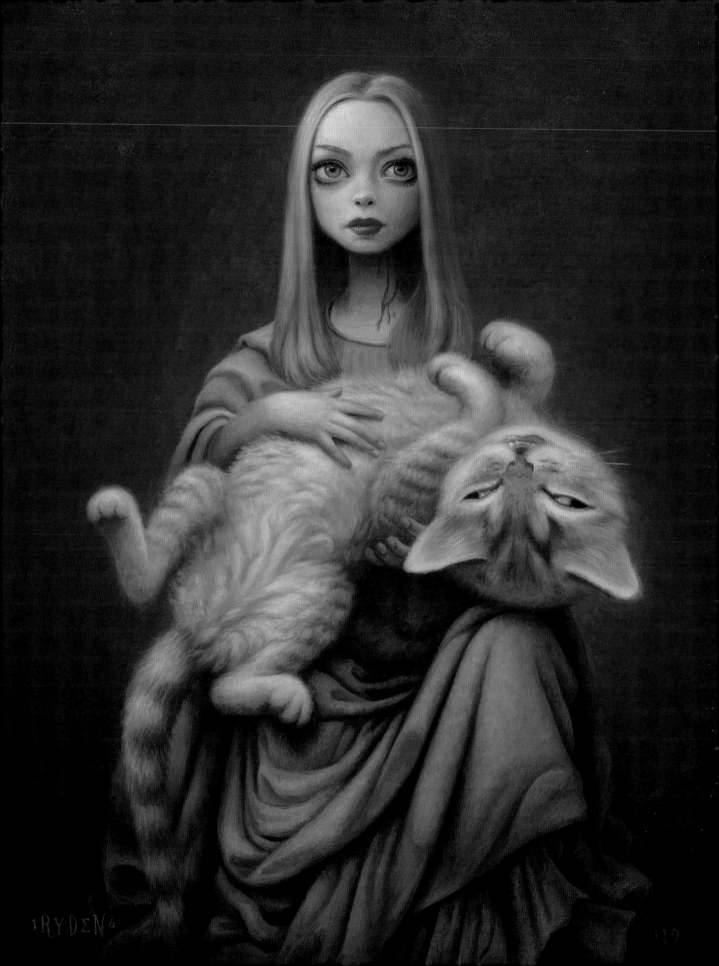

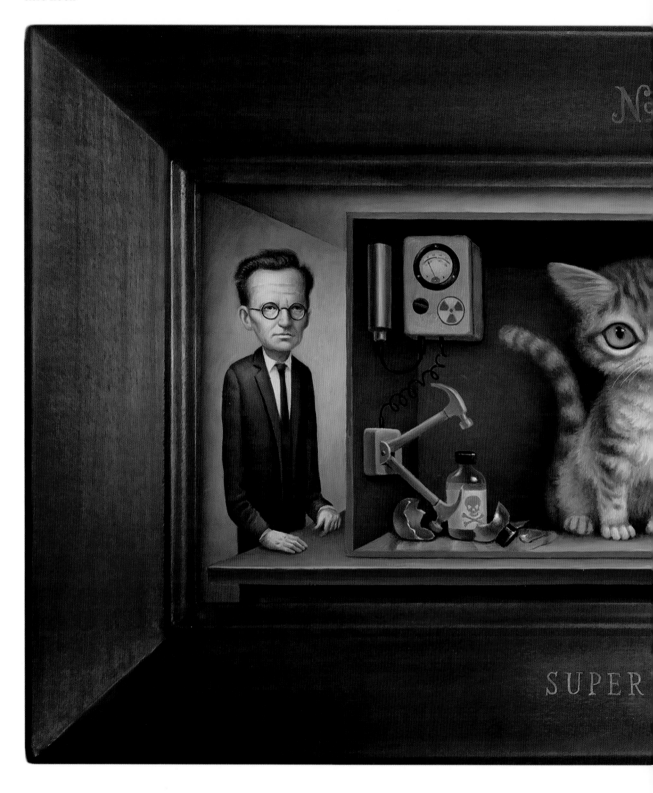

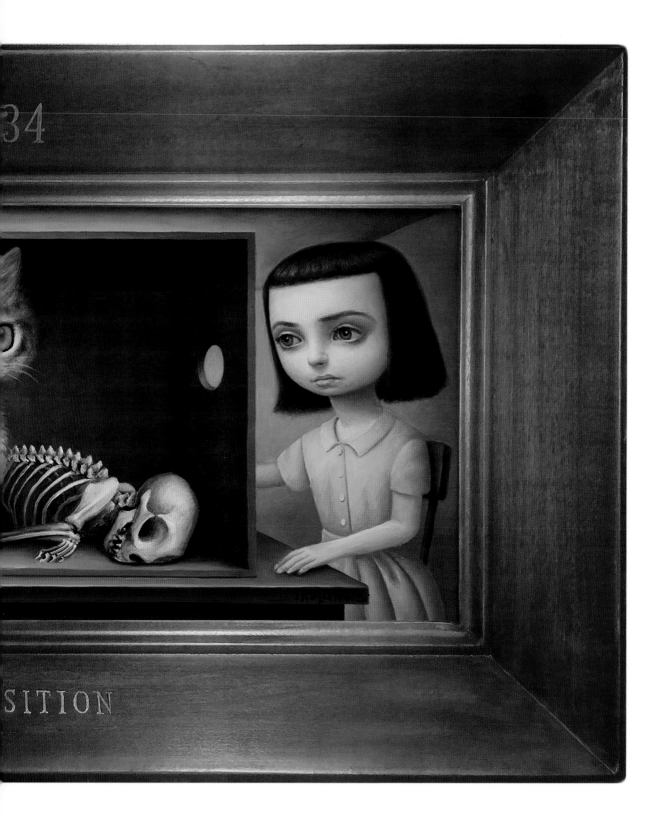

ADIPOCERE

Adipocere is from Australia and developed an interest in embroidery as art in 2014, after they cross-stitched an homage to the film *Alien*. From there they have created their own visuals inspired by a fascination with the macabre, combining themes of innocence with an unsettling and sinister melancholy, referring to many of their works as 'emotional self-portraiture'. As an environmental science student, flora and fauna related theory often influence their work, as does a desire to utilize materials that are more sustainable. Working predominantly on natural linen, they have occasionally stitched temporary works into the epidermis layer of their left hand.

Instagram: @adipocere

When and why did you start including cats in your work?
Not too long after I started embroidering, sometime in late 2014 I began including cats in my work. There are multiple reasons! Fauna in general, and especially underrepresented or misrepresented fauna are very important to me. So black cats, spiders, and bats tend to appear a lot in my work. Cats also have multiple interesting mythological and spiritual ties I sometimes touch on.

Why did you take on the name Adipocere and what does it mean (for those reading this book)?
Adipocere is a substance formed by decomposition of soft tissue under certain circumstances. 'Adipocere' as a pseudonym happened rather accidentally. It was the name I had on Instagram due to a general morbid curiosity. It just remained as I discovered embroidery. I still get the occasional e-mail from people exclaiming that they googled my name and saw some not so pleasant imagery.

Do you have a personal relationship with any cats and how has that informed your work at all?
I do not, or rather I do, but with all cats! Maybe a lack of personal relationship to any one cat is another reason why I'm constantly embroidering them, as a coping mechanism. Pet ownership is a conflicting thought for me morally, but I can see myself adopting a few rescues down the line when my environment becomes ideal for it.

How did you get started in embroidery and why is it your medium of preference?
I've always been drawn to slow-burning traditional mediums, so it just clicked with me. Previously I had dabbled in other cathartic mediums like stop-motion animation and sculpture, but I never could be quite consumed by either, as I am now with embroidery. I really enjoy the preservation of human error that hand embroidery allows, and the grid-like approach that comes with working within the natural weave of linen.

THIS PAGE
Untitled (Cat Girl Animation Sheet)
Hand embroidery on natural linen, 7 x 5". 2018.

RIGHT PAGE
Six of Swords
Hand embroidery on natural linen, 7.5 x 8.5". 2018.

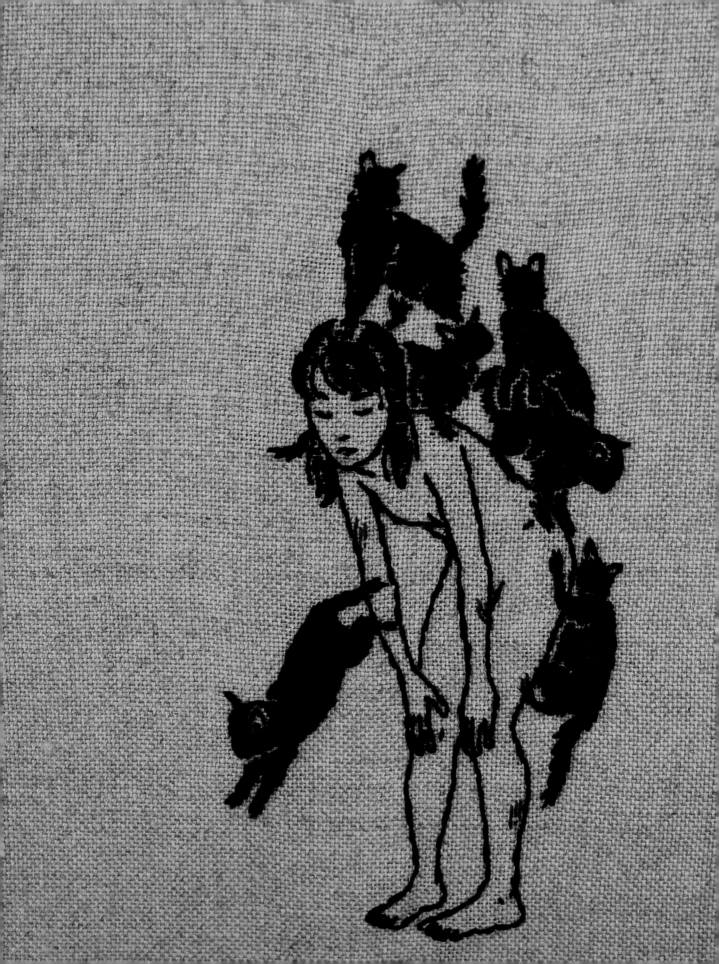

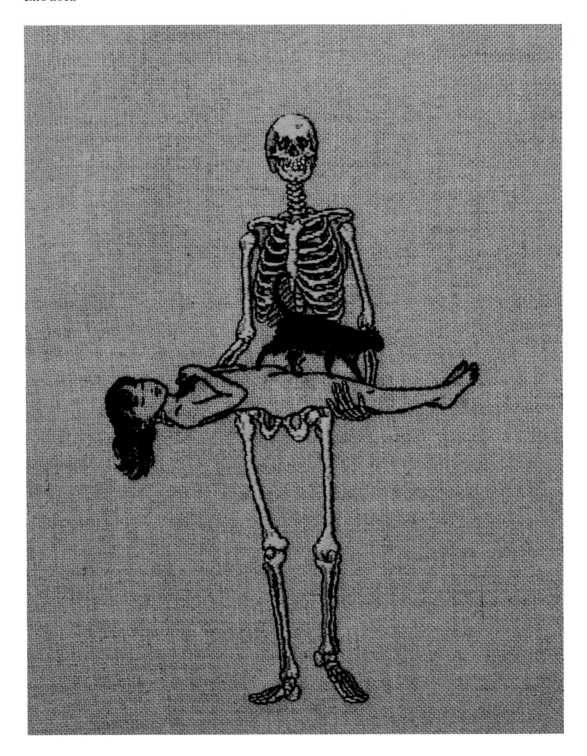

THIS PAGE

Volatile Existence
Hand embroidery on natural
linen, 8 x 10.5". 2018.

RIGHT PAGE, TOP

Artemis
Hand embroidery on natural
linen, cotton thread. Float
mounted within wooden
frame, 9.75 x 8.5". 2019.

RIGHT PAGE, BOTTOM

Lady Godiva
Hand embroidery on natural
linen, 14 x 10". 2016.

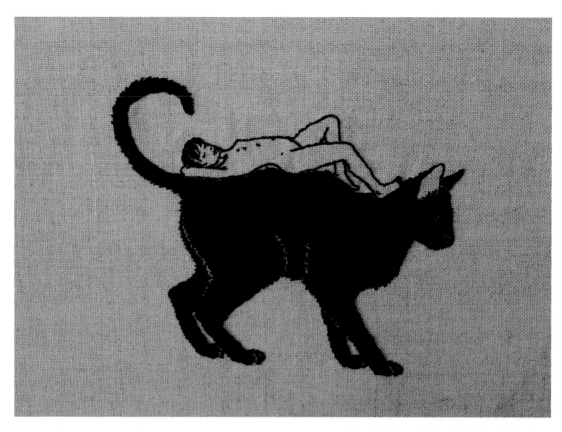

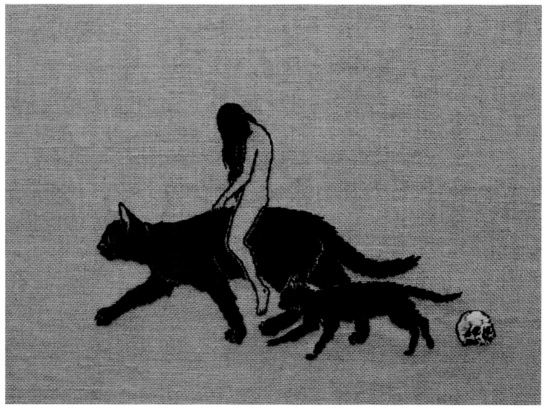

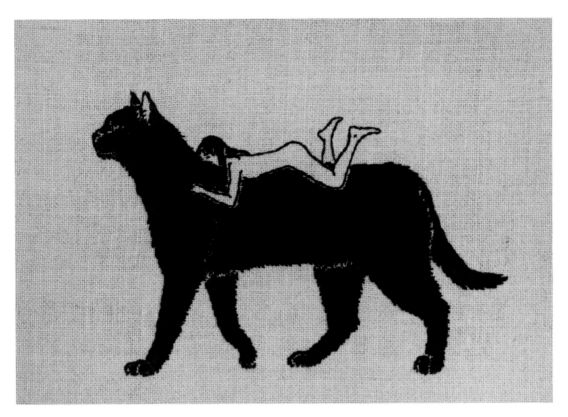

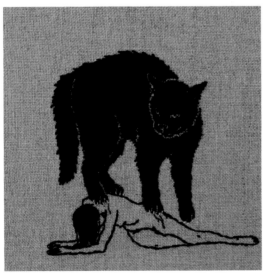

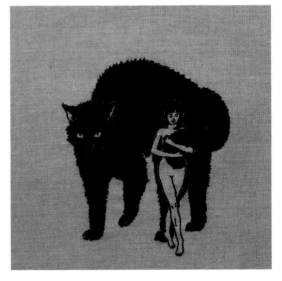

TOP

I'm Taking You With Me
Hand embroidery on natural
linen, cotton thread. Float
mounted within wooden
frame, 8.5 x 7.5". 2018.

BOTTOM LEFT

Pneuma
Hand embroidery on natural
linen, 7.5 x 7". 2018.

BOTTOM RIGHT

Familiar
Hand embroidery on natural
linen, 10 x 14". 2016.

RIGHT PAGE

Brood
Hand embroidery on natural
linen, 8.5 x 9.5". 2018.

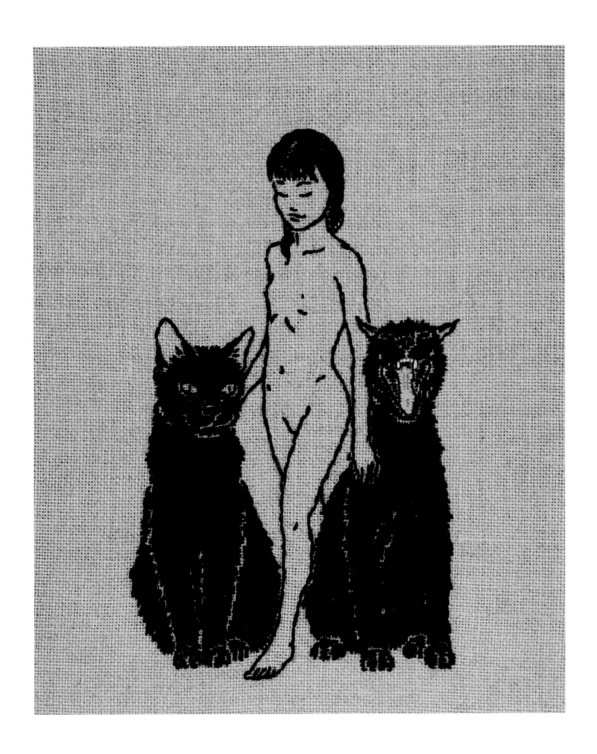

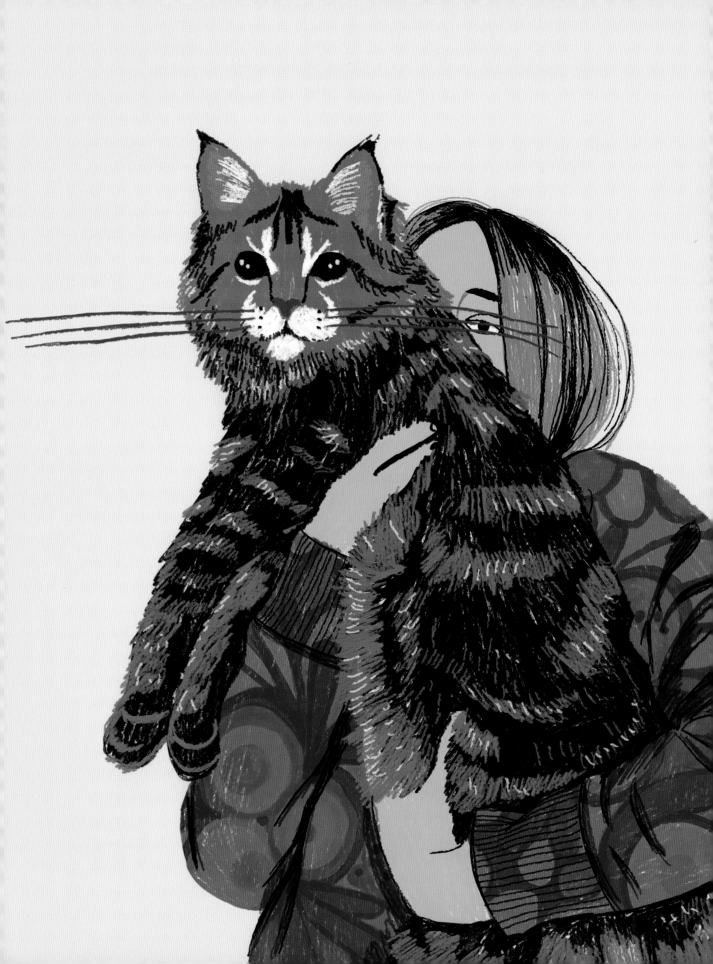

ALISSA LEVY

Alissa Levy was born in 1992 in Kiev, Ukraine. Since 1998 she has been living with family in Germany. Years before finishing school, Levy decided to pursue a career in the arts. She is currently a freelance illustrator and owner of the Etsy shop LevysFriends where she sells prints and custom Illustrations. Levy studied illustration and experimental art at the Folkwang University of Arts in Germany.

Instagram: @levysfriends
www.etsy.com/shop/LevysFriends

Cat Hug
Digitally painted with a Wacom
Cintiq in Adobe Photoshop,
8 x 8".

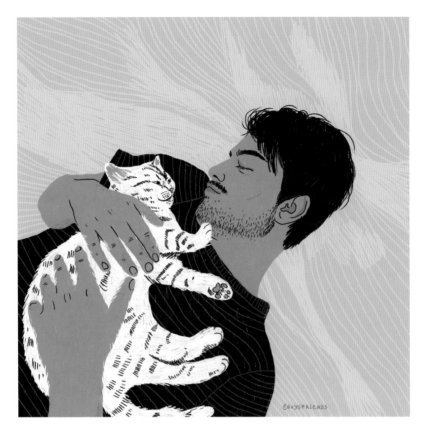

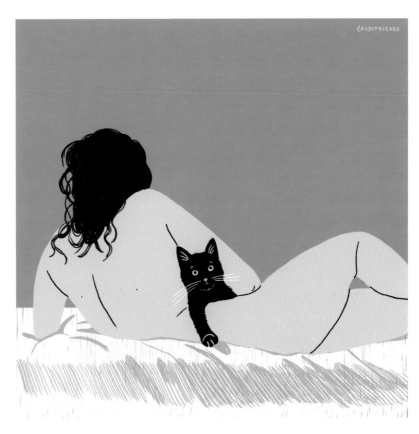

LEFT PAGE, TOP
Guy & Cat
Digitally painted with a
Wacom Cintiq in Adobe
Photoshop, 8 x 8".

LEFT PAGE, BOTTOM
Ghosts
Digitally painted with a
Wacom Cintiq in Adobe
Photoshop, 8 x 8".

TOP
Cat Nude
Digitally painted with a
Wacom Cintiq in Adobe
Photoshop, 8 x 8".

BOTTOM
Cat Kiss
Digitally painted with a
Wacom Cintiq in Adobe
Photoshop, 8 x 8".

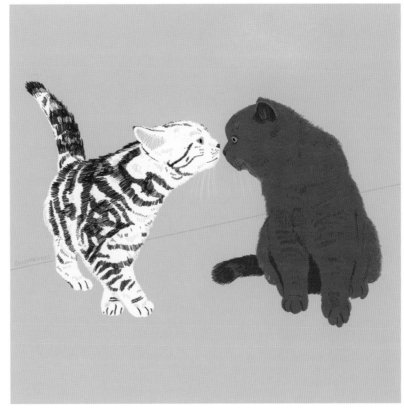

Leopard Lady
Digitally painted with a
Wacom Cintiq in Adobe
Photoshop, 8 x 8".

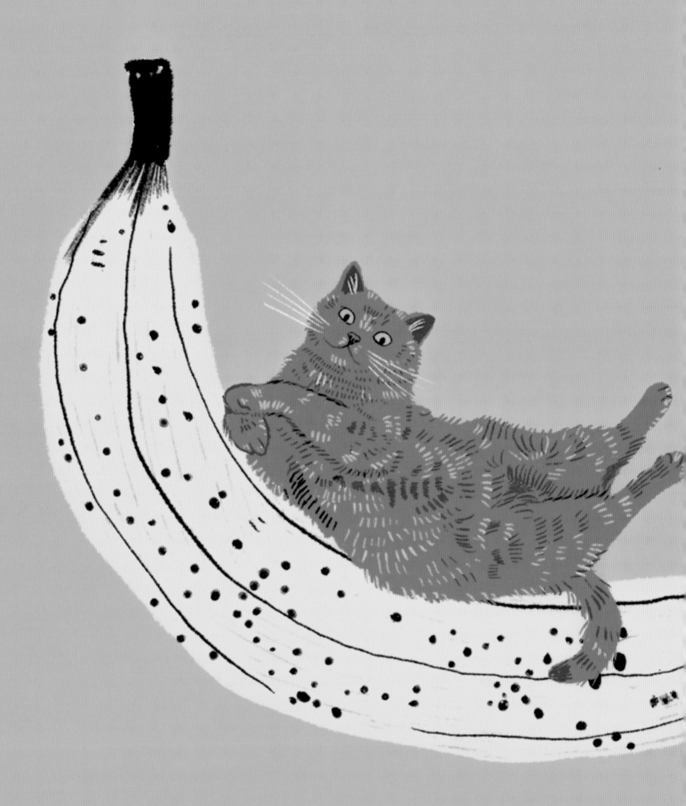

When and why did you start incorporating cats into your work and what do you feel they bring to it?

I never really had a real connection with cats, until my family got to cat-sit an absolutely adorable British Shorthair, while our neighbors were renovating their house. Shortly after, we decided to adopt one of our own and since then, I'm absolutely in love with cats. As an art student, I started to draw cats in their favorite positions, trying to translate their coloring and the softness of their fur by illustrating them in a minimalist but realistic way. I want viewers to relate, and be reminded of their own cats when seeing my artwork.

Is there any work of art featuring cats that has inspired you? Where did you encounter it, and how did it make you feel?

If I had to name my favorite cat artist, it definitely would be Louis Wain. His work humanized cats and he invented his own world for them. One can see his love and admiration for the animals in his drawings. I would love to explore his more abstract approach, deconstructing cats in textures, patterns and shapes, for my own work.

What process do you go through to create your work? What inspires you?

I'm always gathering new ideas for my illustration in a small notebook in order to save them for later. I also take lots of photos for reference when I see something interesting. There are also times when I'm just doodling on my graphic tablet and ornaments and shapes start to grow on their own. To create a consistent aesthetic in my work, I'm working with a limited color palette, mixing muted pastels with bolder colors. I especially like to capture funny and odd moments in my everyday life.

What might people be surprised to know about you (or your work)?

I majored in experimental film, working with abstract images only— a complete contrast to my colorful and realistic illustrations. At first I struggled a lot, trying to combine both styles in one artwork. But I decided later to just keep them separated. Now I can find an inner balance with two absolutely different aesthetic points of view in my work.

What role does art play in your life?

As someone working in the creative field, art is always around me. I am an observer, exploring and processing life around me so I can use my discoveries later in my work. Nearly everything has artistic value to me. Movies and music can be big resources as well. Always walking around with your eyes open and just being in the moment helps with catching things.

Banana Cat
Digitally painted with a Wacom
Cintiq in Adobe Photoshop,
8 x 8".

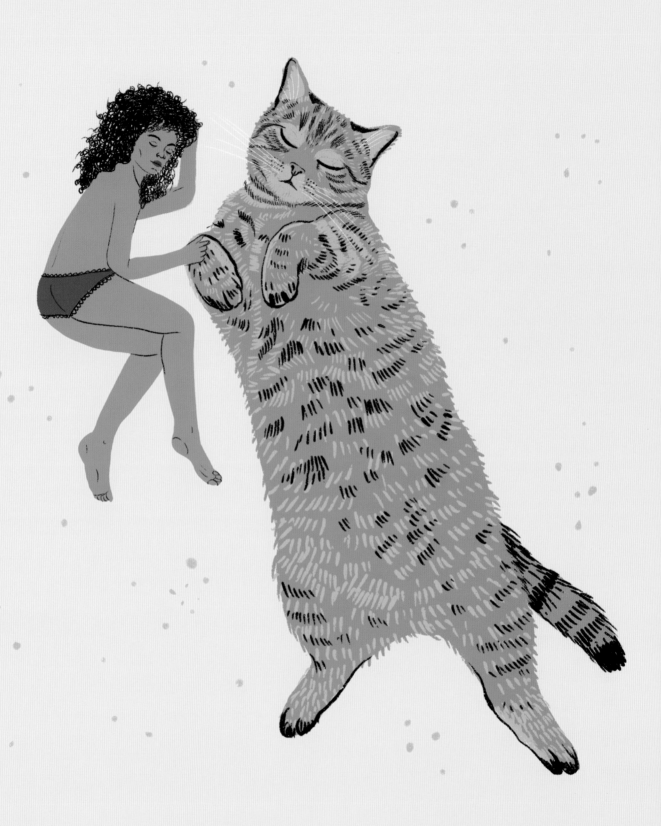

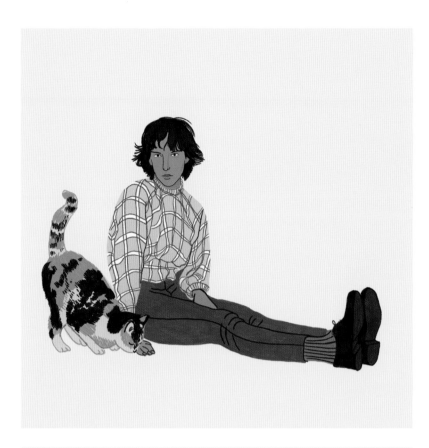

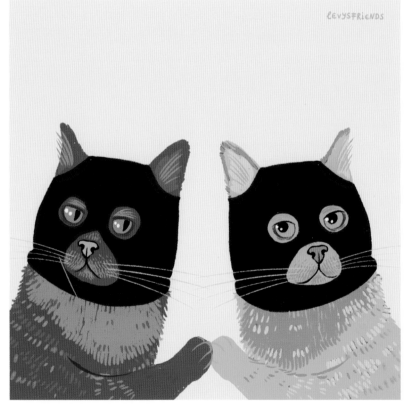

ANITA KUNZ

Anita Kunz is a Canadian artist who has lived in London, New York and Toronto and is published globally. Her critically acclaimed paintings and sculptures have appeared in galleries worldwide, including at the Norman Rockwell Museum in Massachusetts, the Teatrio Cultural Association in Rome, Italy and in solo shows at the Foreign Press office in New York City, Creation Gallery in Tokyo, Govinda Gallery in Washington, D.C., the Art Institute of Boston and Massachusetts College of Art and Design. She had a mid-career retrospective at the Society of Illustrators Museum of American Illustration in New York where she was inducted into its Hall of Fame. She is the first woman and first Canadian to have a solo show at the Library of Congress in Washington, D.C., where her work is retained as part of its permanent collection. Her work is also in permanent collections of the Canadian Archives in Ottawa, the Musée Militaire de France in Paris, and the Museum of Contemporary Art in Rome. A number of her *Time* magazine cover paintings are in the permanent collection at the National Portrait Gallery in Washington, D.C. Kunz was named one of the fifty most influential women in Canada by the National Post newspaper. She has received honorary doctorates from the Ontario College of Art and Design in Toronto and from MassArt College of Art and Design in Massachusetts. She was appointed Officer of the Order of Canada, Canada's highest civilian honor, and recently received the Queen's Jubilee Medal of Honor. In 2018, Canada Post released a postage stamp honoring her work as a Canadian illustrator and artist. Her work has been seen in and/or on covers of: *Time* magazine, *Rolling Stone*, *Vanity Fair*, *The New Yorker*, *GQ, The New York Times Magazine*, *The Atlantic Monthly*, *Newsweek Magazine*, *Sports Illustrated* and on numerous book covers.

www.anitakunz.com

RIGHT PAGE

Flesh and Blood
Acrylic on board,
30 x 40". 2008.

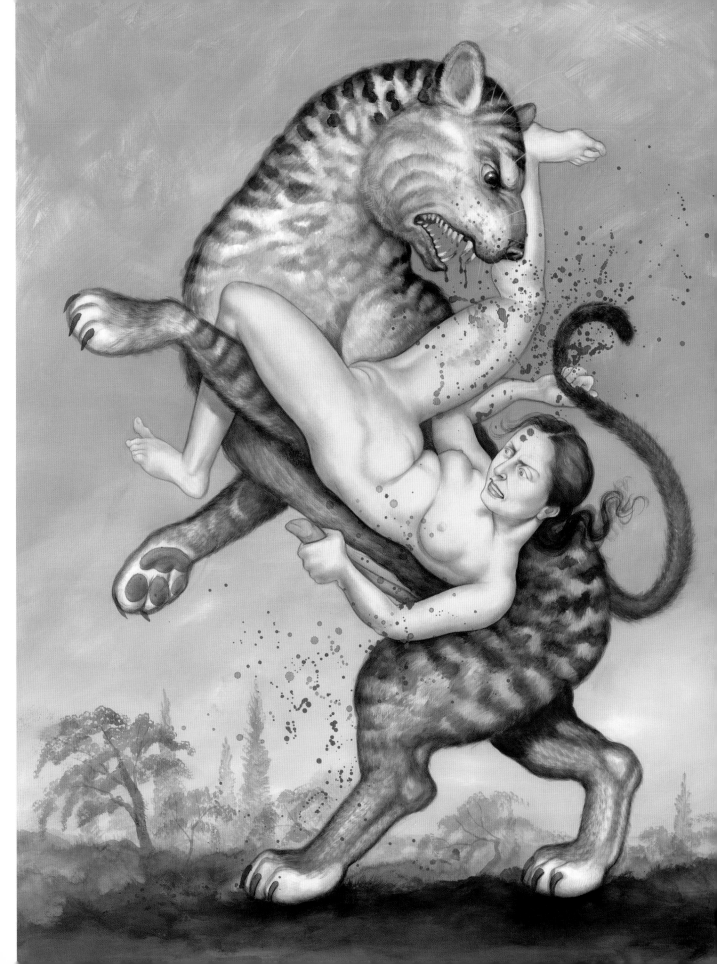

When and why did you start incorporating cats into your work and what do you feel they bring to it?

I've been an animal lover my whole life and have done a fair bit of rescue work. I work with primates and cats. I do trap neuter release work with local feral cats, and have adopted four former strays. I paint what I know, so it's natural for me to paint the animals I love.

Is there any work of art featuring cats that has inspired you? Where did you encounter it, and how did it make you feel?

Not specifically, but I'm always surprised to see cats pop up in old paintings. They always seem to be peeking out from somewhere in the background. Seems they've been loved forever!

What process do you go through to create your work? What inspires you?

I've been doing illustration work internationally for four decades. So much of my work is informed by the subject matter I'm given, and it's typical for me to make work about social and political issues. But my personal work has to do with my personal beliefs. And mainly I'm inspired by how we exist with other species on the planet, and specifically how we fall short as stewards of our planet.

What might people be surprised to know about you (or your work)?

Well I'm fairly open about my process and what inspires me. But as far as technique goes, I work in watercolors and most people think it's oils.

THIS PAGE

Friends
Acrylic on board,
11 x 14". 2006.

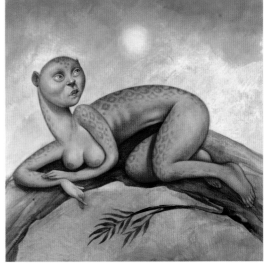

TOP LEFT

Panther
Acrylic on board,
11 x 14". 2003.

TOP RIGHT

Pussy
Acrylic on board,
18 x 24". 2009.

BOTTOM RIGHT

Chimera
Acrylic on board,
14 x 14". 2012.

101

JANE LEWIS

Jane Lewis was born in London, where she spent the first half of her life. She has since lived and worked in Yorkshire, in the north of England. Lewis graduated from the Slade School of Art University College London in 1977, where she later taught. She went on to lecture at other London art colleges until, following a 12-month residency with Kent Opera, she was able pursue an independent studio practice. Lewis has received commissions and awards from Standard Chartered Bank, the Oppenheim-John Downes Trust, Arts Council England and the Henry Moore Foundation, the last of which, a Fellowship in Drawing, attracted the attention of Portal Gallery in London, where she exhibited from 1993 to 2013. Articles about Lewis' work and reproductions have appeared in art catalogues, books and periodicals. Her original paintings and graphic works are in a number of public collections and numerous private collections. Her work has been shown in solo and group exhibitions throughout the United Kingdom and also internationally. Since 2013, Lewis has exhibited regularly with the Nicholas Treadwell Gallery in Vienna.

www.janelewisartist.com
Instagram: @janelewisartist

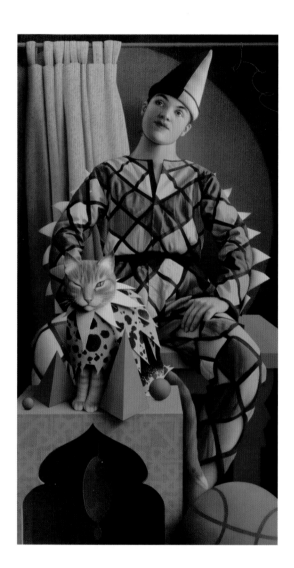

ABOVE
The Harlequin's Cat
Oil on canvas,
24 x 46". 2006.

RIGHT PAGE
Cat Mask
Oil on canvas,
24 x 34". 1997.

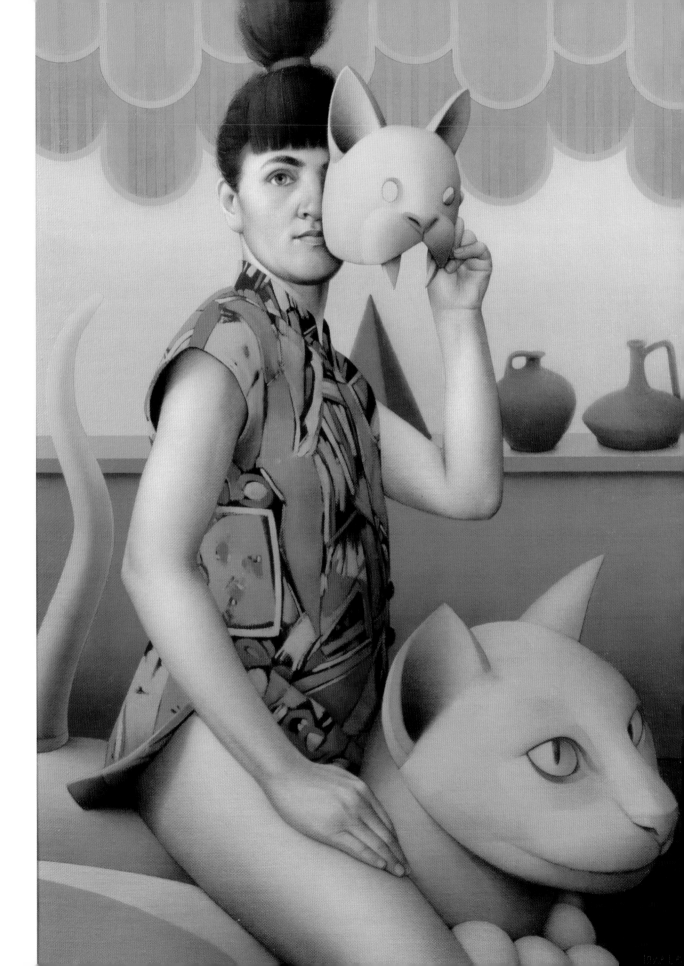

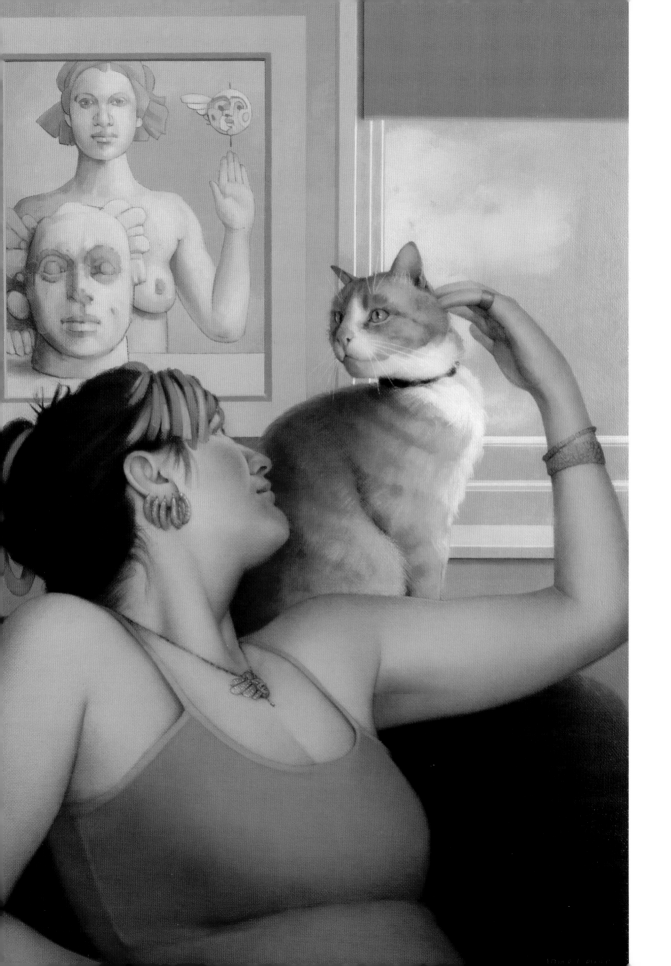

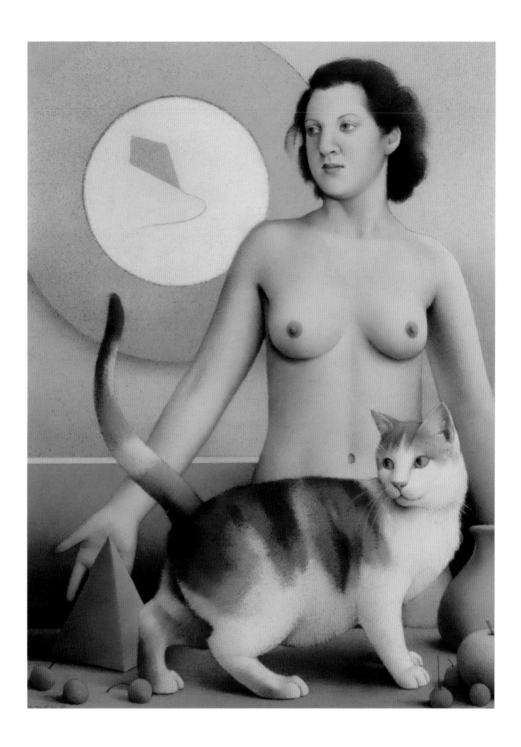

The Caress
Oil on canvas,
20 x 30". 2000.

Nude, Cat and Kite
Pastel on hand-made paper,
20 x 28.5". 1997.

Girl with a Toy Cat
Oil on canvas,
16 x 20". 2014.

When and why did you start incorporating cats into your work and what do you feel they bring to it?

Cats first appeared in my work in 1990, when I did two paintings that featured my own beloved ginger and white cat Tybert. The first is entitled *The Ship of Fools*, where he appears as part of a large composition amongst human figures in a boat. The other is a fantasy self-portrait with him entitled *Tybert The Cat*, which was used on the cover of *The Book of Cats* published by Bloodaxe Books. Before this, all my compositions were of and about the human figure, but after these two pictures, cats and other animals appeared with increasing frequency. Some of my depicted cats are in unlikely costume, others are cat-masks or dolls, others still just happen to be there as a woman's companion or with an arrangement of objects. They lend beauty, sensuality and inscrutability to a composition.

Is there any work of art featuring cats that has inspired you? Where did you encounter it, and how did it make you feel?

A painter of the 20th century that I very much admire is Balthus, whose works have the timeless quality of the ancient frescoes of Pompeii. Cats occasionally make an appearance in his pictures, and the first that I remember seeing is one entitled *The Room* (1952-54) which I saw when I was a student as part of a slide show in a history of art lecture. The composition is atmospherically strange, in which a diminutive person has drawn back the curtain from a window to let light flood over a nude girl sprawled on a chaise longue, and to one side of the window sits a cat on a small table who has turned its head to observe the scene. It evokes a kind of drama of stillness tinged with the surreal, and the image has stayed with me during all the following years. Another memorable Balthus painting is *Nude With A Cat* (1949-50) in which a similarly posed young woman reaches back to touch a smiling cat.

What process do you go through to create your work? What inspires you?

I currently work in oil on canvas and various drawing media, and I also work in pastel, as pastel paintings rather than drawings. For me, oil painting has a richness and luminosity unequalled by other paint media, and I love its versatility and subtlety.

An idea can gestate for weeks or months or even years before I use it in a composition. Some ideas may never be used. I keep small sketchbooks with plans for future works, usually in the form of simple line and wash drawings, sometimes as written notes. When preparing a painting I work up an idea in outline drawing to the full size of the canvas (called a cartoon) before I begin laying on paint, and it inevitably changes and takes on a life of its own during the painting process. My technique is influenced by early Italian and Northern European painting, but there are many other kinds of art and artists that interest me and which have informed my own style. I am inspired by the human-animal connection in the modern world, that is to say by all creatures and their relationship to each other.

What might people be surprised to know about you (or your work)?

That I am an animal rights activist and I believe passionately in the acknowledgement of sentience in all living beings. As well as trying to convey this through some of my work, I actually get out on the street from time to time to engage with members of the public on this issue. Rats, as well as cats, are among my favorite animals.

What question do you wish I had asked you?

Do you believe that cats are equal or even superior to humans?

What is your answer to that question?

Yes, probably superior. They surpass us in beauty, instinct and elegance. As do most other animals.

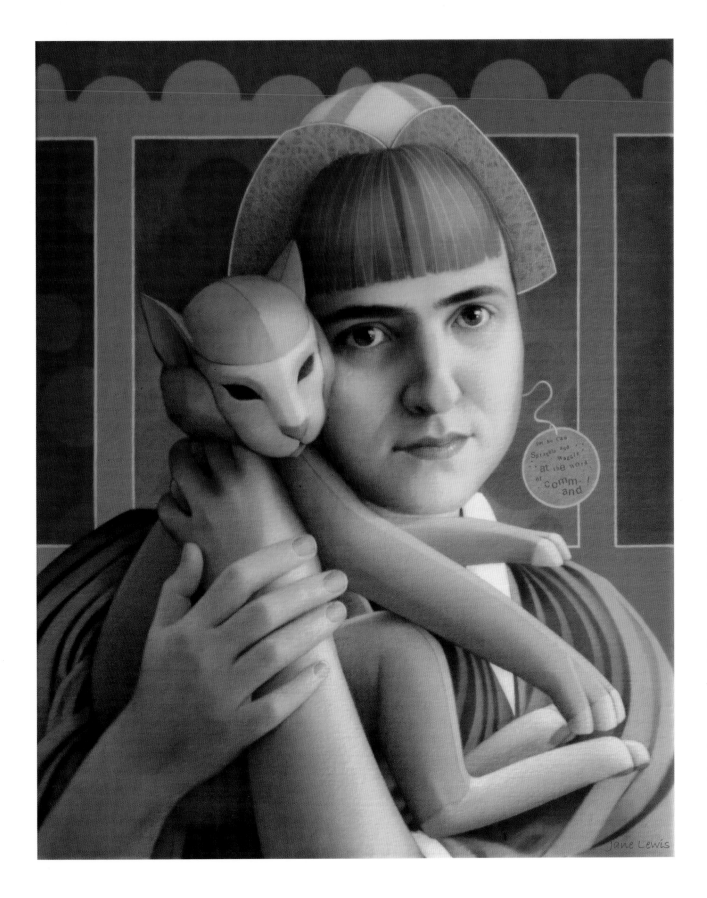

JOSE ANGEL NAZABAL

Jose Angel Nazabal is a Cuban artist born in 1994 and based in in Havana City. He works mainly in drawing, painting and digital art. Nazabal obtained a bachelor's degree in fine arts from the Fine Arts National Academy San Alejandro in 2013. He also attended the Polytechnic Institute of Havana in 2014, earning a degree in Architecture and Urbanism. Nazabal had a solo show,

Photophobia, in the 11th Havana Biennial, Fine Arts National Academy Gallery (2012). Nazabal has been in numerous design and architecture collective exhibitions at Fabrica de Arte Cubano, including Basics of Design (2015), Social Housing and Public Space (2016) and Sustainable Materials and Emerging Architecture (2017).

Instagram: @j.nazabal

THIS PAGE

Enzzo and Picasso
Ink on paper, 11.9 x 9.5". 2016.

RIGHT PAGE

Selfportrait with Misu
Digital art, 11.9 x 19". 2019.

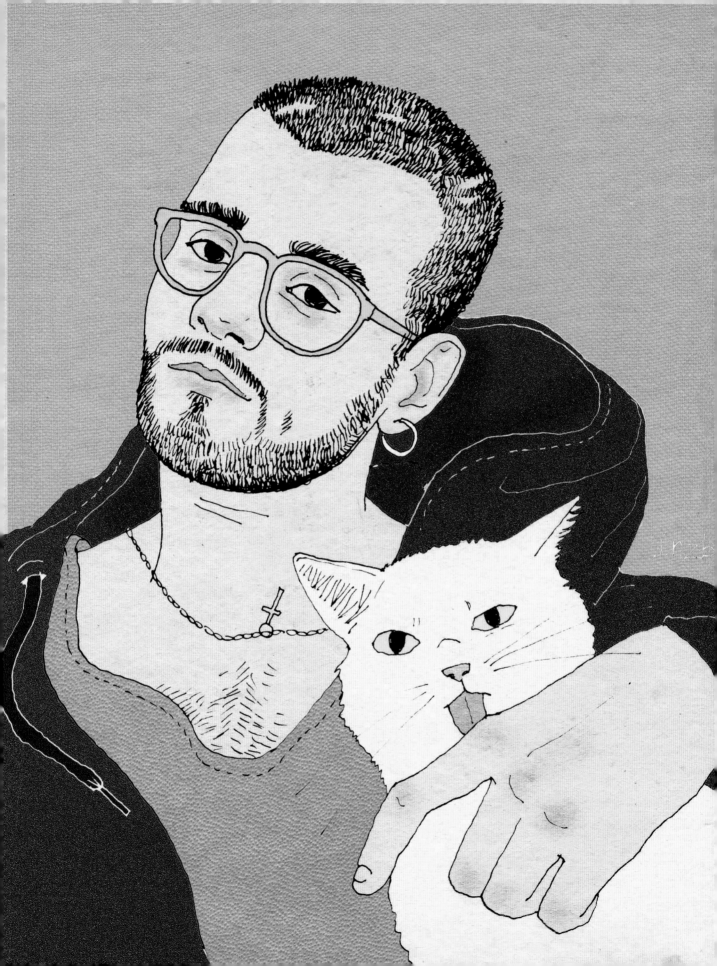

What is it like to be an artist working in Cuba, a country often known for its censorship, especially considering your work with queer themes?

The times are changing in Cuba. A few years ago, Internet access on the island for Cuban citizens was something almost unimaginable. Since December 6, 2018, Cubans can have full mobile Internet access provided by Cuba's telecommunications company, ETECSA, at 3G speeds. Also, the LGBTQ community in Cuba is going through a transition. At this moment, Cuban transgender people are able to have free gender confirmation surgeries in Cuba and we're clamoring for the legalization of same-sex marriage. However, there is still really a lot to do in terms of social tolerance, LGBTQ rights and the fight against homophobia.

Why did you decide to start including cats in your work and do they symbolize anything?

I wanted to be a veterinarian since I was a kid. I've always loved animals, particularly cats. Cats fascinated me very early on. In my childhood I always asked for cat books and then I used to spend hours and hours only reading about cats and memorizing cat breeds. Later, in puberty, I started to do temporary cat fostering on my own, which I still do. Later, in the Fine Arts National Academy, I started to fill white canvases with colorful cat heads and hairy tails. I was portraying my pets and a world of cats. Cats for me symbolize long time friendship, travel companions and a major source of inspiration.

Where do you get your inspiration?

I got my inspiration mostly from my pets (three cats) Zuca, Picasso and Tundra and queer models and figures from the Internet. I am also very influenced by movies and New Queer Cinema, especially Greg Araki´s films. Other significant influences and sources of inspiration are artists such as Nan Goldin, David Hockney, Paul Cadmus, Jared French, Edward Hopper and Rocío García, a Cuban queer painter and my art professor back at the Fine Arts National Academy. Also, recently I discovered I was fascinated with the drag queen's world. Drag is inspiring for me.

Do you show your art in Cuba and/or abroad? What has the reaction been?

Yes. There's has been different kinds of reactions, in Cuba and abroad. The common reaction has been really rewarding because there's always people who get in touch with me and write me saying a bunch of lovely things. It's really great to know that some people enjoy my work or that an art piece done by me can resonate for someone in a communicative and intimate way. Sometimes I get the feeling that maybe I'm helping someone through art, someone who needs to be listened to or considered.

When did you first go on the Internet and how did you react? Do you remember?

Yes, I remember. The first time I started to upload my artwork to the Internet was recently and it was quite significant to me. In the beginning, I was a little nervous about the whole process of promoting my work on global social media platforms. Over time I became more and more confident on digital media and started to become aware of the benefits of online communication and the power of diffusion in cyberspace.

LEFT PAGE

A Cat Named Japan
Digital art, 11.9 x 21". 2018.

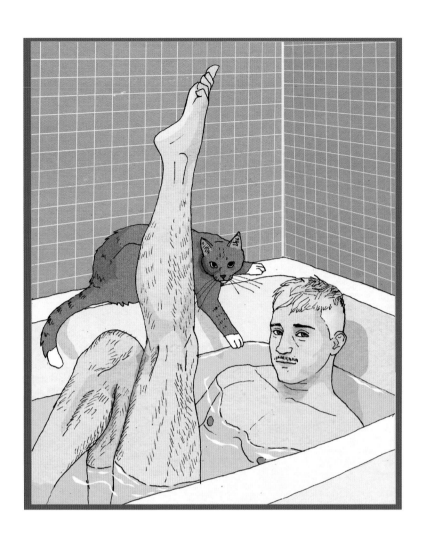

ABOVE

Zuca
Digital art, 21 x 21". 2019.

LEFT

A Cat Named Norway
Digital art, 13 x 18". 2018.

MARÍA LUQUE

María Luque was born in Argentina in 1983. She has been exhibiting her work since 2005 in museums and independent spaces in Argentina, Chile, Peru, Mexico, Spain, and Portugal. Her work is primarily drawing and painting and it sometimes results in publications and fanzines. She's the author of *La mano del pintor*, a graphic novel about the painter Cándido López (Sigilo, 2016, L'Agrume Éditions, 2017), *Casa transparente* (Sexto piso, 2017, Premio Novela Gráfica Ciudades Iberoamericanas) and *Noticias de pintores* (Sigilo, 2019).

www.cargocollective.com/marialuque
Instagram: @maria.j.luque

All Dogs are Sleeping
Gouache on paper,
5.5 x 6". 2019.

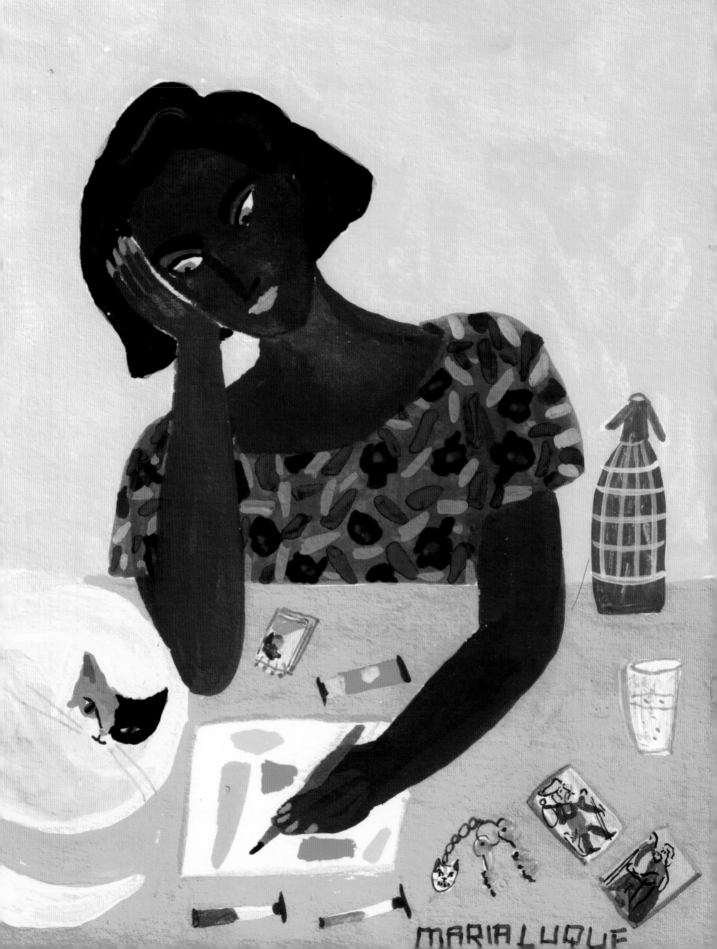

MARIA LUQUE

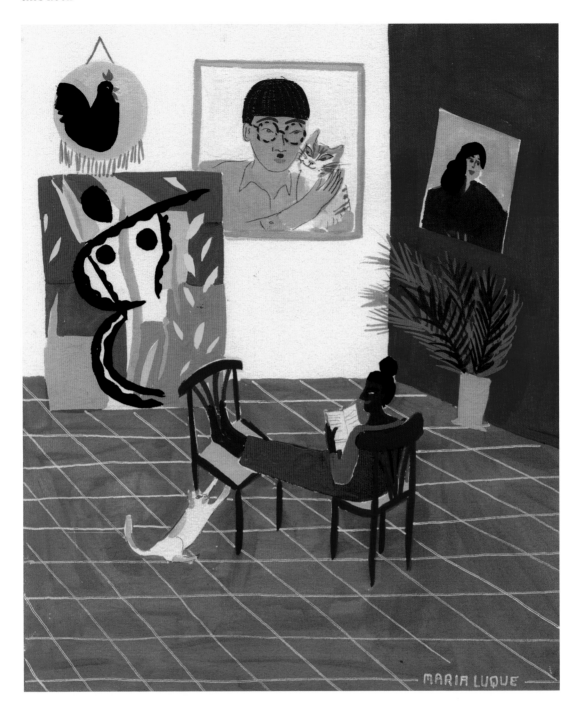

THIS PAGE

500 Landscapes
Gouache on paper,
6 x 8". 2017.

RIGHT PAGE

Internet is an Illusion
Gouache on paper,
5 x 11". 2019.

NEXT SPREAD

World's Museums
Gouache on paper,
13 x 8". 2019.

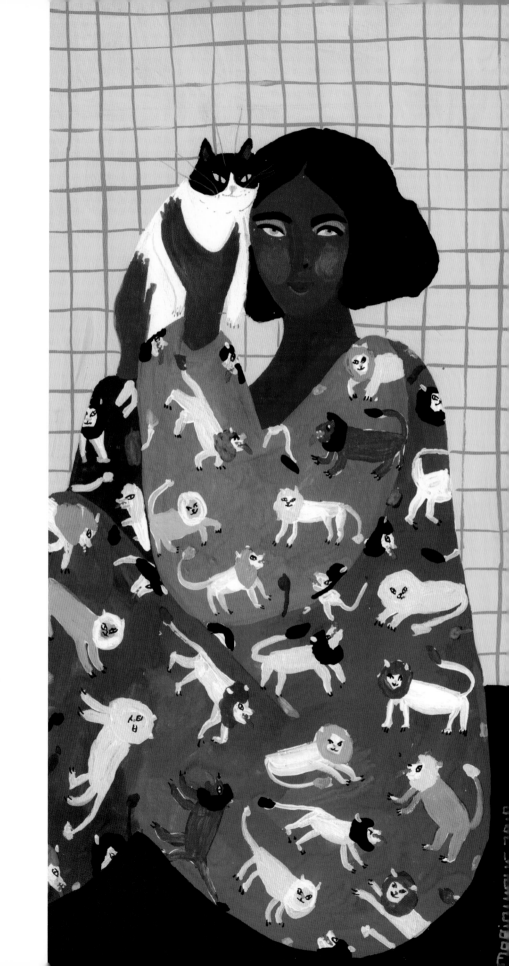

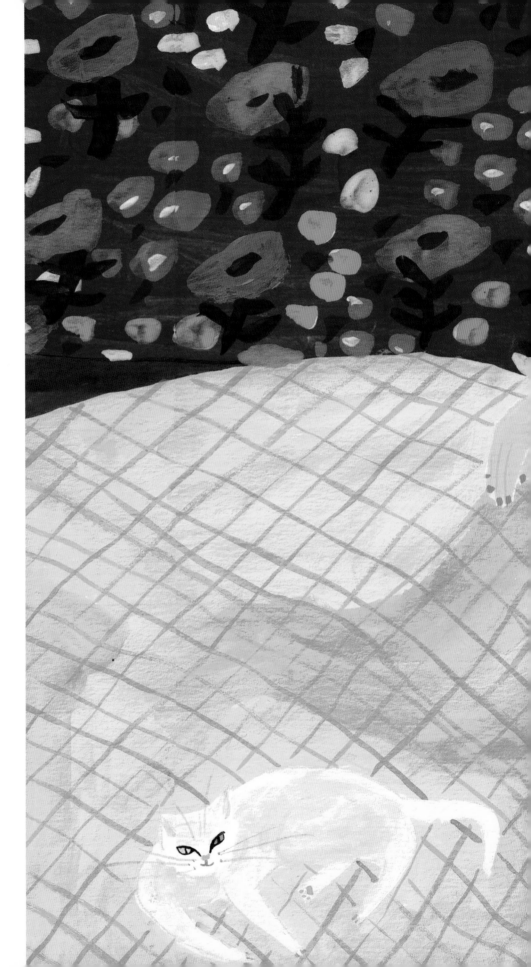

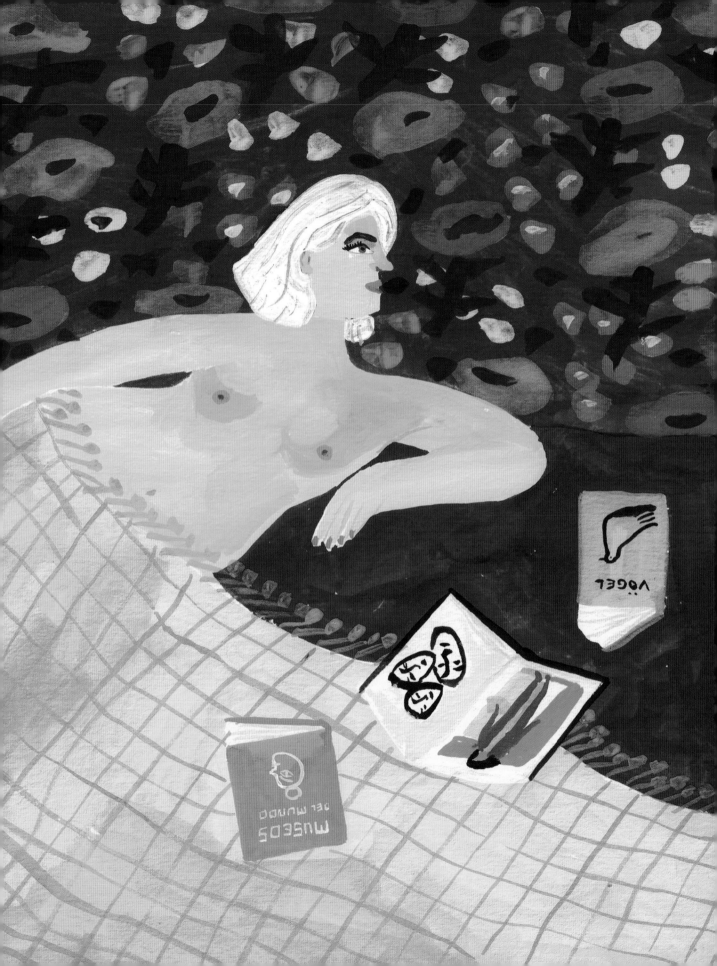

When and why did you start incorporating cats into your work and what do you feel they bring to it?

I can't resist painting them. I think I've been drawing cats since I was a kid. Also, for the past few years I've been traveling a lot and I don't have a steady home so I can't have a cat. I realized that painting them was a good way to keep them close to me.

Is there any work of art featuring cats that has inspired you? Where did you encounter it, and how did it make you feel?

I adore Foujita's cats. He is one of my favorite painters. He's got a very special relation with his cat Miké and painted it a lot. The first time I saw his paintings in a book I was amazed.

What process do you go through to create your work? What inspires you?

As soon as I start, I know whether the drawing will work out. I usually draw pretty quickly, I never prepare sketches, I go straight to the paper. I like it to be intuitive. I like to feel that my hand is almost possessed and drawing by itself. The things that inspire me the most are things that happened to me because I'm the person I know best. I'm also on the lookout for whatever happens to my friends or situations I spot on the street.

What might people be surprised to know about you (or your work)?

I used to like throwing drawings from the balcony when I was a kid. They were self portraits and on the back I wrote: "This is me, I have curly hair, I'm in third grade. Do you want to be my friend? I live on the first floor." I imagined that the bell would ring immediately and the house would be full of new friends that wanted to draw with me. I realized that the wind blew the drawings away, so I started to tie them with a string and the drawings stayed there hanging from the balcony.

What question do you wish I had asked you?
What's my background?

What is your answer to that question?

I went to art school, studied there for a few years and I learned a lot, but in the end I dropped out. I started to attend workshops by artists I was interested in and to go to residences in order to educate myself outside academic institutions. I'm still learning everyday, especially from my friends and colleagues.

RIGHT PAGE

Neris
Gouache on paper,
6 x 8". 2019.

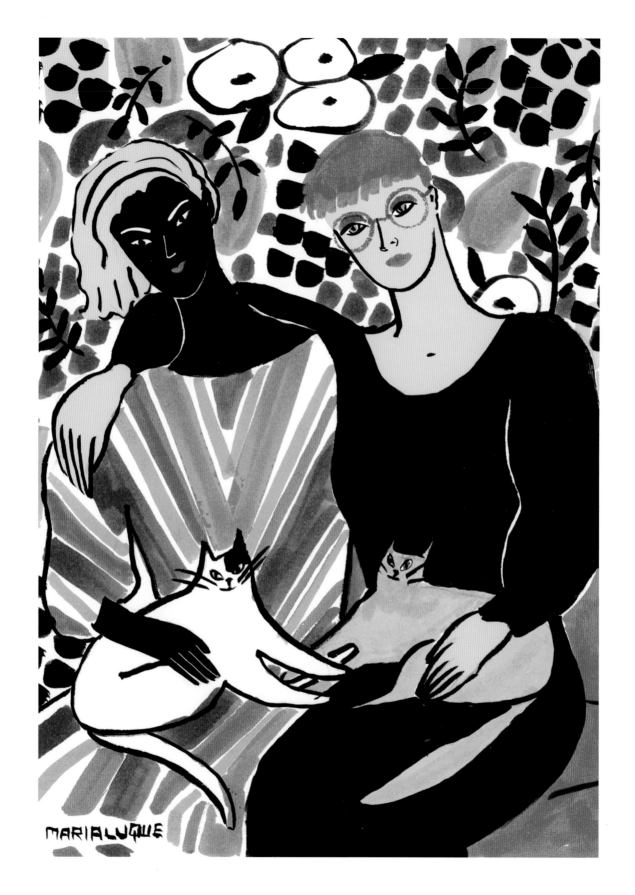

PETER HARSKAMP

Peter Harskamp was born in 1951 in The Hague, Holland. He attended the Academy of Fine Arts in Rotterdam, where he studied graphic techniques and came in contact with ceramics and sculpture. His first solo exhibition was in 1975, and since then he has worked as an independent painter and sculptor. His painting and sculpture is varied and each genre has inspired the other. Until 1985, he worked in three-dimensional ceramic sculpture, then he began to make bronze sculpture. His work has been shown over the years in many exhibitions in the Netherlands, France, Germany, Switzerland, America (New York) and annually in Taiwan since 2012. His works are included in business and private collections around the world. He has regular solo exhibitions at renowned galleries in the Netherlands and Germany, namely: Morren Galleries at Utrecht, Gallery A-Quadraat at Vorden, Gallery Laimböck at Langbroek, Kunsthaus Bühler at Stuttgart and Galerie Oocker at Heusden. In 2005 a book about his work was published entitled: *Peter Harskamp and the Curbing of the Time*. In 2016 a second book was published: *Peter Harskamp, Painter - Sculptor*. To this day, his sculpture and paintings keep inspiring one another. He lives and works in Gelderland, the Netherlands.

www.peterharskamp.com

 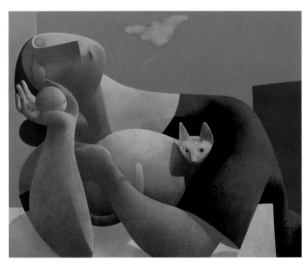

LEFT

Woman with Fat Cat
Oil on canvas,
47 x 39". 2012.

RIGHT

Woman with Cat and Peach
Oil on canvas,
39 x 47". 2012.

RIGHT PAGE

Woman with Red Cat in Lamp Light
Oil on canvas,
55 x 47". 2017.

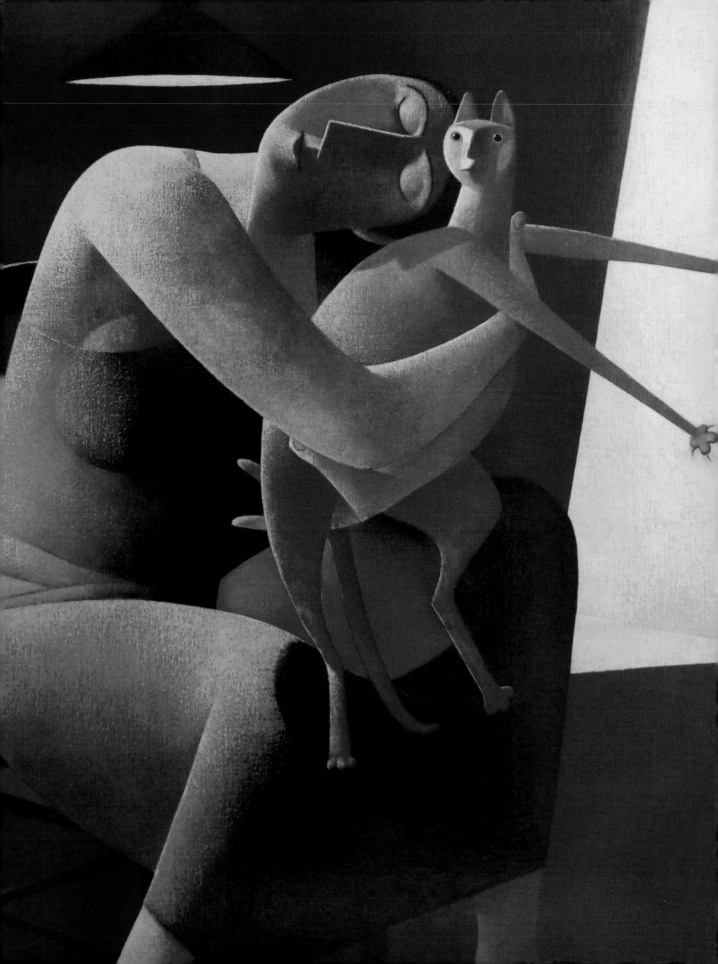

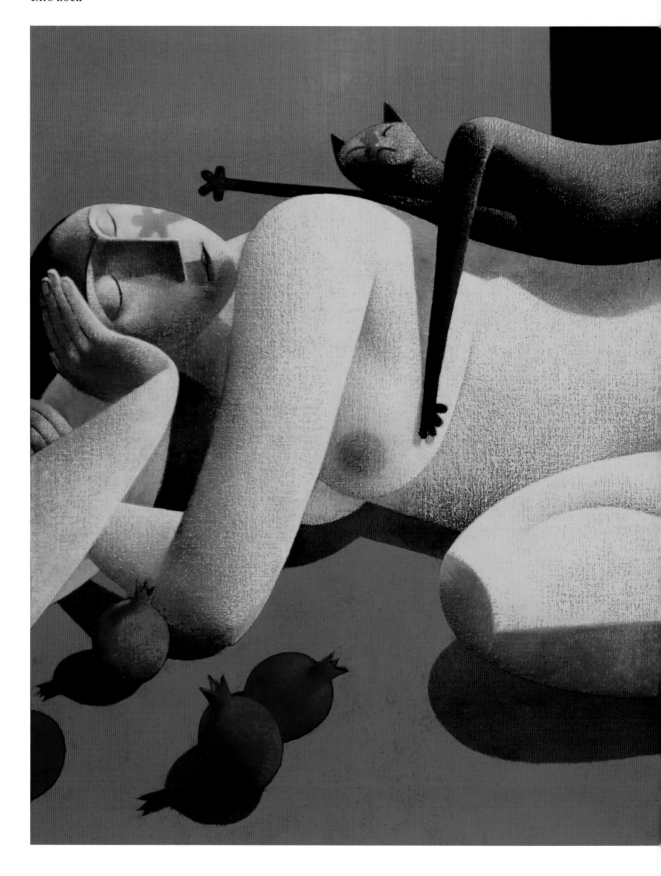

Reclining Woman with
Cat and Pomegranates
Oil on canvas,
39 x 47". 2018.

*When and why did you start incorporating cats into
your work and what do you feel they bring to it?*
The first cats appeared in my paintings in the 1980s.
At that time, a stray cat had come to our house and
decided to stay with us. This allowed me to observe
a cat very well. I found this beautiful loving cat very
impressive. I noticed that adding a cat to a painting
increased the intimacy of the painting.

*Is there any work of art featuring cats that has inspired
you? Where did you encounter it, and how did it make
you feel?*
No. The reason for painting cats in my work is really
due to the stray cat, who also gave birth to four
kittens after a few weeks.

*I notice you make many works with cats and women
in them together, what do you think the relationship is
between cats and women?*
I think the most important thing in my work is that
there is a figure who does nothing and yet fascinates.
The figures are generally calm and introverted, while
the cats are often alert. My paintings represent the
special bond between humans and animals. This is
mainly about tenderness, friendship and trust. I also
portrayed male figures with cats, but I like to paint
women, so they appear more often on the canvas.

*What might people be surprised to know about you (or
your work)?*
The fact that my wife and I have three dogs and no
cats! It is also true that I do not only paint women
with cats. Bulls, owls, horses and birds fascinate me
too and appear regularly in my paintings. But all
topics have the function of reinforcing intimacy.

What question do you wish I had asked you?
Do you also work in materials other than oil paint?

What is your answer to that question?
Yes, besides painting I also make sculptures in bronze,
(sometimes) with the same theme.

ROSE FREYMUTH-FRAZIER

Rose Freymuth-Frazier lives in New York City and was born and raised in Nevada City, California - a small gold rush town in the foothills of the Sierra Nevada Mountains. She attended Interlochen Arts Academy, a private boarding high school in northern Michigan. She studied theater at the American Academy of Dramatic Arts in New York City on a scholarship, but after a few years in Hollywood, (including a stint on a campy, nighttime teen soap opera), she decided to pursue another interest: figurative oil painting. She studied for two years at the Art Students League in New York City and after taking a master class at the New York Academy of Art with Steven Assael, she continued her studies in a tradition common to painters of the past: full-time apprenticeship. Her first apprenticeship was two years under Assael in his New York City studio. Her second was with Odd Nerdrum in Norway, at his farm and studio on the North Sea. Freymuth-Frazier's work has been exhibited internationally in Barcelona, Sydney, Amsterdam and across the United States. Her work is in private collections, including The Seven Bridges Foundation in Connecticut and the John and Diane Marek Collection in Tennessee. She has received attention and reviews from numerous publications including *Playboy*, *Ms.*, *ArtNews*, *Hi-Fructose*, *Beautiful Bizarre*, *The Chicago Tribune*, *Art Papers*, *American Artist*, and *The Huffington Post*. In October 2015, her work was included in Cavalier Galleries extraordinary survey of American realist works, *American Realism: Past to Present* in New York City. Freymuth-Frazier is represented by Cavalier Galleries in New York City, Connecticut and Nantucket, and Victor Armendariz Gallery in Chicago.

www.freymuth-frazier.com

THIS PAGE
Divine Intervention
Oil on linen,
18 x 24". 2018.

RIGHT PAGE
In the Study
Oil on linen,
20 x 30". 2013.

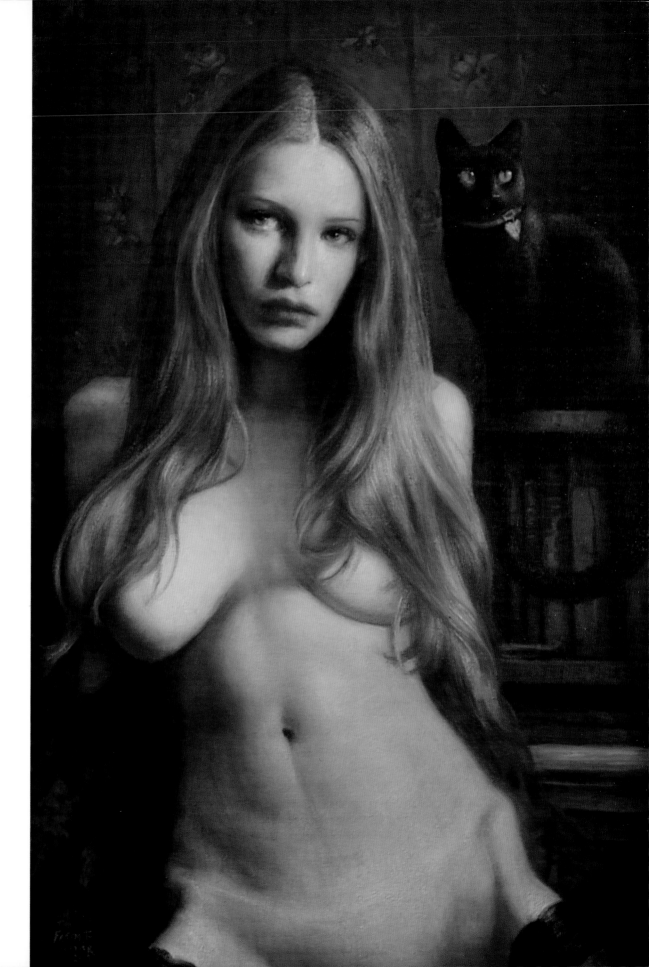

When and why did you start including cats in your work?

Various cats have appeared in my paintings over the last decade or so beginning with *Domestic Bliss*. Animals in general are an important part of my work and cats specifically represent feminine, intuitive and supernatural elements in the paintings.

How has the way in which you depict cats changed over time?

I was never really a "cat person," because I was always slightly allergic, but when I took the plunge and adopted a beautiful, charismatic and ill-tempered little white Persian of my own in 2016, I began to understand firsthand why cats are so beloved. She had been rescued from the streets of Giza in Egypt and is a remarkable little creature. Shortly after I got her she appeared in my paintings, starting with *Head Games* which was the first of my *On the Couch* series. She is a big part of my life and by extension has become a big part of my work.

Do you have a personal relationship with any cats and how has that informed your work at all?

Bun Ra, aka, Bunny shows up in all my *On the Couch* paintings. They are a slightly comedic take on therapy and self-analysis, so of course she must be there to accompany me on whatever internal exploration the painting depicts. She even starred in two portraits of her own —lording over a Donald Trump cat toy! She's a gorgeous little thing and I love painting her. Because of her I've been involved in several charity fundraisers for international animal rescue organizations and that feels good too. She has connected me and my work to the world in a special way.

Do you see the cats as bringing to light qualities in the people you are depicting, as you often depict cats and people together—if so what kinds of qualities? How are cats being used?

There's a reason cats have captured our imagination so much. They are on a different frequency than humans. The cerebral cortex of cats is almost constantly in alpha mode, a brain wave pattern associated with intuition and empathy in humans. I think I use the cats as a counterbalance to the people they accompany. Rather than echoing human qualities, I want them to bring the added dimension of a mystical, magical, feline consciousness to the work.

RIGHT PAGE

Painted Ladies
Oil on panel,
16 x 20". 2017.

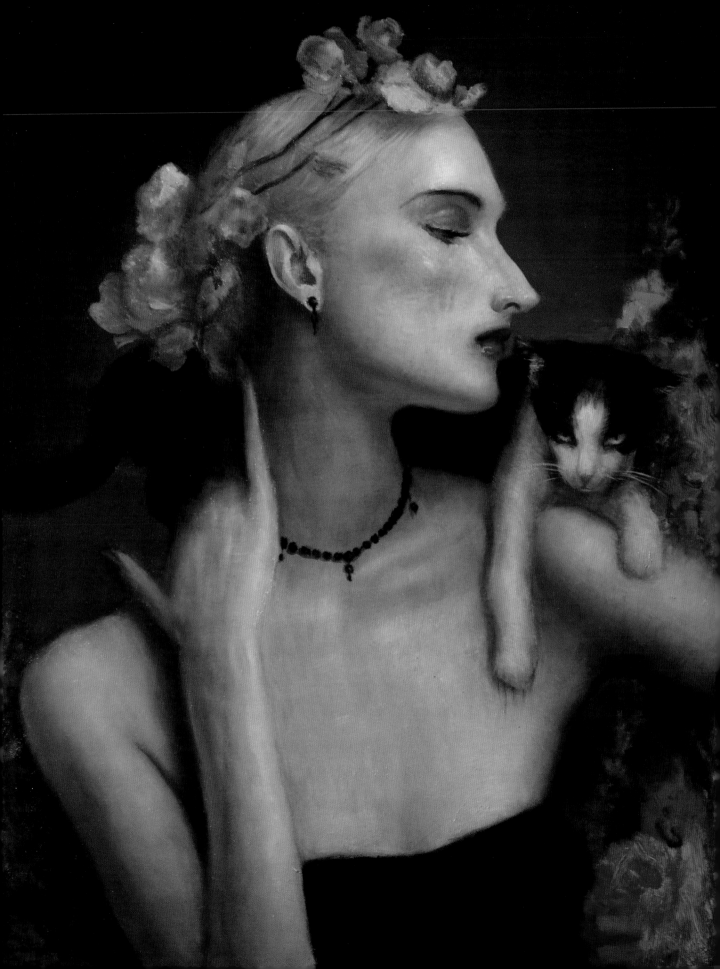

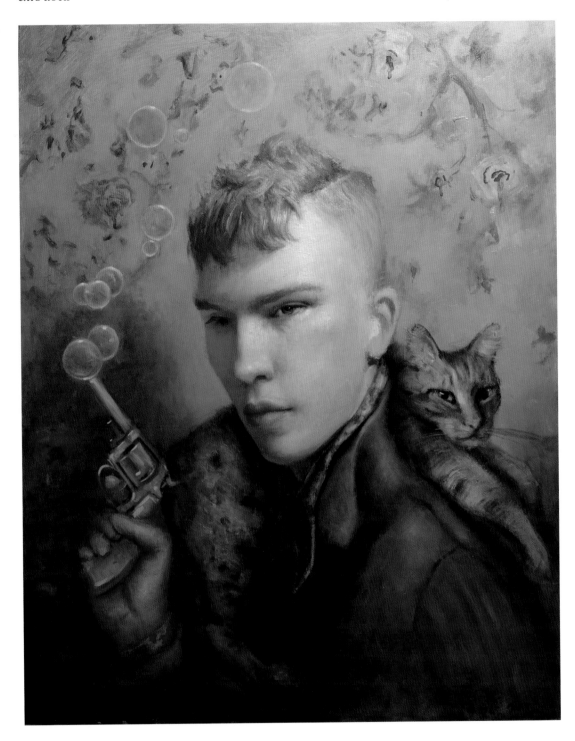

Small Game Hunter
Oil on panel,
16 x 20". 2018.

Gone Fishing
Oil on linen,
54 x 34". 2018.

Inner Space
Oil on linen,
54 x 34". 2019.

Painted Ladies
Oil on linen,
54 x 34". 2018.

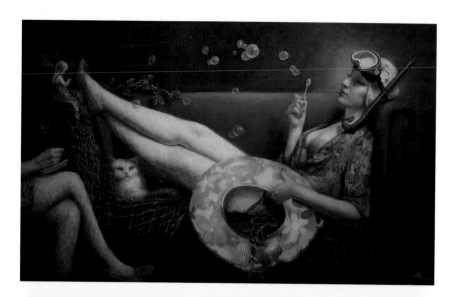

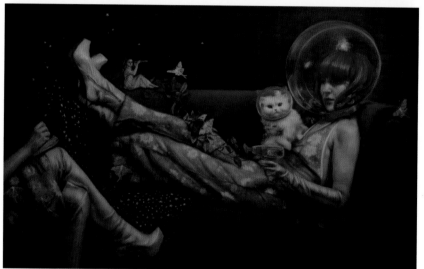

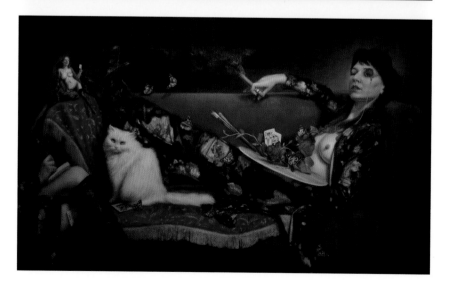

STEPHANIE INAGAKI

Stephanie Inagaki is a southern California-based, multifaceted artist mainly working in fine art and jewelry making. Her jewelry and accessory company is Miyu Decay. Inagaki received her B.F.A. from Boston University's College of Fine Art and her M.F.A. from the San Francisco Art Institute. Her artwork can be seen at www.stephanieinagaki.com and her jewelry at www.miyudecay.com. She vends at cat-related conventions, contributes artwork annually to cat rescue organizations and posts regularly on social media about her cats.

www.stephanieinagaki.com
www.miyudecay.com

ABOVE
Blossoms
Charcoal and washi paper,
5 x 7". 2018.

RIGHT PAGE
Familiars - Nekomata
Charcoal and washi paper,
11 1/2 x 14". 2017.

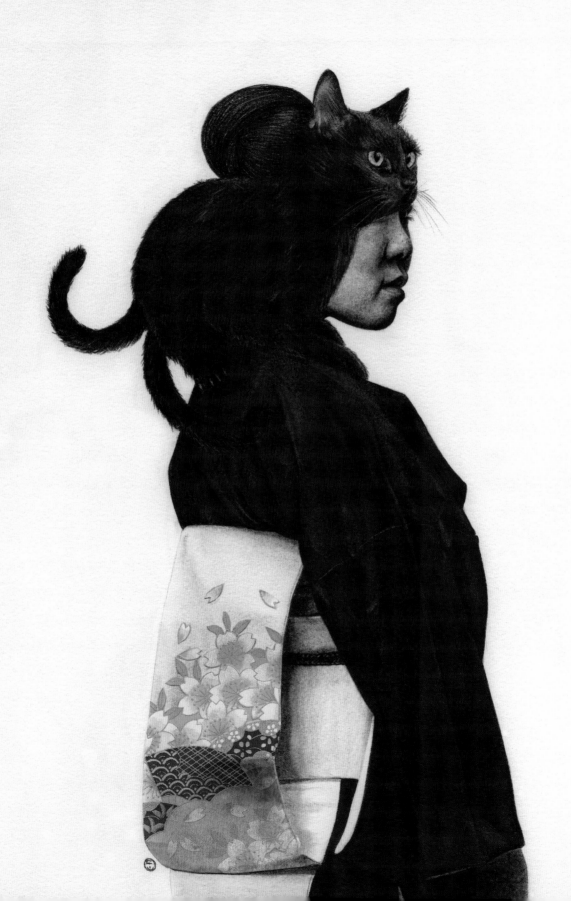

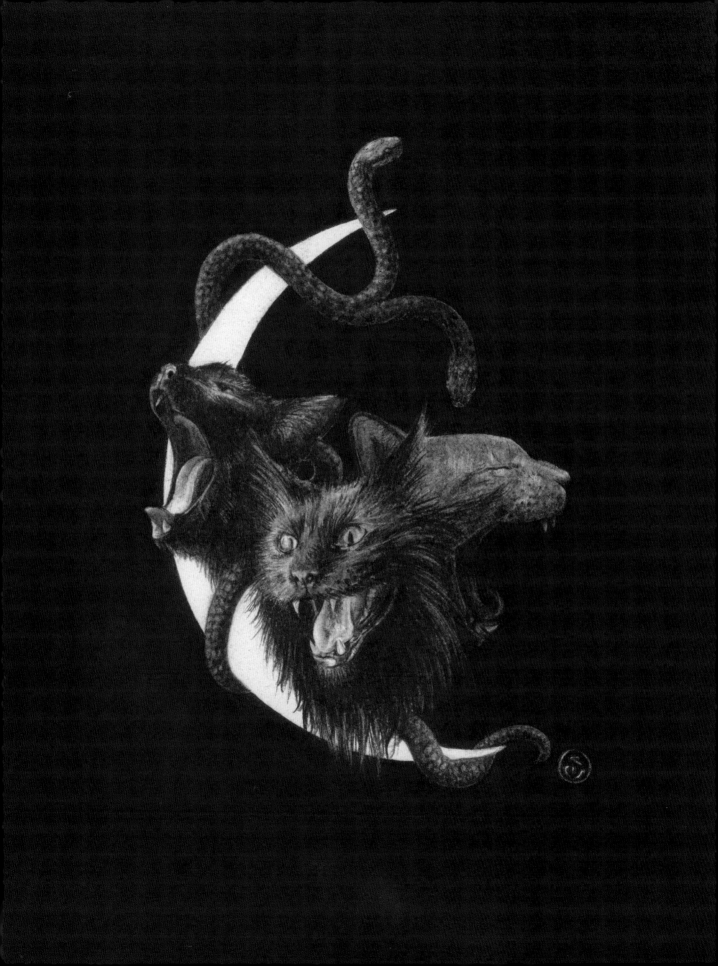

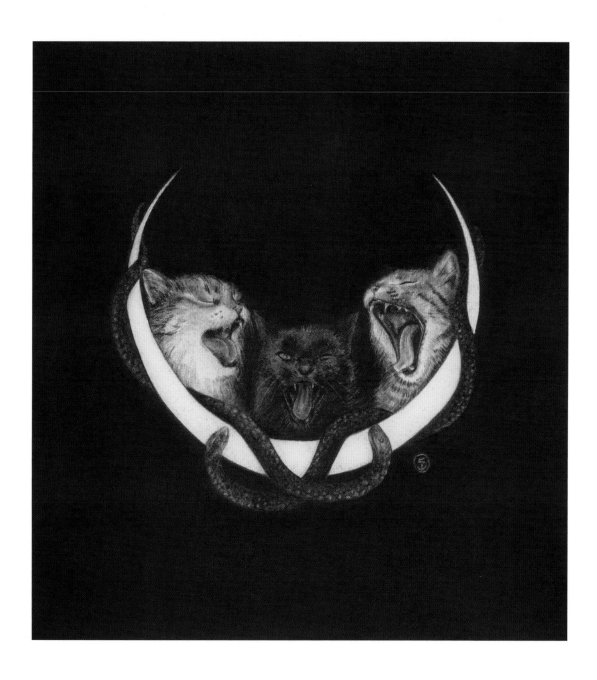

When and why did you start incorporating cat imagery into your work and what do you feel it brings? What is the relationship between women and cats—or maybe you as a specific woman and cats?

The visual narrative and mythology I have been building to create the stories in my drawings is a way to synthesize my personal experiences. As my own ways of storytelling have grown, I have been inspired by my Japanese cultural background and the use of anthropomorphizing animals in its folklore and mythology. Most cultures have stories using animals to illustrate the human condition as a palatable means for us to relate and understand. And of course it helps if it they are cute. Cats have been seen historically as coinciding with the feminine, for better or worse. Regardless, they have served as our companions with emotional and intellectual depth, capable of understanding us. They can invoke many things from the mystical, dark, playful, adoring, independent, and compassionate. They have so much personality for a creature that we do not share a spoken language with.

Is there any work of art featuring cats that has inspired you? Where did you encounter it, and how did it make you feel?

As I mentioned above, I have been inspired by Japanese folklore and mythology. I love all the old prints featuring animals and yokai (supernatural creatures) like cats or bakeneko, kitsune, and bats. There is something beautifully whimsical and supernatural with a touch of humor to them. I have a great book called, Yokai Museum: The Art of Japanese Supernatural Beings from Yumoto Koichi Collection that exhibits a vast selection prints, paintings, sculptures, and games from the last few hundred years with yokai on them.

What process do you go through to create your work? What inspires you?

My drawings tend to start off as rough sketches in order to figure out the compositions and where to place the washi paper flowers. Sometimes the composition and feeling of the drawings can change when I include the flowers and I will spend as much time cutting out and picking which washi paper flowers to use as I do drawing. I am of course inspired by my own silly cats, Cowboy and Bebop. Many of my close friends are animal lovers too and have several fur babies to draw inspiration from. I also view life and death as being cyclical and have always had a sense of the macabre, which is evident in my work.

What might people be surprised to know about you (or your work)?

As dark and skull-filled as my work is (both my artwork and jewelry), I am a pretty happy person. Friends who know me know I am a positive and hopeful person. Despite much of the trauma and loss I have dealt with over the years, I have had a solid group of friends and family close by whom I am very grateful for. I think due to that, I have a healthy outlook on life.

RIGHT PAGE

Nesting - Nekomata
Charcoal and watercolor on rives BFK, 15 x 15". 2014.

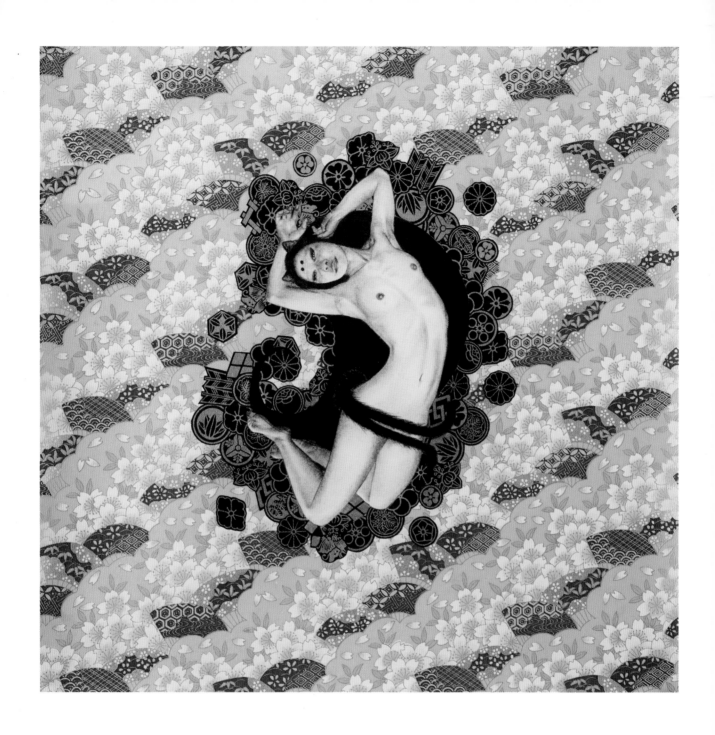

PSYCHEDELIC CATS

Jacob Garvin
Succulent Thoughts (detail)
2017.

"To begin with," said the Cat, "a dog's not mad. You grant that?"

"I suppose so," said Alice.

"Well, then," the Cat went on, "you see a dog growls when it's angry, and wags its tail when it's pleased. Now I growl when I'm pleased, and wag my tail when I'm angry. Therefore I'm mad."

"I call it purring, not growling," said Alice.

"Call it what you like," said the Cat.

— LEWIS CARROLL, *ALICE'S ADVENTURES IN WONDERLAND*, 1865.

Louis Wain is the Godfather of psychedelic cat art. He was a potentially schizophrenic English artist born in 1860, with a penchant for drawing colorful anthropomorphized cats. He was prolific, producing hundreds of drawings and illustrations for books, postcards and magazines. In 1898 and 1911 he was chairman of the National Cat Club. Though he was successful, the changes in his work over time are thought to be a prime example of the deterioration in skill and technique often experienced by schizophrenic artists. However, to many art historians, Wain's later more surreal work is his most exciting. Wain is joined by more modern "psychedelic" cat artists such as Joan Miró (1893-1983) and Remedios Varo (1908-1963), who depicted cats in their work in brightly-colored fantastical scenes.

The most famous surrealist, Salvador Dalí (1904-1989), was also a known cat lover. He was said to be in the perpetual company of his personal pet ocelot, Babou. According to legend, Dalí once claimed to have painted the spots on the Columbian wildcat himself, to help the cat seem harmless to those who feared him. Cats also appear in one of the most famous portraits of Dalí. In the photo, *Dali Atomicus*, by Philippe Halsman (1906-1979), the artist paints at an easel in midair as cats and water fly in front of him.

While there is nothing inherently psychedelic about cats, in various accounts regarding witchcraft, cats are said to have spoken. They do often move in such a way that they seem to disappear out of thin air, only to reappear somewhere else.

One of the most famous tales of speaking and disappearing cats is by Lewis Carroll. *Alice's Adventures in Wonderland* (1865), begins with Alice playing with her cat Dinah and falling down a hole. She subsequently encounters the speaking Cheshire Cat, who is filled with riddles and a smile of large teeth. John Tenniel's illustrations in the book are as frightening and surreal as the story itself.

Children today have a similarly psychedelic cat tale in the form of *The Cat in The Hat* (1957), by Dr. Seuss. In this story, a freakish looking bipedal talking cat shows up one day when parents are away and shows children his "tricks," seemingly without permission and to the great objection of the family goldfish. The illustrations show him wreaking havoc in the family home and generally introducing psychedelic chaos.

While many artists have since made psychedelic cat art part of their oeuvre, perhaps the best contemporary example can be found in the ubiquitous work of Lisa Frank. All things wild and cute inhabit Frank's brightly colored world. Her art is featured heavily on American children's school supplies from the 1990s to the present. A notable recluse, Frank's impact on contemporary cat art cannot be understated. Like Wain, Varo, Miró and Frank, the artists in this section push colorful cat art to its limits, at times making us wonder whether cats are even being depicted.

JACOB GARVIN

Jacob "Sex.thecat" Garvin is 32 and resides in Bozeman, Montana. Garvin has been in love with cats since getting his two sweet boys (Pistol and Pickle) in 2015. Garvin is always trying to grow and explore new artistic mediums including sewing, glassblowing, jewelry making, collage and spray paint, and he is currently crocheting quite a bit. He strives to have fun while making art and tries not to take things too seriously.

Instagram: @sex.thecat

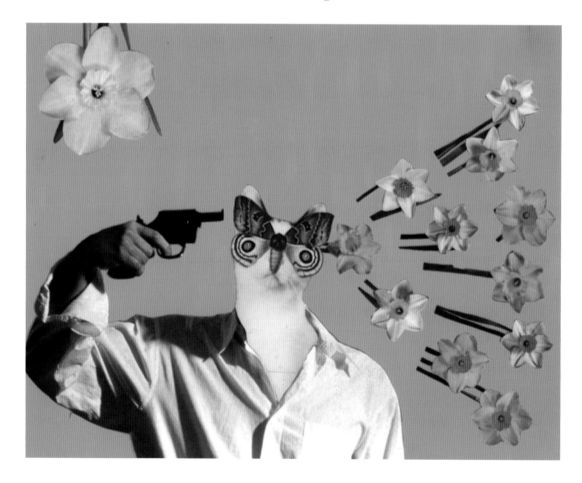

THIS PAGE

Options
Acrylic paint and reference books on canvas,
8 x 10". 2018.

RIGHT PAGE

Floral Clash
Reference books on canvas,
8 x 10". 2019.

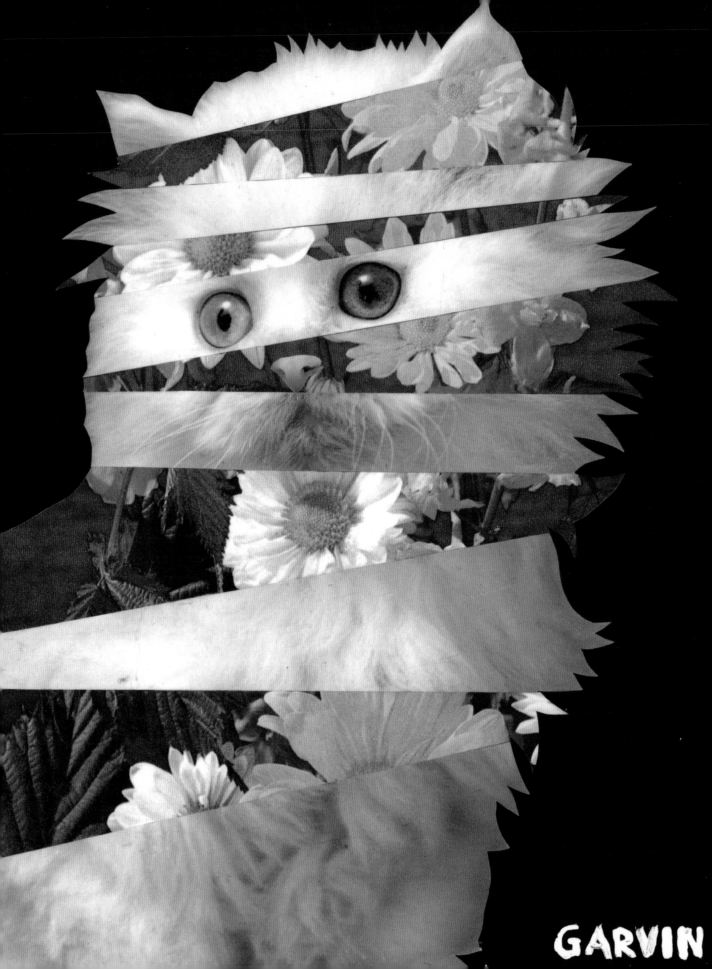

GARVIN

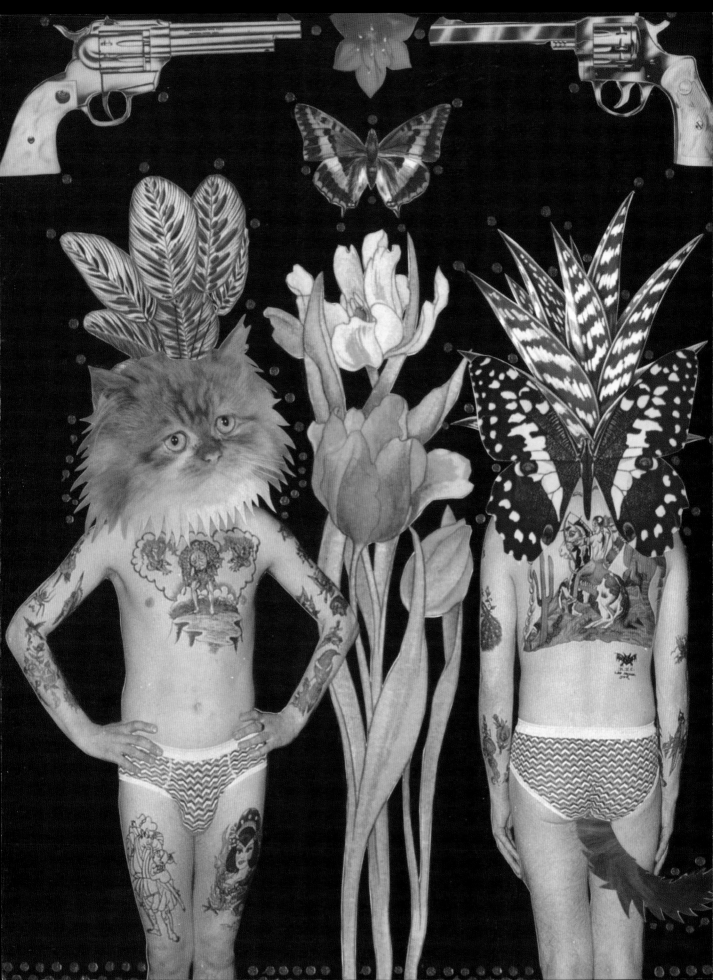

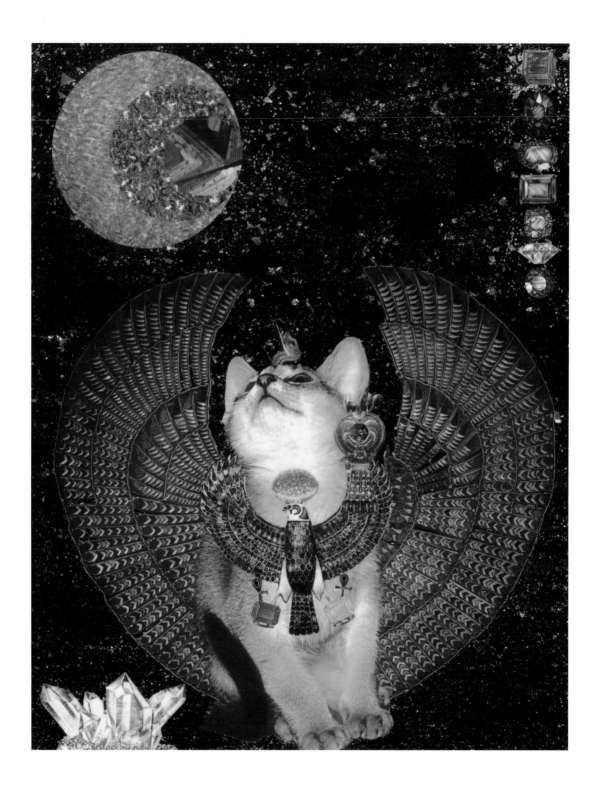

LEFT PAGE

Tattoo Montage
Acrylic paint, reference books
on canvas, 8 x 10". 2018.

THIS PAGE

Pharaoh Gazer
Acrylic paint, glitter,
reference books on canvas,
11 x 14". 2018.

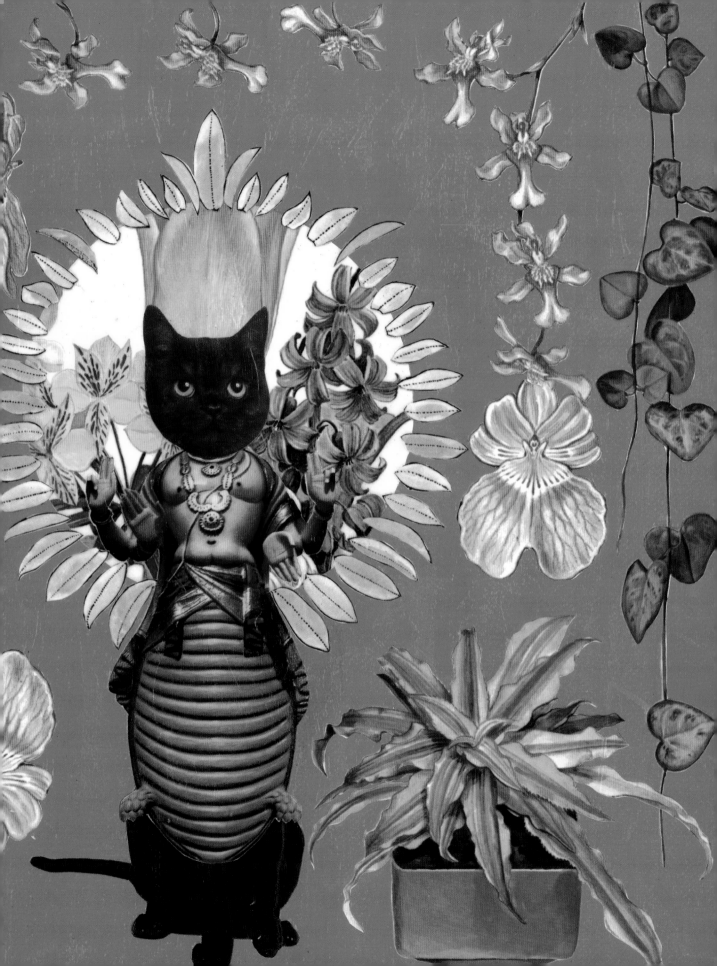

When and why did you start incorporating cat imagery into your work and what do you feel it brings?

I've been doing collage on and off for over 15 years, but it wasn't until 2017, while going through the grueling process of getting sober, that I started incorporating cats into the collage medium! I love thrift shopping and being a lover of cats. I started buying cat books, mostly vintage ones. I love the unique quality of the paper and the almost painted look the lower quality photos and colors produce. I really enjoy pairing the almost human-like expressions cats can make onto human bodies and trying to fit the posture and mood with the human in the photo. Cats are so much like people: unique and beautiful. I enjoy bringing out that uniquness through collage.

Is there any work of art featuring cats that has inspired you? Where did you encounter it, and how did it make you feel?

When I started working with cats in my art I was doing it without direct influence, but now I've come in contact with some very inspirational cat artists. Stephen Eichhorn makes beautifully meticulous yet very simple collages with cats and plants! Another is an artist named Matt McCarthy. He embodies the playful and absolutely ridiculous characteristics of cats, but with an interesting twist! I also love Andy Warhol's book of cats from 1954, *25 Cats Name Sam and One Blue Pussy*. It's so cute and he made it with his mother which makes the story even more endearing!

What process do you go through to create your work? What inspires you?

I start most pieces by picking up a book, (either a cat book or another photo book I've thrifted) and find one image that strikes me as unique or inspiring and build from there! I have a large collection of books to cut pictures from. I try to mostly pull from books and not online.

What might people be surprised to know about you (or your work)?

I make most of my art based only on aesthetics and not to make statement. Also I am a terrible painter!

What question do you wish I had asked you?

How many cats do you have?

What is your answer to that question?

Two, Pickle and Pistol, they are muses, my flames. They can be found in the form of stray hairs glued into some of my work. Without them I don't think I would have ever dedicated my art to cats.

LEFT PAGE

Floral Vishnu
Acrylic paint, reference books
on canvas, 8 x 10". 2019.

BRITT EHRINGER

Britt Ehringer lives and works on a large studio compound nestled in the hills of Topatopa Mountains near the town of Ojai, California, an hour north of Los Angeles. He lives there because the paintings he makes require that he be sufficiently removed from the bustle of the city to be able to think clearly about what it all means. His work explores the clash between worlds, islands, chambers of marvels, biotopes and ideas - the subatomic weather of everyday life. To paraphrase Philip K. Dick, we live in a society in which spurious realities are manufactured by the media, by governments, by big corporations, by religious groups, political groups. Unceasingly we are bombarded with sophisticated pseudo-realities. Ehringer's work investigates the layers of perception in a search for what is real.

www.robertbermangallery.com/artists/britt-ehringer

When and why did you start including cats in your work?
I started working with cats about 15 years ago. I was doing a series of nudes and people kept telling me "I love your work but I have kids" so I started adding kittens to the nudes as kind of a joke. Soon afterwards I started to just enjoy painting them as a satire on popular culture, and besides, painting fur is fun!

How would you define your style?
Electric Kool-Aid Pop Realism.

Do you have a personal relationship with any cats and how has that informed your work at all?
Yes. I have a grey tabby named "the dude." I've used pictures of him as a kitten in quite a few paintings.

Why, in your opinion, are cats so trendy right now?
I think it's the rise of social media. There is so much great art and design that people are able to crowd share. When I first started painting kittens, Facebook and Instagram were not yet available.

THIS PAGE

Say Hello to
my Little Friends
Oil on linen over panel,
48 x 60". 2014.

RIGHT PAGE

2Catalypse Now
Oil on linen over panel,
48 x 72". 2018.

LEFT PAGE

Don't Mess with Texas
Oil on canvas, 84 x 48". 2008.

THIS PAGE

Fritz and Scholders
Oil on linen, 47 x 47". 2014.

149

Fridakatlobrow
Oil on linen over panel,
48 x 38". 2016.

So Long my Long Lost
Innocence
Oil on canvas,
24 x 36". 2008.

LEEGAN KOO

Leegan Koo was born in Seoul, Korea and began drawing and painting independently at a young age. He grew up moving from one city to another: Baltimore, Philadelphia, and New York City have all been homes to him. Perhaps as a result, cultural diversity, dynamic urban life, jazz, hip hop and graffiti became major sources of artistic inspiration for him. In 2011, Koo began focusing on painting cityscapes: visual manifestations of memories and emotions attached to certain places. He experimented with various styles of realism and surrealism. In 2013, he moved to San Francisco to attend the Academy of Art University where he received his first formal art education. In 2014, he moved to Los Angeles and joined Leftbank Art, a corporation that specializes in producing and printing artwork for clients such as Crate and Barrel, Pottery Barn and Z Gallery. He currently lives and works as a freelance artist and art instructor in Bellingham, Washington.

www.leeganart.com

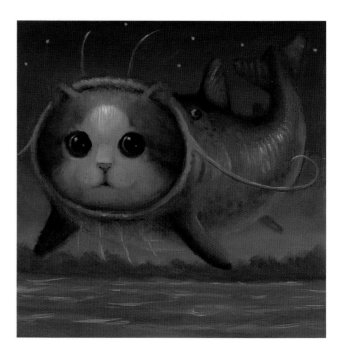

ABOVE

Catfish 2
Oil on wood, 6 x 6". 2018.

RIGHT PAGE

Bike Ride
Oil on wood, 12 x 12". 2016.

NEXT SPREAD, LEFT

Bodega Cat
Oil on wood, 8 x 8". 2015.

NEXT SPREAD, RIGHT

Catzilla 3
Oil on wood, 6 x 6". 2018.

152

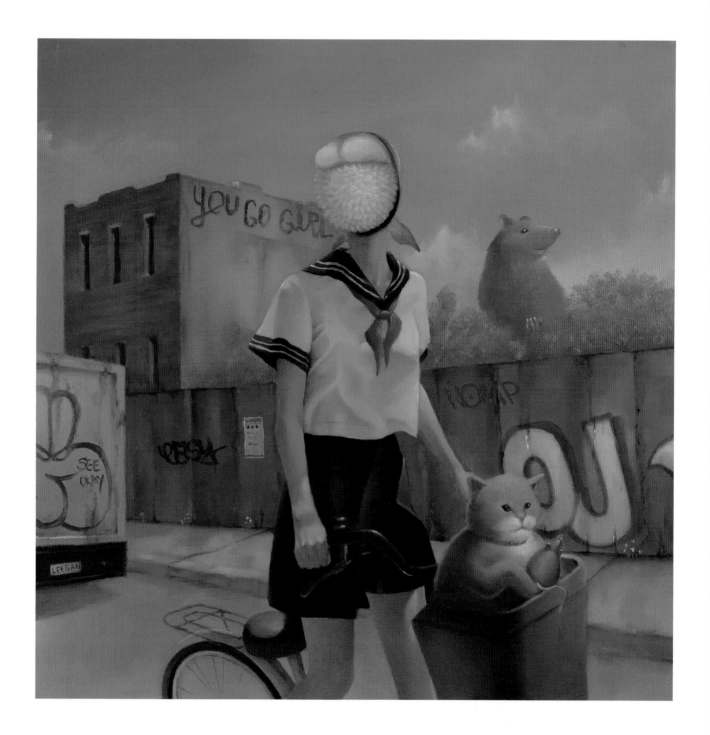

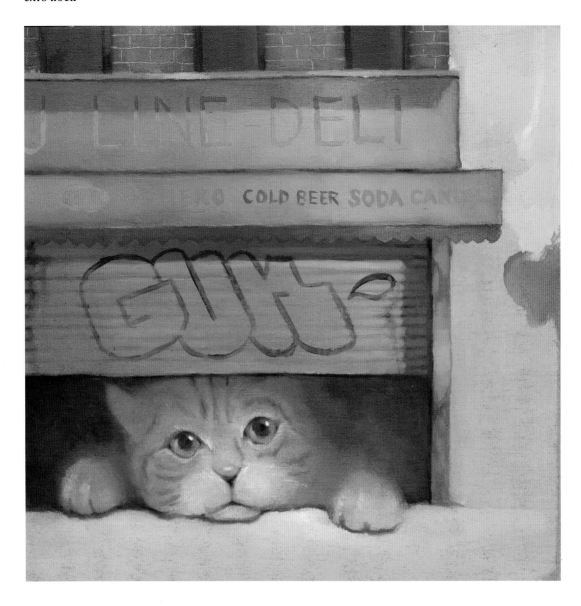

When and why did you start incorporating cats into your work and what do you feel they bring to it?

I began to incorporate cats in my artwork around 2015, based on my experience of living in New York. In New York, I naturally encountered many bodega cats in delis and corner stores. They were lolling about on the floor, taking a nap in the corner, or sitting between the boxes on the shelf. I was experimenting with urban surrealism in those days, and I thought bodega cats really captured the essence of urban life and represented New York City. I also thought they brought a certain whimsical feel to my art.

Is there any work of art featuring cats that has inspired you? Where did you encounter it, and how did it make you feel?

I've seen Korean folk paintings featuring cats. Even with the simple and clean lines and a subdued palette, which are characteristics of these folk paintings, the cats are painted with surprising details and vivacity. I like looking at the old paintings with cats and imagining their lives hundreds of years ago and how they must have inspired the same kind of love and fascination, just as cats do in present time.

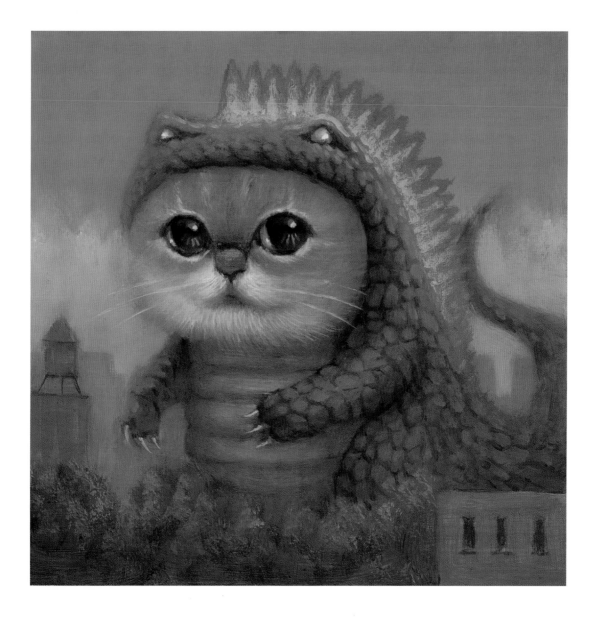

What process do you go through to create your work? What inspires you?

Once I get an idea for a painting, I would think about the idea over and over for a few weeks, sometimes for months. It's constantly in the back of my mind, whether I'm taking a walk or doing laundry. It's sort of like waiting for a seed to germinate. I will develop it on canvas only if it doesn't get boring in the end. I'm most heavily influenced by my surroundings and where I live. I'm currently living in Washington State and its landscape, weather and atmosphere are very much embedded in my current paintings.

What might people be surprised to know about you (or your work)?

Although I do sketch prior to painting as a study, I don't really like to sketch. I never bring a sketchbook with me when I go out and I don't have any pencil or pen artwork.

What question do you wish I had asked you?
Other interests besides art.

What is your answer to that question?
Music is a big part of my life, especially jazz and hip hop, and I hope to learn how to produce music someday.

GaAs

Born in Gijón, Spain in the 80s with a family tree full of artists, GaAs never had to discover art because it was always there. His flirting with painting was constant and at the age of 8, he began learning techniques in the studio of a painter who was a family friend. A constructor of universes ruled by symbolism, GaAs sees his art as a union of cultural and artistic references that work to achieve organic chaotic beauty. He finds possibility in the unconscious. According to GaAs, reality imposed by the human condition is far from the attempts of the unconscious, where everything is possible. In his work, he seeks to present a final reality where we can lose ourselves in the search for hidden meanings. GaAs has participated in group exhibitions in Los Angeles at Think Tank Gallery with artists such as Mark Ryden, Gary Baseman, Marion Peck, Shepard Fairey and Lola Gil. He has had solo exhibitions in Barcelona at Hell Gallery, Mutual Art Center and Suara Store. He has participated in artistic interventions, including the third edition of 'Los ilustrados de Ornamante,' also in Barcelona. In addition, he has collaborated with global fashion brands like Flamingo Sunglasses and Steve.co

www.gaas-artwork.com
Instagram: @gaas_artwork

Suara 200
Digital,
10 x 10". 2015.

TOP LEFT

Cat Bowie
Digital,
10 x 10". 2013.

TOP RIGHT

Rorschat
Mixed media,
10 x 10". 2017.

BOTTOM LEFT

Ibiza
Mixed media,
20 x 28". 2015.

BOTTOM RIGHT

Ade
Mixed media,
20 x 28". 2015.

Cat Bird Manifesto
Oil on wood,
19 x 19". 2018.

When and why did you start incorporating cats into your work and what do you feel they bring to it?

I work for Suara, a brand that bases itself on cats because Coyu, a musical artist who founded it is a big fan of cats. We started using portraits of cats for the covers of our record company, then we started featuring cats on clothing, and to complete the circle and return everything to the cats that had given us so much, we opened our own foundation to help feral cats in Barcelona. All of our benefits go to help cats.

Is there any work of art featuring cats that has inspired you? Where did you encounter it, and how did it make you feel?

I had never seen many artists who used cats as inspiration. I guess cats go unnoticed until you start working more on the topic and share exhibitions with similar artists. I have exhibited at two art shows in Los Angeles dedicated to Cat Art, and that's when I became aware of the number of artists inspired by cats and using very different angles and styles. There is a large community of people interested in cats and art at the same time.

What process do you go through to create your work? What inspires you?

I usually look at hundreds of images of cats to observe their anatomy, their different shapes and everything that goes unnoticed and makes a portrait special. Once this is clear, I have to find a way to go from the general to the particular. I get into the portrait and create an imaginary universe of fauna and flora that allows you to meditate on it and discover hidden meanings.

What might people be surprised to know about you (or your work)?

It all started with our music label, where I met Coyu. In our label, we praise the figure of the cat and give it a prominent place. The public now associates our brand with this animal, our easily recognizable passion. People like Green Velvet and Moby have produced music with our label, and we have collaborated with artists such as FatBoy Slim, with a cat as our logo.

What question do you wish I had asked you?
What does your foundation do to help cats?

What is your answer to that question?

Its main mission is to offer better living conditions for street cats in Barcelona. We offer the necessary veterinary care, and cover all medical expenses. Cats pass through the cathouse to help them adapt to being around humans until they can be given to an adoptive family. Also, we provide educational and ludic activities in the cathouse. We want to improve the image of cats in the community and share our vision of cats forming positive relationships with people.

RIGHT PAGE

Pattern Cat Box
Digital, 8 x 12". 2018.

KIT MIZERES

Kit Mizeres is an American artist and illustrator with no fixed abode. She initially hailed from a small wintery town in Ohio, and went on to graduate from the Columbus College of Art and Design with a focus on Illustration in 2016. Since then, she has enjoyed taking her sweet time living on the road as she continues to collect and draw inspiration from her new and ever-changing surroundings, as well as the wonderful strangers she has met along the way. Her work often takes on a very maximalist, dreamlike approach that heavily incorporates themes of folklore and personal mythology.

www.syntheticflyingmachine.com
Instagram: @kitmizeresart

ABOVE
Bob the Cat
Gouache on paper,
8 x 10". 2018.

RIGHT PAGE
Lady Cat
Gouache on paper,
5.5 x 7". 2019.

When and why did you start incorporating cats into your work and what do you feel they bring to it?

I incorporate a variety of different flora and fauna in my work and just so happened to paint some cats here and there! I think it's only been one year since I painted my first cat and very recently, I've been surprised by the amount of requests I've received for more cat art! I suppose cat art only breeds more cat art. I try to paint a variety of subjects, but you may be seeing more cats coming from me in the very near future. I just think they're very pleasing to the eye and rather expressive beings, and they bring so much personality to the world of storytelling.

Is there any work of art featuring cats that has inspired you? Where did you encounter it, and how did it make you feel?

You know, I honestly can't think of any other artist who I keep a close eye on that really paints cats, except for my close friend and fellow artist, Okell Lee. His work has always had a heavy influence on my development as an artist, and of course, his extremely expressive cat art has always inspired me to push it to the next level.

What process do you go through to create your work? What inspires you?

I'm inspired by other contemporary artists, but I also have a heavy influence from any kind of storytelling, be it folklore or real life events. And oftentimes, something as simple as a color palette can inspire a new painting. Generally I will hear a story or see an image that will bring a new concept or image to my mind, and then I draw away! My travels also play a heavy role in the kind of content I'm creating at the time.

What might people be surprised to know about you (or your work)?

I think the thing that most people don't know about me or seem to understand once they do know is that I haven't had a home in two years and counting. I've been traveling constantly during this time, and I only live out of a backpack. So usually each painting I complete, especially as of lately, has probably been painted in a different city or country and is often heavily inspired by that location at the time. They're also generally small and painted with watercolor or gouache because it's the easiest medium to transport, and I'm quite limited with living out of a carry-on!

What question do you wish I had asked you?

Did you ever think you'd be associated with cat art, let alone featured in a book about cat art?

What is your answer to that question?

The thought had never crossed my mind!

LEFT PAGE

Like the Tide, You Pull Me in Only to...
Gouache on paper,
10 x 12". 2019.

LOLA DUPRE

Lola Dupre is a Scottish artist born in 1982. Over the last decade she has lived and worked in Switzerland, France, Spain, Portugal and Ireland. She has collaborated on projects including cover art for *Time* magazine, assignments with Nike Basketball, *The Atlantic* magazine and Penguin Classics. She loves to find inspiration in the forest and by the beach, among all animals and life forms including humans, in patterns, places, wild and urban areas, and in technology and science. She is also inspired by the history of evolution and the mysteries of quantum mechanics—almost everything real and imagined inspires her. Additionally, she takes inspiration from things that are enchanting or beautiful for all the right or wrong reasons; familiar and bizarre, attractive and repulsive—she finds dichotomy fascinating. All these elements bring dimension to her work. Dupre works in editorial illustration, with a strong interest in fashion and collaboration. In 2018 and 2019 she has so far produced the most animal portraiture in her portfolio, including special Gucci cat images for *Agapornis* magazine and a ferret for *The California Sunday Magazine.*

www.loladupre.com

RIGHT PAGE
Hosico
Paper collage on panel,
8.2 x 11.6". 2018.

NEXT SPREAD, LEFT
Simo
Paper collage on panel,
11.5 x 16.5". 2018.

NEXT SPREAD, RIGHT
Coby
Paper collage on panel,
8.2 x 11.6". 2018.

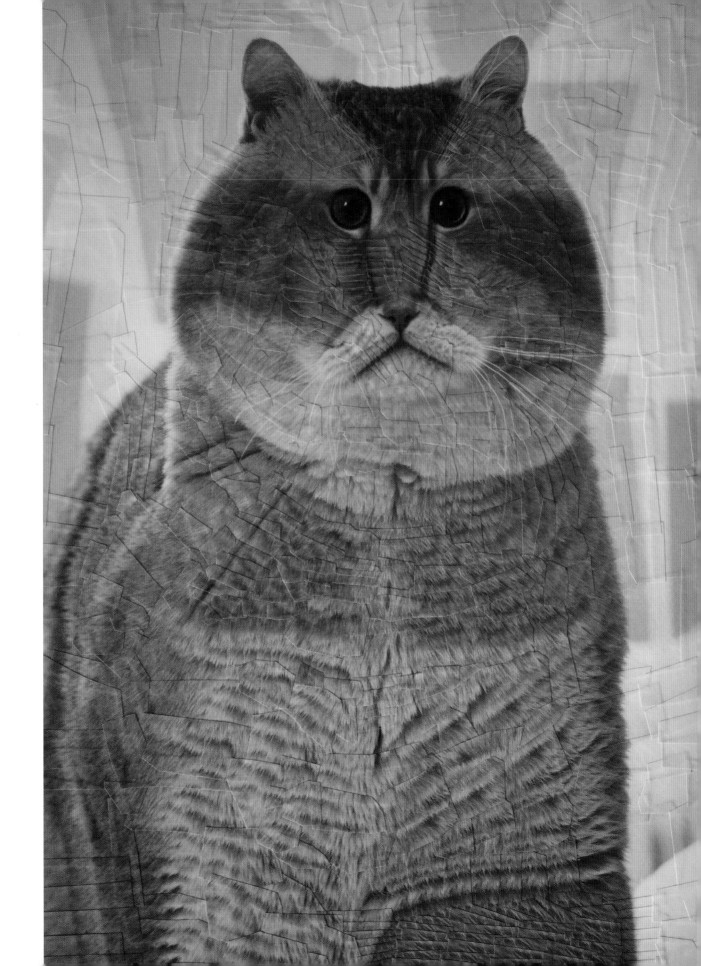

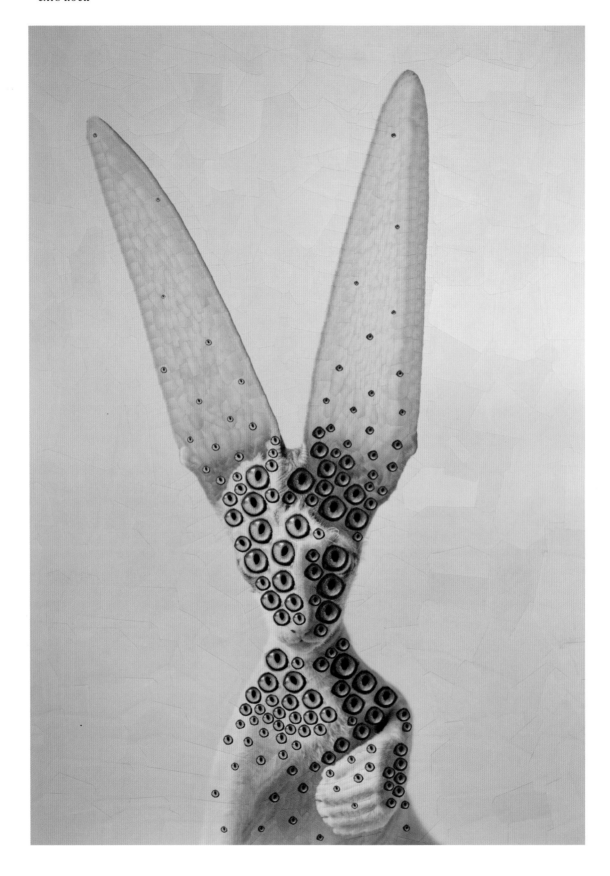

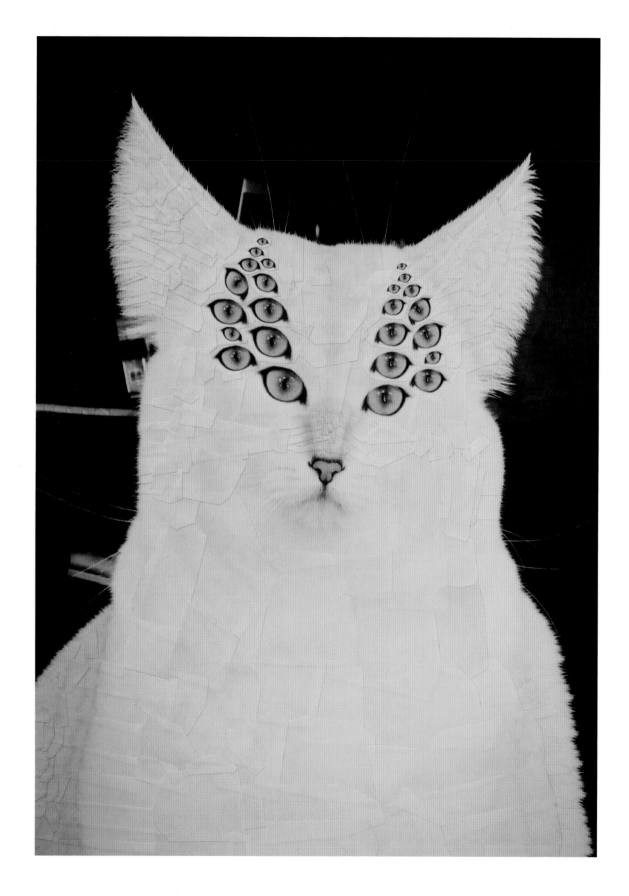

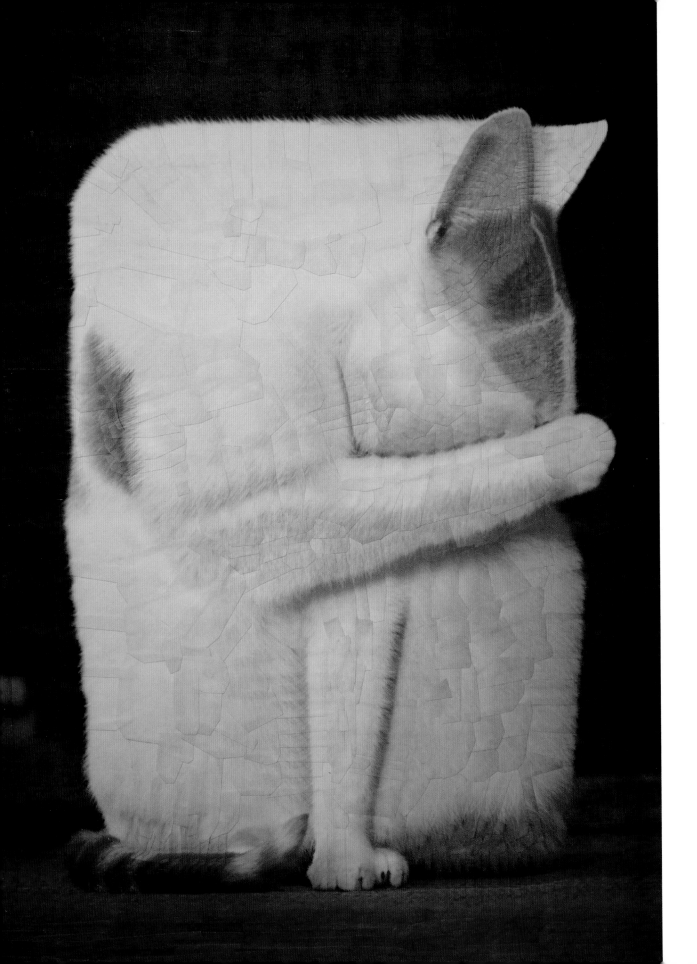

Why are you obsessed with cats?
Well I love all animals really, I just happen to live with a cat right now so naturally I am kind of hypnotized and a little bit obsessed. Cats have such a great presence. They can be so therapeutic, inspirational and funny! That might sound a little unbalanced, but I think most readers will agree.

What do you get and what do you hope viewers get from seeing your distorted images?
Any pleasant feeling would be great. The beginning of a bigger conversation, or any deeper thoughts or interpretations would be great too. Amusement? I think experiencing humor can be a catalyst to positive transcendental or transformative experiences.

Do you have a personal relationship with any cats and how has that informed your work at all?
My cat companion is Charlie, he came with that name when we adopted him. He was pretty scary for the first few weeks, but now he is pretty much always really friendly. He is so inspirational. He does these great stretches and poses throughout the day, I am always trying to capture them in photographs but nearly always miss these great cat moments.

How do you do your work and what inspires you generally?
I think I might be a workaholic. I can get cranky if I'm not working. I do my work out of desire and compulsion. I feel I am like a mirror, being a collage artist. I need existing imagery to produce my work, the works being reflections of reality.

LEFT PAGE

Charlie VIII, even softer
Paper collage on panel,
8.2 x 11.6". 2018.

THIS PAGE

Charlie XIV the Bath
Paper collage on panel,
8.2 x 11.6". 2018.

TROY EMERY

Troy Emery is an artist based in Melbourne and has an art practice encompassing sculpture, painting, drawing, and embroidery. Emery spent his youth in the regional city of Toowoomba in South East Queensland but relocated to Hobart, Tasmania to attend art school. He graduated with a bachelor of fine art from the Hobart School of Art, University of Tasmania in 2005. He then completed a master of fine art at Sydney College of the Arts, University of Sydney in 2010. His work is held in various private and public collections, including The National Gallery of Victoria, Art Bank Australia Collection, City of Townsville Art Collection, Goulburn Regional Art Gallery Collection, and Deacon Art Museum. Troy is represented by Martin Browne Contemporary gallery in Sydney, NSW. Emery's sculpture explores animals as decorative objects as well as the aesthetics of trophy animals and plush toys. He uses materials such as pompoms, tassels, tinsel, and yarn in pieces that intentionally confuse traditional sculpture with handicrafts. The role of surface and color in the production his work is often exaggerated. The luscious textile pelt is a camp interpretation of the way skins and furs are cherished and fetishised. As natural specimens or species, Emery's animal sculptures are impossible combinations of form, color, and material. They exist as hypothetical or mythological animals. These fluffy colorful forms are dream-like monsters that fuse an obsession with childhood stuffed toys and fascination in anthropological and natural history object collections.

www.troyemery.net

THIS PAGE
Lilac Layabout
Polyester, polyurethane, pins, adhesive, 10 x 27 x 17". 2018.

RIGHT PAGE
Sugar High
Polyester, polyurethane, pins, adhesive, 20 x 19 x 14". 2018.

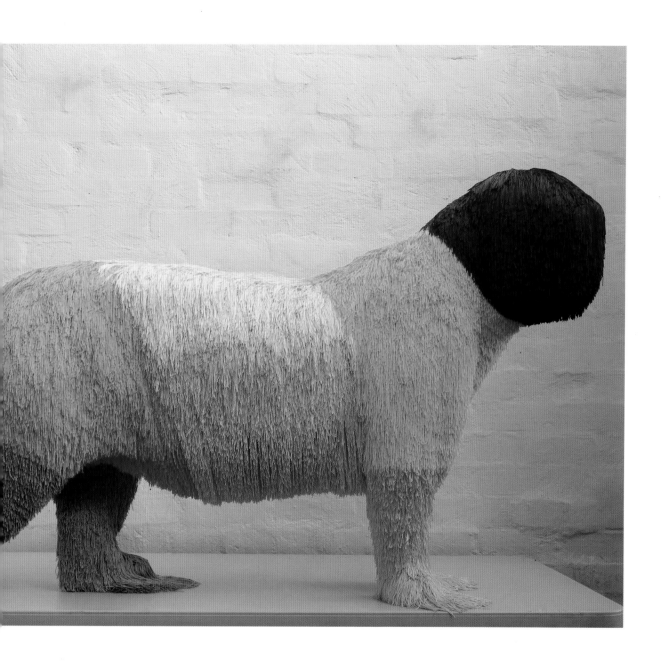

Big Rainbow Cat
Polyester, polyurethane, pins,
adhesive, 35 x 40 x 19". 2018.

Pink Banded Beast
Polyester, polyurethane, pins,
adhesive, 37 x 63 x 22". 2018.

Are these works even cats? What are you doing in a cat art book?

People project a lot of their own ideas onto my work. What one person sees as a cat, another may not. People tell me they see their pet, they see a dog, or they see the work about to move. That's precisely why I'm interested in the animal form, because people do that. Animals are the bearers of our own thoughts and feelings. They are representations of love, of family, of danger, of ecological ruination. Because I work with taxidermy mannequins, my works are technically, taxonomically, cats, wild cats. Bobcats, mountain lions, jaguars, and lions make up the underlying forms. It's through the process of incorporating the textiles that the works become something else. They transform, or mutate. They camouflage.

When and why did you start incorporating cats into your work and what do you feel they bring to it?

I have always been interested in animal forms, even from early days in art school, and I've also always been a cat lover. What's beautiful about cats is you have this dichotomy between the sweet family pet and the ferocious predator in the wild. It's this theme of duality that runs through my work. That of the divided between art and craft, the domestic and the wild, and with taxidermy - the living and the dead.

Is there any work of art featuring cats that has inspired you? Where did you encounter it, and how did it make you feel?

In 2014 I was a recipient of an Australia Arts Council residency in Tokyo and travelled to Japan in 2015 for a three-month research trip to look at Japanese animal mascots. Cats are such a big thing in Japan. While I was there, I saw many cat inspired characters, and I went to lots of cat cafes. I really like the artwork of the Edo Japanese artist Utagawa Kuniyoshi and his anthropomorphic cats.

What process do you go through to create your work? What inspires you?

I'm interested in working with materials that are more traditionally associated with craft and fashion. I work with tassels, tinsel, and pompoms. The materials are the starting point. I also like working with animal forms, and my process is a kind of taxidermy. I create a kind of artificial textile pelt. I call it fake taxidermy. I'm inspired by a whole range of things: science-fiction, natural history museums, computer games, nature documentaries. I have one foot in the real world and the other in a fantasy.

What might people be surprised to know about you (or your work)?

My works require LOTS of materials. A single work could be made up of well over 200 meters of tassels.

RIGHT PAGE

Deep Sleep
Polyester, polyurethane, pins,
adhesive, 21 x 27 x 16". 2018.

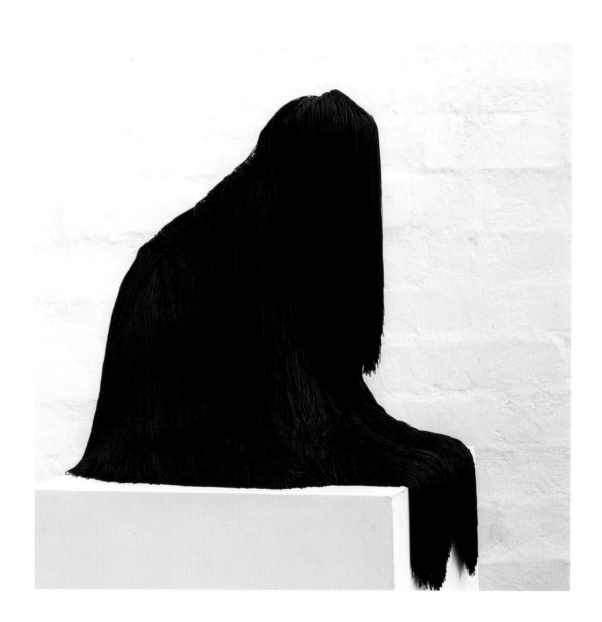

Cats as People, People as Cats

"My brothers," said he, "may make a handsome living by joining their shares together; but, for my part, after I have eaten up my cat, and made myself a muff from his skin, I must then die of hunger."

The cat, who heard all this, but pretended otherwise, said to him with a grave and serious air, "Do not be so concerned, my good master. If you will but give me a bag, and have a pair of boots made for me, that I may scamper through the dirt and the brambles, then you shall see that you are not so poorly off with me as you imagine."

— *THE MASTER CAT; OR, 'PUSS IN BOOTS*, CHARLES PERRAULT, 1697.

Practically since cats were first domesticated, they have been combined with human forms in art. Cats were decorated and mummified like humans and sacrificed to the cat goddess Bast, whom ancient Egyptians depicted as a human-cat hybrid. Aesop's fables, with the first extant collection in the first century AD, famously anthropomorphized animals including cat characters, while in European and Asian folklore, the spirits of various humans were thought to appear before others in the form of cats. Anthropomorphized cats appeared in medieval art playing instruments on the pages of books of hours and psalters at least as early as the 1400s. In the 16th century, at least one cat was dressed as a priest and hung from the gallows in England as an effigy.[1]

As time marched on, it's no wonder that cats appeared anthropomorphically in art. The tale *Puss In Boots*, which first appeared in the 1500s under another name in Italian, featured a cat dressed in human clothes and was illustrated as early as the 1600s. In F.A.P. de Moncrif's 1727 book, *Les Chats*, prints of anthropomorphized cats feature heavily. As it became fashionable for people to welcome cats into well-appointed 1800s homes, these pets came to symbolize us in art.

Author and illustrator Beatrix Potter featured anthropomorphized cats in her work, geared towards children. In *The Tale of Tom Kitten* (1907), her cats and kittens appear as women and children wearing clothes. The kittens are forced to walk on their hind legs in preparation for their mother's tea party and they get into mischief.

British photographer Harry Pointer dressed cats as humans and posed them in scenes as did the American photographer, Harry Whittier Frees (1879-1953). Frees photographed many different animals, but in 1929 he called the kitten "the most versatile animal actor," who "possesses the greatest variety of appeal."

Anthropomorphized cats are among the most popular and universally appealing forms of cat art online and in popular culture. It is hard to even think of an animal more frequently anthropomorphized than the cat. It is, however, interesting to note that art in which cats are depicted as humans is often seen as kitschy, childish or overly precious. It is as if we are comfortable with cats as symbols, but the act of identifying with them is both too attractive and repellant to be taken seriously. Our desire to denigrate or exalt cats may even stem from our ease in anthropomorphizing them. This may also be what leads us to keep them as pets, dress them in clothes and feature them so heavily within art and culture.

Modern famous anthropomorphized cats are too numerous to name. They include Garfield, Hello Kitty, Pusheen, Felix the Cat, Sylvester, Tom from *Tom and Jerry*, Stimpy from *Ren and Stimpy*, R. Crumb's *Fritz the Cat* and many more. It is interesting to note that the male anthropomorphized cats on this list may be cute, but they are not overly so. They are often depicted as ineffective, lazy, irresponsible, foolish or even lewd.

While anthropomorphized cats may be seen as alternatingly adorable or ineffective, people as cats are objects of fear and derision. During witch trials, 'evil' women were said to have taken the form of cats to menace others. Today, Jocelyn Wildenstein, a woman who reportedly had cosmetic surgery to look like a cat, is the object of horror and ridicule while characters like whip-wielding Catwoman are volatile and likely to pounce at any moment. "Fat cat" politicians are seen as greedy and corrupt, the objects of hatred. In this section we will bridge human-cat boundaries, exploring cats depicted as people and people as cats.

MIDORI FURUHASHI

Midori Furuhashi was born in Hiroshima, Japan in 1962. She graduated from Kyoto City University of Art. Furuhashi began making cat artwork after the Great East Japan Earthquake in 2011. Her work has been shown at the Cat Art Show in Los Angeles, and at Ashok Jain Gallery and Agora Gallery, both in New York City. She is the author of the book *Mistigri au Japon* (*Mistigri in Japan*), where her work is featured. The book was published by ION EDITION in France.

www.k102m7s7h.wixsite.com/midori-furuhashi-

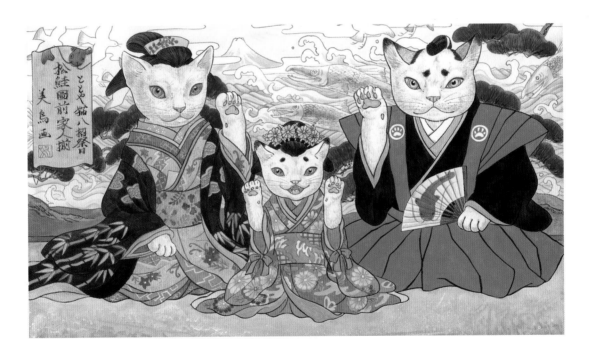

THIS PAGE

A Cat Girl Maneki and her Parents
Pigment, acrylic on paper.
2015.

RIGHT PAGE

Queen Cat Riding on a Unicorn
Pigment, acrylic, ink and colorpencil on paper,
25.59 x 31.49". 2018.

THIS PAGE

Dancing with a Fan N°2
Sumi ink and mineral pigment
on rice paper,
13.7 x 17.71". 2015.

RIGHT PAGE

Celebrating Dance
Sumi ink and mineral pigment
on rice paper,
11.69 x 16.53". 2014.

What made you decide to put cats in human clothing?
As a child, I grew up with manga and anime. When I showed my art abroad, I thought that using Manga style was a good way to express Japanese pop culture. This style has its roots in the Ukiyoe prints from the 18th century Edo period..

Why did you decide to use traditional Japanese materials when creating your work?
I learned Japanese traditional painting technique while studying at my university. By using Sumi ink and mineral pigments on rice paper, I can create artwork that has the same atmosphere as the great hand-painted Ukiyoe of the Edo period.

When did you decide to first start painting cats and why?
The Great East Japan Earthquake happened in 2011. I thought that giving people happiness and making them smile at the sight of artwork should be a painter's mission. I made cats the subjects of my work because cats are lovely and have charm, and this would make people smile.

Can you tell us a little bit about the cat in a Japanese context? Have people in Japan always loved cats or have they become more popular recently? How are cats represented in Japanese pop culture and does that inspire you? If not, how do you feel about it?
Japanese people have loved cats since ancient times. Ukiyoe artwork by Utagawa Kuniyoshi shows the cat's popularity in the Edo period.
However, more recently, especially after 2010, there has been a big cat boom in Japan. Reports say that it has also had a great economic impact. The trigger of the boom was in 2007 with Station Master Tama. Tama was a friendly stray cat who happened to live in a rail station. Due to budget cuts, the position of station master became an honorary position without a salary. In many areas, the position was given to local business owners, who had the job of greeting people at rail stations. However, at Tama's station they gave her the position, which even came with its own little cat uniform. Having a cat as station master increased ridership, was adorable and sparked an increased interest in cats overall. Today, there are so many magazines about cats published and so many events held in Japan. During this boom, Utagawa Kuniyoshi and Tusguharu Foujita were re-evaluated. Honestly, I'm not very familiar with the pop culture movement, but I love and respect these two great cat artists. I would like to inherit their spirits and love for cats.

Idol Unit Meow Meows
Ink, acrylic and pigment on paper, 11.69 x 16.53". 2015.

POLINA KANEVSKY

Polina Kanevsky is a mixed media artist and illustrator born in 1978 in Kiev, Ukraine when it was part of the Soviet Union. She immigrated to Israel in 1990 and lives and works in Tel-Aviv. Kanevesky does all her work by hand, without using any digital mediums, whether in drawing, watercolor, pencils, markers, collaging, or creating three-dimensional sculptures and objects. Kanevsky draws inspiration from her personal inner worlds rooted in childhood, as well as from the processes and transformations of the human psyche and body. The body, food and cats seem to be recurring themes in her work. Kanevsky is influenced by surrealist and symbolist art, the Russian avant-garde, and naive and outsider art, along with magical realism literature. She was recently adopted by two stray cats.

Instagram: @po.mi.ka
Facebook: @pomika.artist

ABOVE

Giant Space Cat
5.8 x 8.3". 2018.

RIGHT PAGE

Abduction
5.8 x 8.3". 2018.

NEXT SPREAD, LEFT

Meowlder and Scatly
5.8 x 8.3". 2018.

NEXT SPREAD, RIGHT

Cats Abducted
5.8 x 8.3". 2018.

When and why did you start incorporating cats into your work and what do you feel they bring to it?

Cats have always been a recurring theme in my art. I am fascinated by them and spend much of my time observing them and communicating with them (I can in fact waste entire days gazing at a cat). My city is full of stray cats and so many people are busy rescuing, adopting and feeding them. To me, they are symbols of the unique free spirit of Tel-Aviv. This city belongs to cats and single people, and we have much in common. We share the longing for touch and warmth, the trust issues and the difficulty in committing, the springtime angst, the love-hate battle between the sexes. Human and feline life are so intertwined here that it feels natural to me to portray cats as humans and humans as cats.

Is there any work of art featuring cats that has inspired you? Where did you encounter it, and how did it make you feel?

I love the portrayals of cats in medieval art. They are made to look partially human, suffering, grotesque, ridiculous, and I can very much relate to that. Another very different but strong influence can be found in the work of one of my most beloved writers Julio Cortazar ("Orientation of the Cats"). He had tremendous ability to observe and write about cats, really looking at them, truly seeing them as the mystical godlike beings that they are. Like us humans, our companions the cats are earthbound, mortal, pitiful, yet at the same time divine and inexplicable. I find this inspiring and awesome.

What process do you go through to create your work? What inspires you?

My process is very personal and is rooted in my inner dialog with myself. It comes usually while walking alone through the city, or while doing mundane physical labor (as an underpaid starving artist often must). But I find that the best inspiration is in the work itself. There's no use in waiting to get inspired, just grab a piece of paper and start drawing, scribbling, doodling. It doesn't have to be good. Keep moving, persist, and something will come out. Trust that something will be the very thing you wanted to say but couldn't find the words for.

What might people be surprised to know about you (or your work)?

I absolutely hate and desperately avoid signing my work. Yes, I know that's problematic. But in my eyes, once I sign an artwork, it somehow becomes tainted, even ruined. If I must, I will sign on the back of a canvas or in some hidden place. A visible signature or even name initials anywhere on the artwork itself makes the whole thing impossible for me to look at. I guess some day they will have to identify my works by my fingerprints (I'm a very sloppy drawer) and by my hairs that I unintentionally leave everywhere, embedded in paint or glue (another thing I have in common with my cats).

What question do you wish I had asked you?

What great invention would you like to witness in your lifetime and how would it be useful to you?

What is your answer to that question?

That's a great question, Elizabeth. My dream is for humanity to finally develop a functioning cat-human translation device, so I can courteously ask stray cats whether they need assistance crossing the road.

RIGHT PAGE

Cat Walk Cat
5.8 x 8.3". 2018.

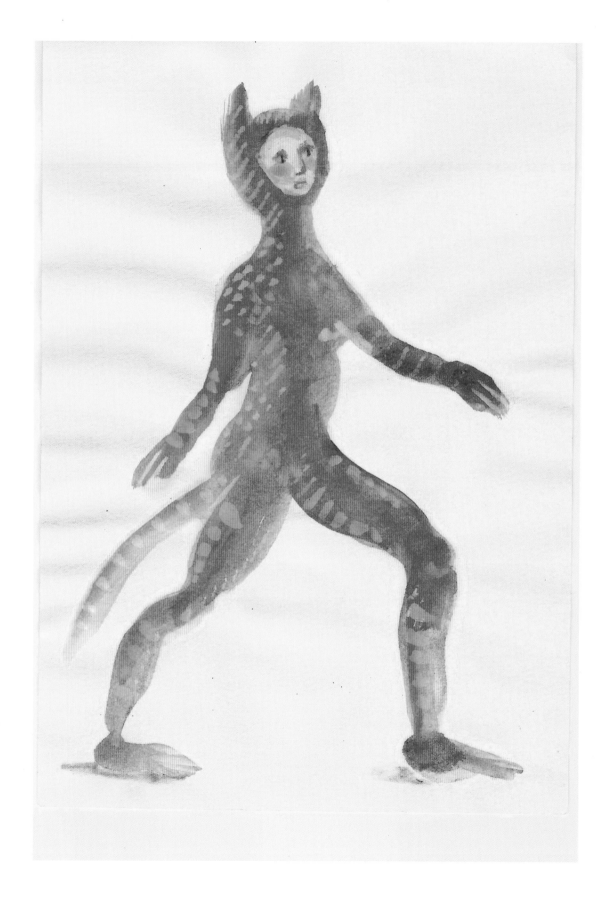

PAUL KOUDOUNARIS

Paul Koudounaris is a photographer and author from Los Angeles. He holds a PhD in Art History and is the author of a series of well-known and award-winning books about the representation of death in world culture. His companion cat and photographic muse, Baba, is a shelter cat discovered in the city pound, and so named for running across the floor and doing a head plant into a dish of babaganoush as a kitten. Together they have produced over 200 costume photos of famous historical and cultural figures. They have an upcoming book to be published by Holt, entitled *A Cat's Tale*. It will provide a narrative of feline history from prehistoric through modern times.

empiredelamort.com
Instagram: @hexenkult

RIGHT PAGE

Supercat
Digital photographic print,
24 x 24". 2016.

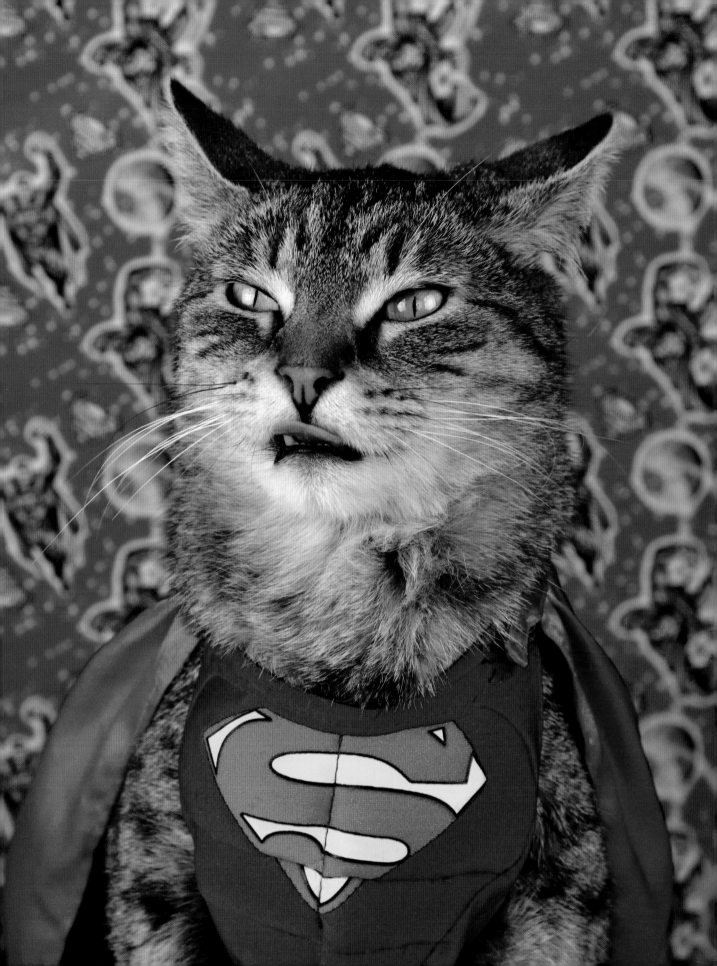

TOP LEFT
Surgeon
Digital photographic print,
26 x 24". 2017.

TOP RIGHT
Cinco de Meow
Digital photographic print,
24 x 24". 2017.

BOTTOM LEFT
Anatomist
Digital photographic print,
24 x 24". 2016.

BOTTOM RIGHT
Mewcifer
Digital photographic print,
24 x 24". 2018.

TOP LEFT

Cattstein
Digital photographic print,
24 x 24". 2017.

TOP RIGHT

Straight Outta Kitten
Digital photographic print,
24 x 24". 2015.

BOTTOM LEFT

Swiss Miss
Digital photographic print,
24 x 24". 2016.

BOTTOM RIGHT

Mewtallica
Digital photographic print,
24 x 24". 2016.

THIS PAGE

Disco Cat
Digital photographic print,
24 x 24". 2017.

RIGHT PAGE

Paw-tober Fest
Digital photographic print,
24 x 24". 2016.

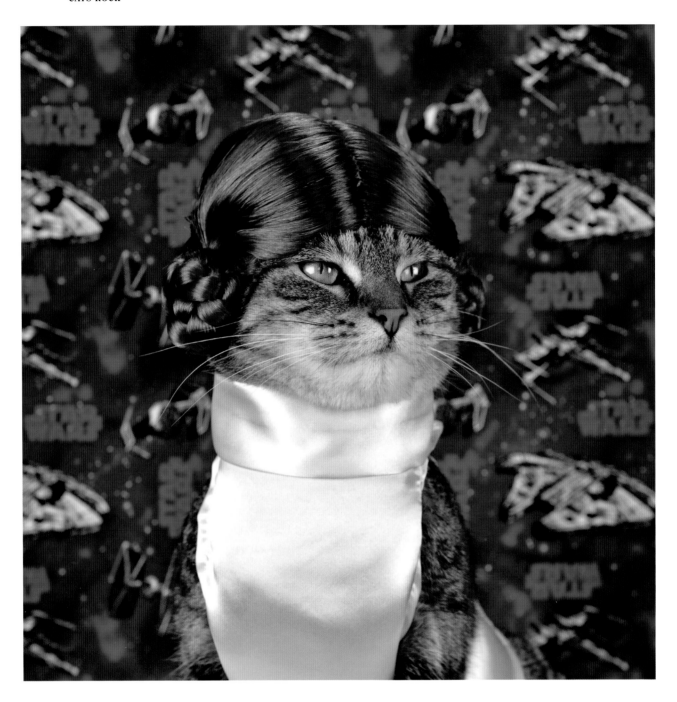

Princess Leia
(May the fur be with you)
Digital photographic print,
24 x 24". 2017.

What is it like to collaborate with a cat? How do you go about it?

It is both challenging and rewarding, and the relationship that develops out of the collaboration is central to the entire series of photos we have done. I don't consider this to be a photography project, but rather an exercise in interspecies communication. These images are intended to be more than simply a cat wearing a costume, but rather capture some essence or feeling of a character. So I have to develop the character—and then convince her to express what I am visualizing. That makes the photos something along the lines of self-portraits, but with Baba playing the roles I imagine. Obviously that's not easy to pull off, but it's amazing how often we succeed. It's always funny to me when people say things like, "she really understands the role." No, she doesn't, she can't. She has no idea who or what she is caricaturing. That comes from me, and it's the genius of Baba, a cat with exceptional intuitive intelligence, that she reads me so well as to be able to consistently pose herself conforming to my vision. Needless to say, we are very close, and these photos have served to draw us even closer.

What inspires you?

To follow up on the previous answer, the inspiration really comes from exploring the relationship I have with my cat, and our ability to communicate nonverbally. Honestly, if it were just a case of me sticking her in a costume and having her sit there like a bump on a log looking bored, I would have no interest in this photo series. It's all about the exchange between us.

Is there any other great work of art featuring cats that you particularly like? If so, can you tell us about it? Where did you encounter it, what is it?

My stock answer to this is that, hey, every cat is its own little masterpiece, isn't it? Well beyond that, it's not like there's any previous cat imagery that I consider inspirational to what we're doing because again to follow up on my first answer, this photo series isn't really about cats per se, it is about communication and exchange with another species. If you want to talk historically though, you know who doesn't get enough credit for being a cat artist? Manet. *The Cats'*

Rendezvous is a somewhat well-known print, but it's more than that. Consider the black cat which appears on the bed in *Olympia*. That painting was the scandal of the Salon of 1865, and not just because of the brazen prostitute staring out at the viewer, but because of the black cat alongside her—the very symbol of the witch and wanton woman. This was at a time, the mid-nineteenth century, when cats were finally being rehabilitated after centuries of persecution and considered acceptable as domestic pets. And Manet was the first major artist to take them seriously. He deserves more credit than he gets.

What might people be surprised to know about you (or your work)?

That I make pretty much all of these costumes. Either I make them from scratch or I buy old doll and teddy bear outfits and re-cut them and tailor them to her. So I prowl the doll shows (yes, there is a circuit of doll shows) trying to score cheap outfits that I can modify. The doll shows are primarily filled with old ladies and the age range is generally 70-plus. I definitely don't fit in. Some of these ladies think my cat photos are charming, others think I'm a reprobate eccentric.

What question do you wish I had asked you?

What are your plans for this photo series?

What is your answer to that question?

Ah, well, glad you (didn't) ask! In non-cat life I have a PhD, do historical research, and write books. Over the past several years I have become obsessed with historical research on cats, on discovering felines who made great contributions to history and society and then got written out of the picture. And there are a lot. We tell history from a human perspective, so we tend to downplay the accomplishments of animals in general, and cats in particular, since the idea of them being heroic confounds our stereotype of them as passive, aloof animals. So the point of this photo series is a book that Baba is "writing" (OK, maybe I'm helping in the writing a little bit), that presents history from a feline point of view. The photos, mostly of Baba in historical garb, will illustrate the periods and people she mentions in her narrative. *A Cat's Tale* will be available . . . well, depending on when this volume is published, maybe not long after.

NG LING TZE

Ng Ling Tze was born and currently lives and works in Singapore as an independent full-time artist and painter. Ling Tze graduated from Nanyang Academy of Fine Arts in Singapore and received a diploma in Fine Art, majoring in Western Painting. She was the recipient of the Nafa Merit Award and Georgette Chen Arts Scholarship and was awarded 2nd Prize at the Asian Civilization Museum Anime Drawing Competition in Singapore in 2005. Thereafter she obtained a finalist award at the Tiger Translate Future Competition, also in Singapore. Her artwork received an Honorable Mention in the 2016 Asia Illustration Annual Awards in Taiwan. Ling Tze works primarily in the medium of acrylic, sometimes also working in other traditional mediums such as graphite or pen and ink. She has showcased her artwork in various group and solo exhibitions, mostly in Singapore and countries like Japan, Taiwan and the United States.

Instagram: @tamaow

THIS PAGE
XuXu
Acrylic on canvas,
9 x 12 x 1". 2016.

RIGHT PAGE
Bebe
Acrylic on canvas,
9 x 12 x 1". 2016.

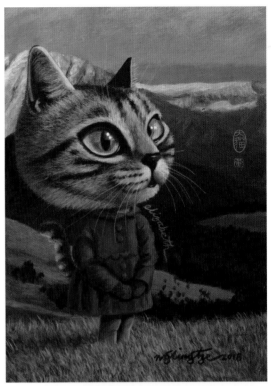

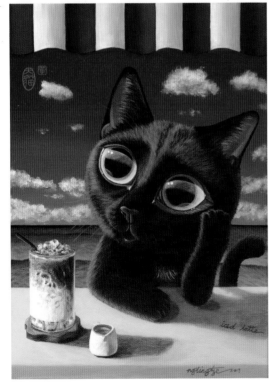

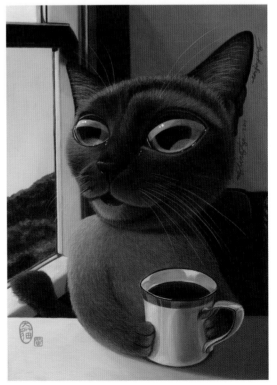

When and why did you start incorporating cats into your work and what do you feel they bring to it?

I was terrified of cats when I was a kid. As I grew older, I realized a lot of friends actually owned cats as pets at home. One friend introduced to me to her gentle yet friendly cats when I frequented her home after school. Another friend never stopped talking about his many cats and their weird behaviors. Slowly it started to spark my interest in these curious creatures. Before I knew it, most of my paintings took a turn in 2001 as I got to know more cats, be it friends' pets, or my neighborhood's strays. Cats' unusual unique behaviors and personalities seem to always inspire me with ideas, be it just simple portraitures, or surreal themed compositions. I hope that my paintings express the perspectives of cats and their awesome nature and quirks and allow more people to appreciate them for what they are.

Is there any work of art featuring cats that has inspired you? Where did you encounter it, and how did it make you feel?

There are many great artists who have inspired me, but most of them do not paint cats. There is a female cat artist, Martine Coppens, whom I encountered few years back on Facebook. I love most of her cat paintings as they make me feel happy and wonderful about life.

What process do you go through to create your work? What inspires you?

As I am unable to have my own cat in my house, I go around to look for my neighborhood's stray cats. I play and talk with them. I will stay around and observe the cats and also take photos of them for painting reference. I also create my work based on my past experience of fostering two sweet female cats, BanBan and GuaiGuai, as I gained lots of wonderful memories with the two of them. Most of the time, I get inspired by friends' stories about their cats, newspaper stories, cat books, movie and TV shows and interesting Internet cats stories. In addition, daily issues in life also give me great ideas for making paintings.

What might people be surprised to know about you (or your work)?

I think people might be surprised that cats in my paintings are not just cats; they can do anything just like human beings. For example, cats can cosplay as superheroes, be a Samurai warrior or drink Kopi (local coffee in Singapore). They can take photos wearing fashionable clothing. In addition, there are no identical-looking cats in my paintings, as I paint every cat based on his/her unique look and character. I love cat eyes and I like to paint their beautiful eyes bigger than usual in my paintings.

TOP LEFT
A Birthday Wish
Acrylic on canvas. 2018.

TOP RIGHT
Elizabeth
Acrylic on canvas. 2018.

BOTTOM LEFT
Iced Latte
Acrylic on canvas. 2017.

BOTTOM RIGHT
Enjoying
Acrylic on canvas. 2017.

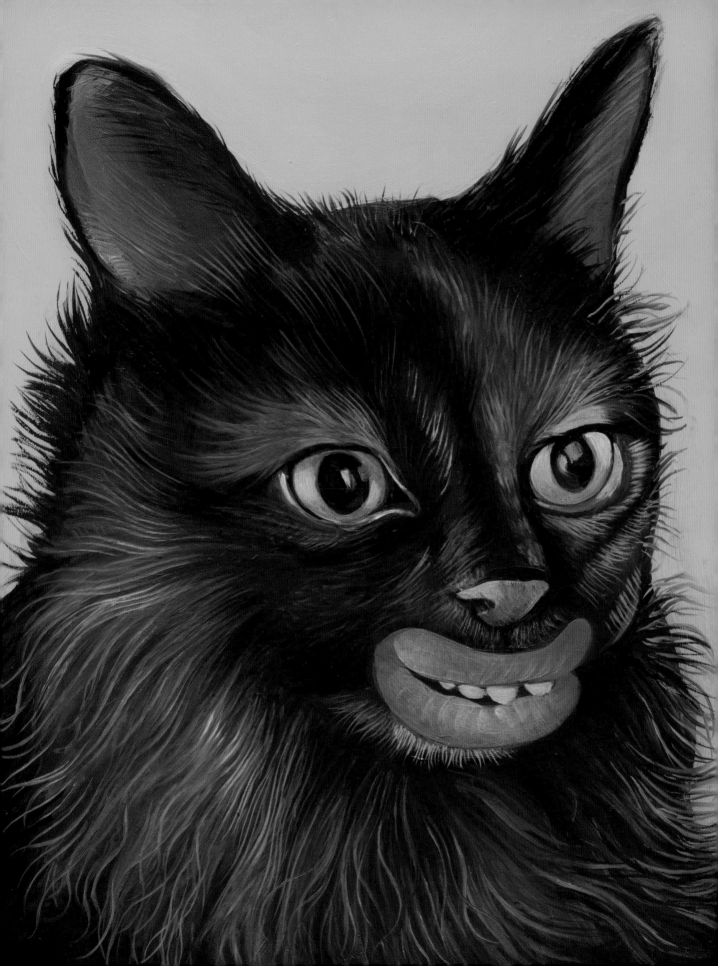

GREGORY JACOBSEN

About his work, Gregory Jacobsen states, "I paint figures, focusing on the little bits that obsess me... flab hanging over a waistband, ill-fitting shoes, overbites, noses, teeth, and flesh. Either through portraiture or busy tableaux, I create a world and vocabulary of characters that live and embrace their so-called faults. The work is absurd, grotesque, and a bit brutal, but I try to bring the viewer in with lush and glowing surfaces, creating a disorientating and hilarious balance of revulsion and attraction." Jacobsen applies this same sense and non-sensibility to the series of paintings he calls *Glamor Cats*. You can find more of his work through Zg Gallery in Chicago or at:

www.gregoryjacobsen.com

When and why did you start incorporating cats into your work and what do you feel they bring to it?

I started incorporating cats into my larger tableaux paintings a while ago. They grounded the fantastical subject matter. Whatever is happening within the painting, they don't care. They are also much like my paintings, but in reverse—they are cute, but mischievous, and if they want to, they will claw your eyes out.

Is there any work of art featuring cats that has inspired you? Where did you encounter it, and how did it make you feel?

I like the cats that Picasso painted. They're usually killing birds and showing off their buttholes, normal cat activities. Botero's cats are hilarious in their bored overfed plumpness. I always liked the weird observing cats in medieval painting. They're always the stars of the paintings for me.

What process do you go through to create your work? What inspires you?

I have been painting 6 x 6" portraits of people's cats sent in to me from Instagram. I try to hone in on a subtle expression the cat might have in the photo: goofy, sultry, angry, etc., while still keeping the painting faithfully representational. Sometimes things get out of hand, and the cat becomes very fantastical. Attempting to capture this subtle emotion has carried over into my other portrait work in a positive way.

What might people be surprised to know about you (or your work)?

Usually the most simple-looking painting has taken the longest to complete.

LEFT PAGE

Yucky
Oil on panel, 6 x 6". 2018.
© Gregory Jacobsen,
image courtesy of Zg Gallery.

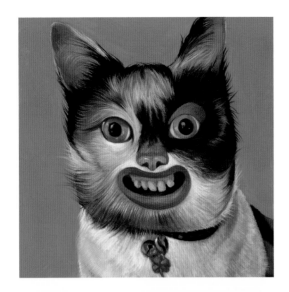

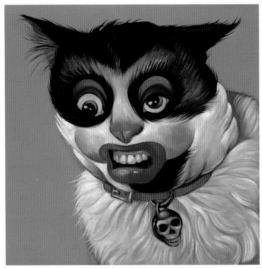

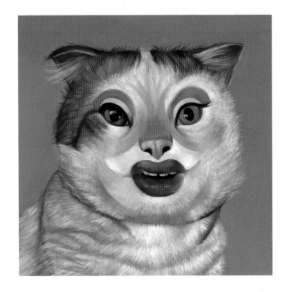

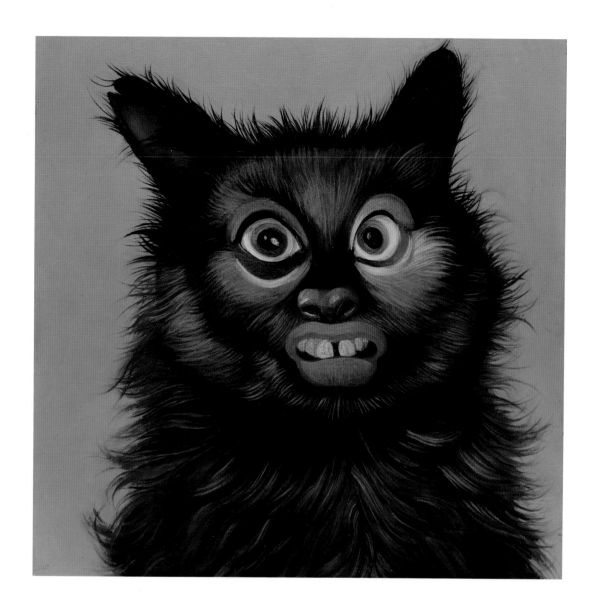

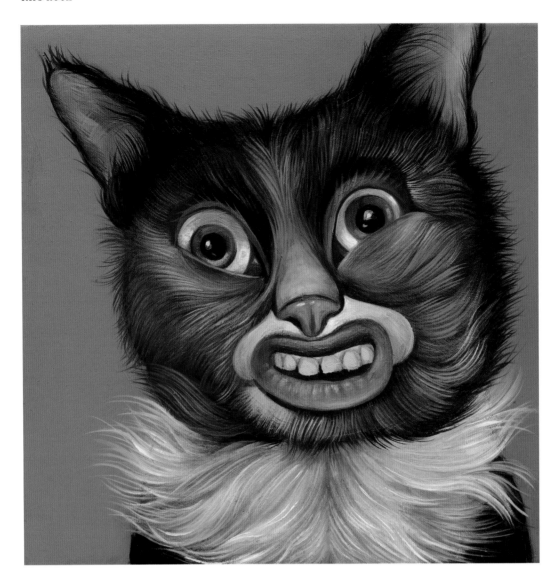

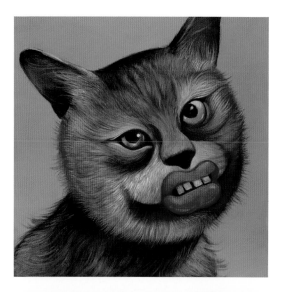

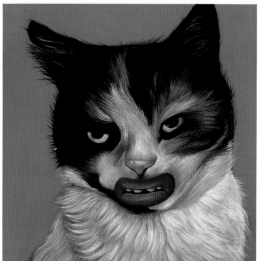

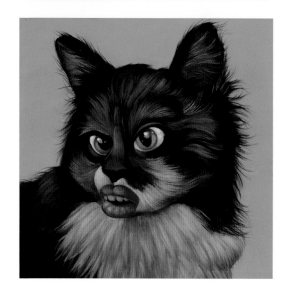

MARION PECK

Marion Peck was born on October 3, 1963 in Manila, the Philippines, while her family was on a trip around the world, and grew up in Seattle, Washington. She received a B.F.A. from The Rhode Island School of Design in 1985. Subsequently she studied in two different M.F.A. programs, Syracuse University in New York and Temple University in Rome. She currently lives in Los Angeles, California.

www.marionpeck.com

When and why did you start incorporating cats into your work and what do you feel they bring to it?
The first time I painted cats was in 2003, the three-eyed kittens in a basket. Those kittens came to me in a dream. Cats are always slightly magical, as well as being very cute, which is why I suppose I like to paint them.

Is there any work of art featuring cats that has inspired you? Where did you encounter it, and how did it make you feel?
I remember a very long time ago, it must have been the 80s, seeing a woman wearing a soft-looking Angora sweater, painting cats on a "how to" show on television, like Bob Ross but for cats. She had a kind of little girl voice. She was very into making her cats look soft, which she managed to do quite successfully. She was especially excited about putting the highlights in their eyes, exclaiming ecstatically about how it brought them to life. I have no idea what her name was, but I really enjoyed watching her paint, and I often think of her.

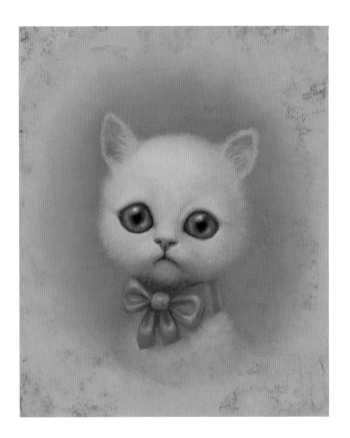

ABOVE
Snowball 1927–1939
Oil on panel,
15 3/4 x 13 3/4". 2006.

RIGHT PAGE
Pussy
Oil on canvas,
11 x 9". 2005.

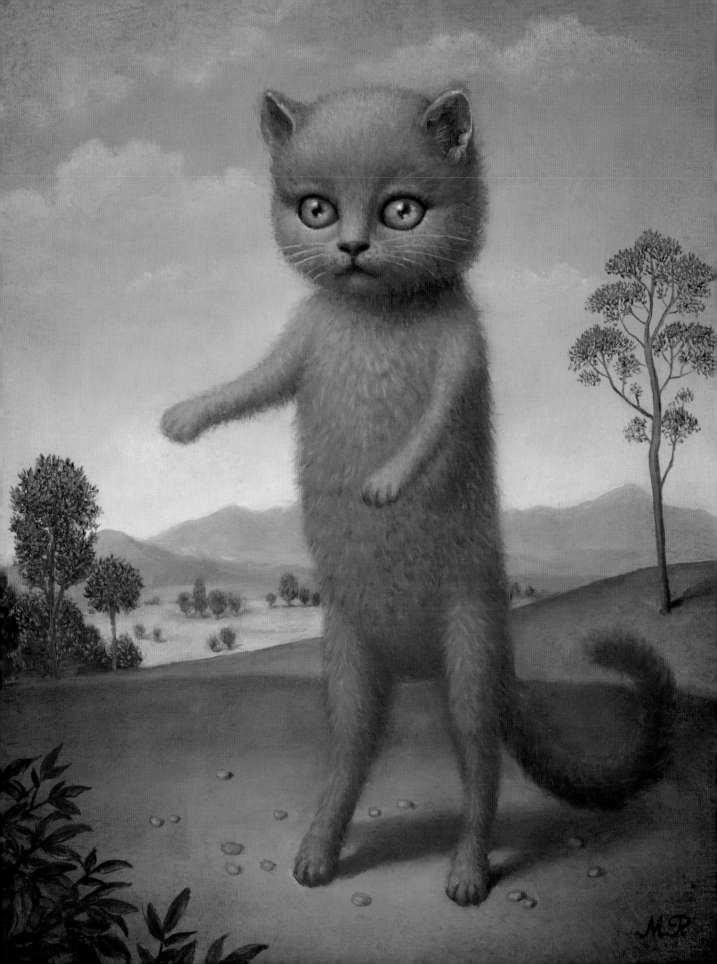

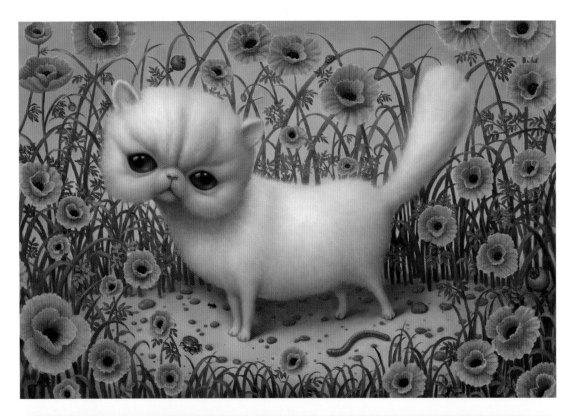

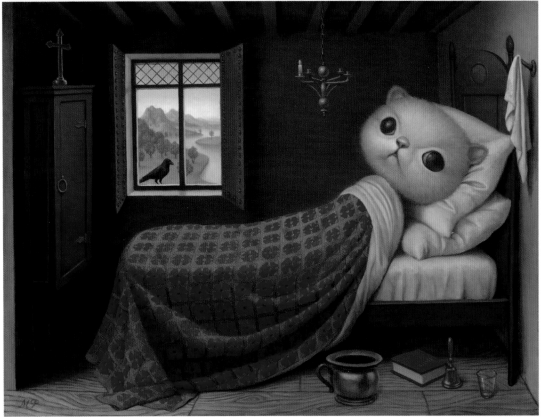

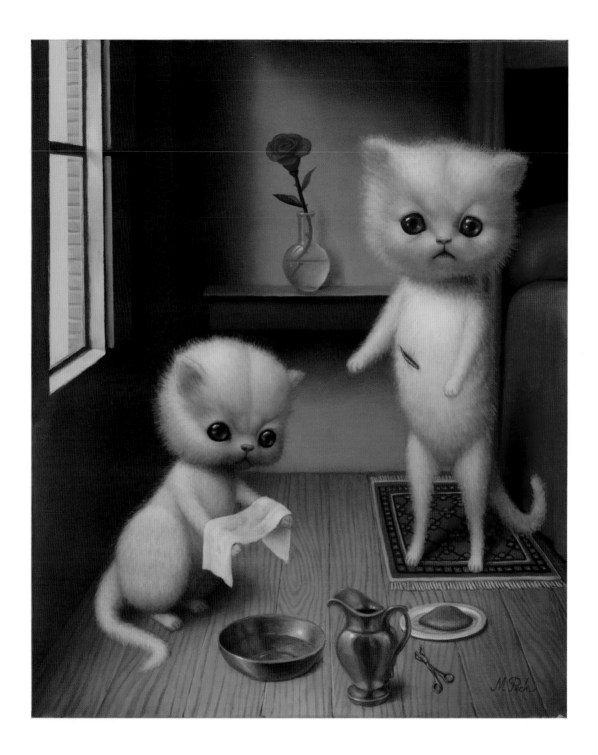

LEFT PAGE, TOP

Big White Pussy
Oil on canvas,
34 x 46". 2012.

LEFT PAGE, BOTTOM

Sick Kitten
Oil on canvas,
24 x 32". 2013.

THIS PAGE

Kitty's Sacrifice
Oil on canvas,
26 x 16". 2014.

213

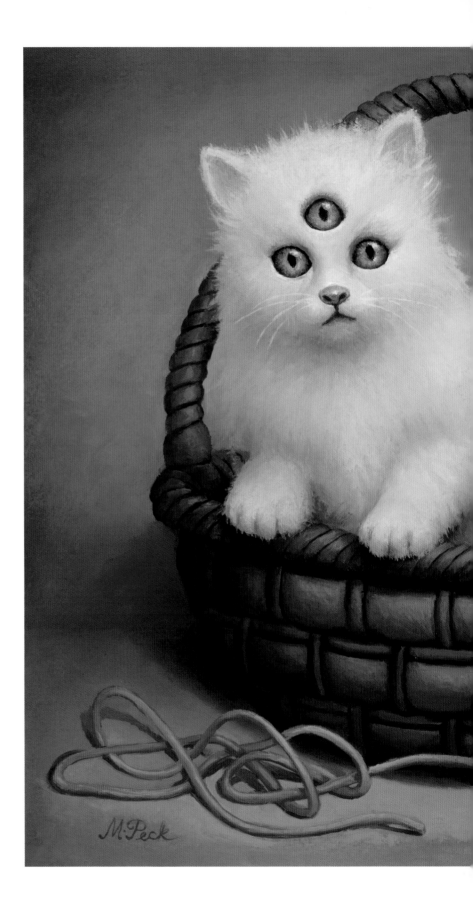

M. Peck

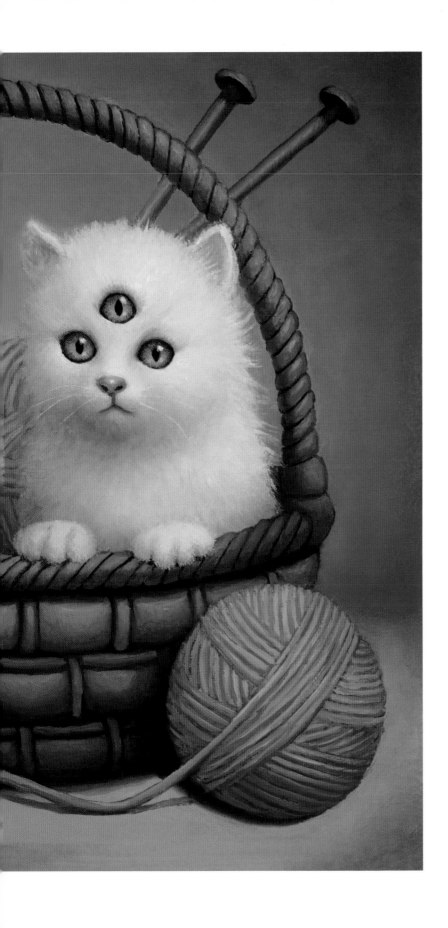

MICHAEL CAINES

Michael Caines' most recent exhibitions include *Cat Art Show Los Angeles, Mammalia* at Galerie Youn in Montreal, and *Volta NYC* with Katharine Mulherin, where he had a solo art fair booth featured in *The New York Times*. Past residencies include Millay Colony, SFAI, I-Park, The Bemis Center, The Banff Centre, Jentel and Gibraltar Point. Caines has been awarded fellowships from the Avery and Chalmers foundations, and grants from the Canada Council, The Ontario Arts Council,

and the Toronto Arts Council. His book, *Revelations & Dog*, a graphic version of the Book of Revelations, was released in March 2010 by Mark Batty Publisher in New York. A ten-year survey of Caines' animal- and human-themed work, *Wild/Tame*, was exhibited at the Art Gallery of Peterborough in Canada in 2011. Caines was born in Halifax, Nova Scotia in Canada and has made New York City home for the past twelve years.

www.michael-caines.com

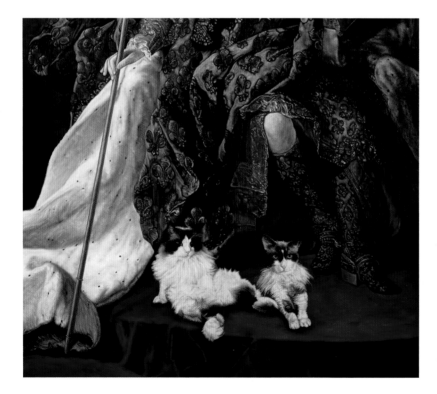

THIS PAGE
Louis XIV
Oil on canvas,
48 x 42". 2018.

RIGHT PAGE
Black Jack
Oil on canvas,
18 x 24". 2016.

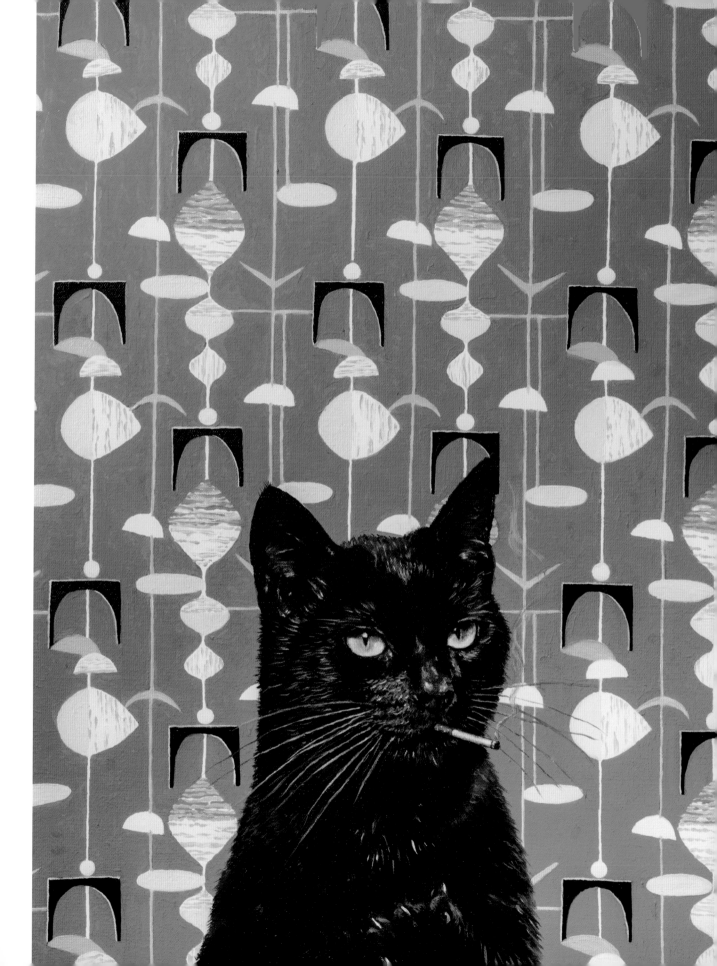

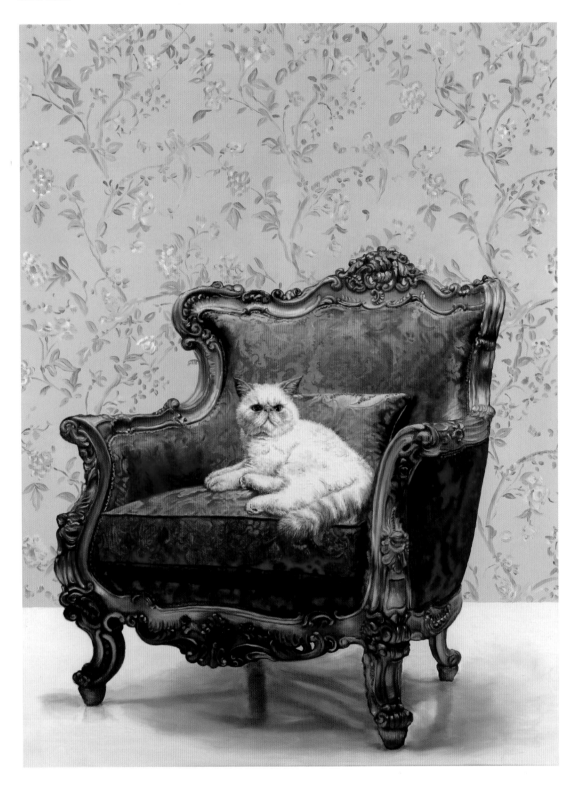

THIS PAGE

Gus
Oil on canvas,
40 × 30". 2016.

RIGHT PAGE

Smoking Cat
Oil on canvas,
24 x 30". 2015.

NEXT SPREAD, LEFT

Black Cat
Oil on canvas,
16 x 20". 2015.

NEXT SPREAD, RIGHT

Black Cat
Oil on canvas,
16 x 20". 2014.

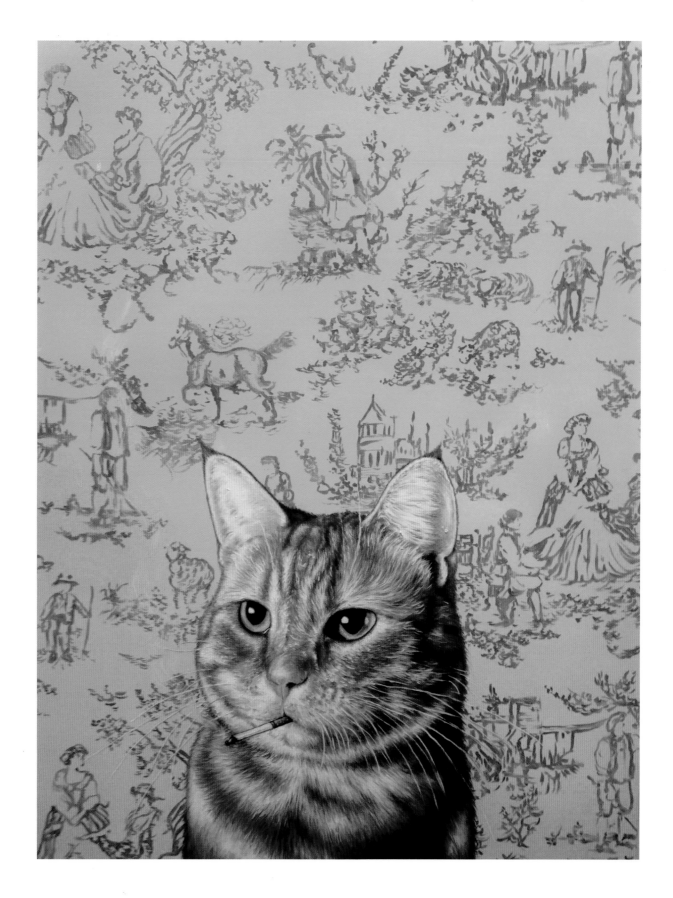

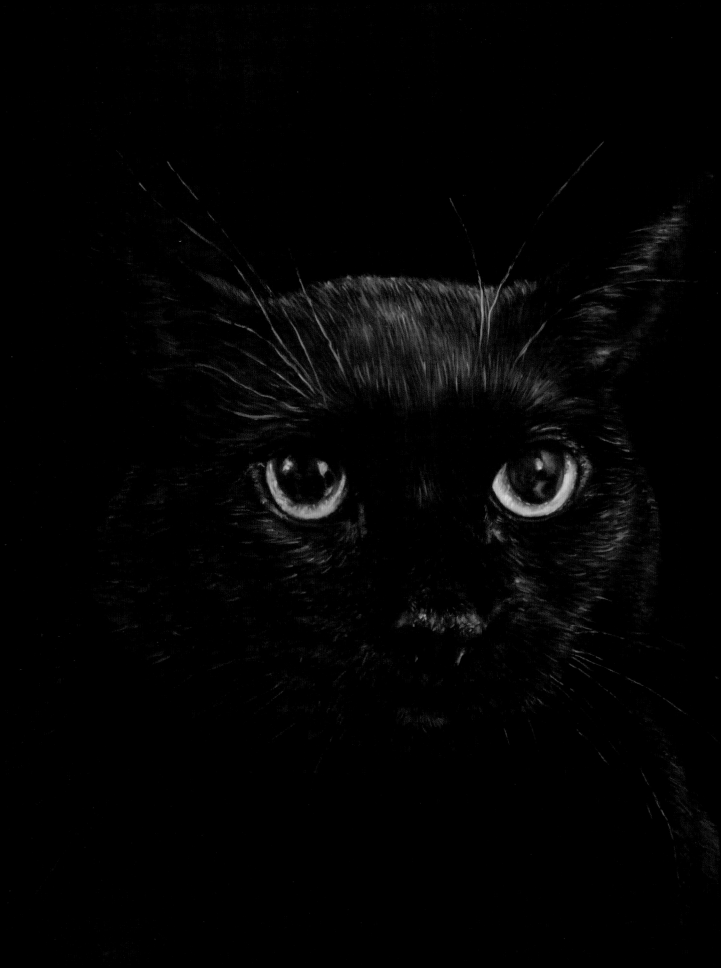

How is depicting cats different from depicting other animals?

I have been painting various animals these past few years, but cats seemed an obvious choice for self-possessed portraits while smoking. I never really smoked, but I miss seeing smoking in television and movies. It just looks good. Interestingly, when I proposed one of my smoking cats for a cat-themed exhibition, the curator was initially a little nervous that people would be offended. Cat smoking: bad example! I think I would be proud if one of my paintings inspired a child to smoke. That would be an interesting kid, though obviously I'd slap the cigarette out of his little, stupid hand.

What inspired your series containing the George Jr. cat drawing and why did you choose to use cat images for the series?

I started out thinking I would put the eyes of every US political figure I could think of in the face of a cat, but I petered out at around six, thus demonstrating my commitment to that particular political gesture. The idea reflected both hopelessness and humor. It was an absurd "political" act, intended to deflate the power of those figures while turning them into something furry and a little creepy. Cats are basically selfish assholes, and their acts of affection are aimed at manipulating their humans, so they are just about right as avatars for grubby politicians. They can go from purring and rubbing up against you (the cats that is), to biting you in a second. Who better to represent an ex-president or a predatory Supreme Court judge?

What was the first cat image you created and why?

I did a series of black on black paintings a few years ago; portraits of black animals against black backgrounds inspired by 18th-century Dutch portraiture, with a slight nod to late modernist all-black abstract painting. Pointless satire is really my deepest reflex. Black cats were an obvious choice for that series. I found some images of wide-eyed, startled/angry cats that felt perfect and strange. Such cat-ish facial expressions, but ones that would nevertheless never be chosen for a portrait. Therefore, perfecto!

Why is cat art so popular right now, in your opinion? What is it about cats?

Cat people are lovely, weird and solitary creatures. They spend lots of time alone, so throw together a cat-themed event and they'll come out in droves to not talk to each other. They do seem to have aesthetic sensibilities though, and appreciate art. Dog people are more friendly—actually more my kind of people, but a little dumber and less fancy and less likely to buy art. Cat people need beautiful things around them in their lonely, gorgeous apartments. Dog people will make do with a Pink Floyd poster and some cracked china.

PRINCESS CHEETO

Hugo Martinez is a New York-based
photographer, originally from Nogales,
Arizona. He is best known for his surreal
photographs that center around his cat,
Princess Cheeto. He infuses elements
of pop culture into his work while
anthropomorphizing and exploring ideas
of the feline as modern-day muse. His work
has been featured in numerous commercial
campaigns, fashion editorials, museums and
public installations around the globe.

Instagram: @princesscheeto

ABOVE

**Sorry, I cannot hear you,
I'm kinda busy**
Digital photographic print.
2018.

RIGHT PAGE

Cheeto Catlo
Digital photographic print.
2018.

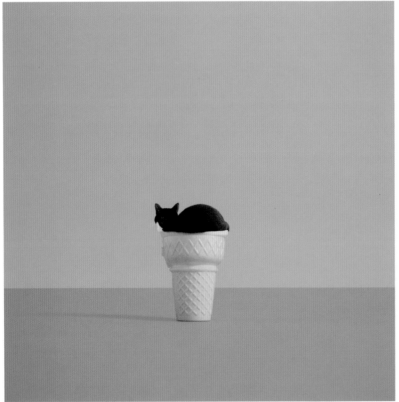

How did you come to make work with your cat Princess Cheeto?

I started shooting Cheeto around 2012 and it all happened pretty organically. I didn't set out with a planned goal of posting these images online, I just sort of did it because it made me and and my friends happy. I guess Marie Kondo would say these images "sparked joy" for me!

How do you get her to pose for you with such expressive eyes?

Cheeto and I have a very special relationship. To me she is so much more than a pet, she's my best friend. So much like in every friendship, sometimes you have fun, sometimes you are grumpy and sometimes you just want to loaf around. Its the same with Cheeto. Her personality is literally what you see depicted in each photo. Sometimes I have an idea and I'll set the stage for something and then Cheeto comes on set and does whatever she wants to do and it changes the entire direction of the image. I don't train her to do anything, she just walks on and all she does is be herself, and herself just happens to be a super amazing feline!

Why is the Internet obsessed with cats in your opinion?

In my opinion, the Internet is obsessed with cats because humans are obsessed with cats. If you look back to even the most ancient cultures, cats were always around, worshiped even. There's something mysterious about them that draws out our curiosity.

I think we just long to understand cats. But I'm not sure we ever will, at least not 100%. And to be honest, I think cats like it that way!

How has Princess Cheeto changed your life?

Cheeto has changed my life entirely. She's my constant source of inspiration. Living in today's world can sometimes get really overwhelming. Just turn on the news at any point in the day and see how long it takes for the anxiety to hit. For me, Cheeto isn't just an escape from all that, she's a reminder that not everything in life is terrible or scary. That life can be silly and colorful and playful and weird and she's helped me bring that into every aspect of my life and for that I am forever grateful to Cheeto.

It seems you have done so much with Princess Cheeto, how do you come up with new ideas? What inspires you?

Like I've always said, Cheeto is my muse in every sense of the word. But other than her being my main source of inspiration, I really just pull from anywhere and anything. I pull from pop culture a lot, so if something exciting or new is happening in society or in music or art, it can end up in my work either as a direct reference or sometimes just a subtle head nod. I like it when when an image at face value says one thing but takes on a whole different meaning when placed in the context of the culture at large. Like meme culture- I find that super interesting. It's such a modern idea that has literally changed the way we think.

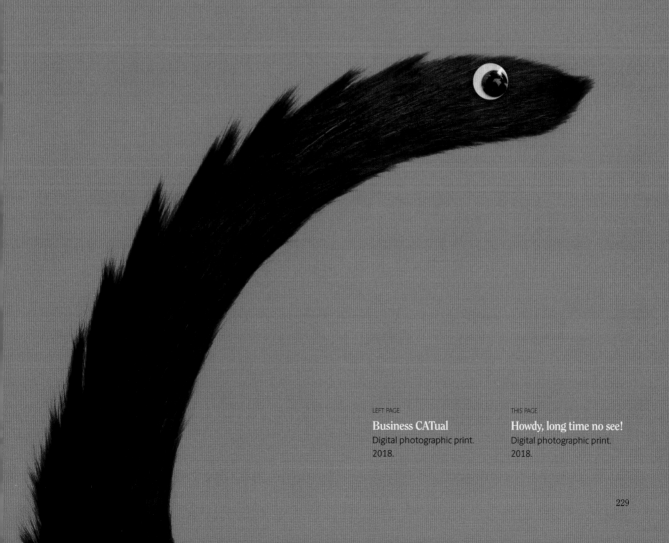

LEFT PAGE

Business CATual
Digital photographic print.
2018.

THIS PAGE

Howdy, long time no see!
Digital photographic print.
2018.

SANAE INA

Sanae Ina is a paper cutting artist who lives
in Kanagawa, Japan. Her original and printed
works are available at local galleries and cafes.
Ina enjoys creating small stories using cats that
take on human qualities and emotions. She is
prolific and makes new paper cut work daily,
uploading it to Facebook and Instagram. She
hopes you will find her work online and meet
her cat characters and enjoy their stories.

Instagram: @kirienojikan

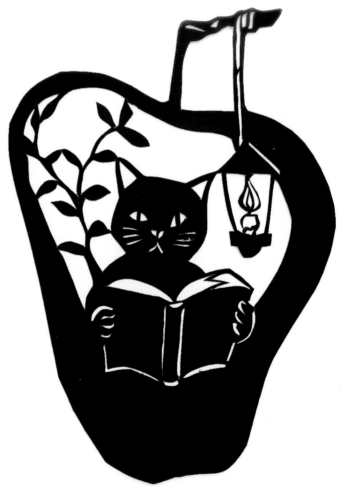

THIS PAGE

Silence
Paper cut art. 2017.

RIGHT PAGE

Midnight
Paper cut art. 2018.

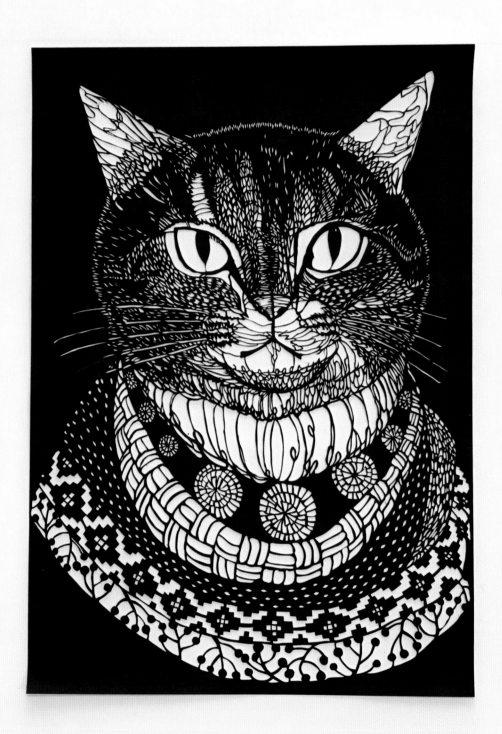

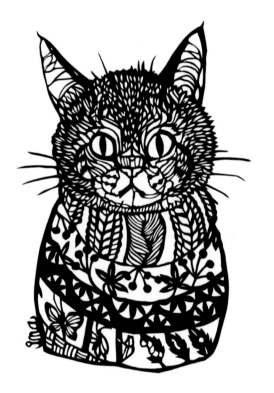

When and why did you start incorporating cats into your work and what do you feel they bring to it?
I started paper cutting images of cats in 2016. I enjoy seeing the cat's adventures in my work.

Is there any work of art featuring cats that has inspired you? Where did you encounter it, and how did it make you feel?
I love to see cats in art, but I am not influenced by other specific artists or particular works. However, I love picture books for children, so I can say that I am influenced by art in countless picture books.

How did you learn to do paper cutting and is it very difficult?
I learned paper cutting in my own way. I don't think it's difficult.

What might people be surprised to know about you (or your work)?
When I produce a work, I am not conscious of the gaze or evaluation of others. But I am very happy if my work makes someone feel sympathy or makes someone smile.

THIS PAGE
Ready to Go
Paper cut art. 2018.

RIGHT PAGE
I don't know
Paper cut art. 2018.

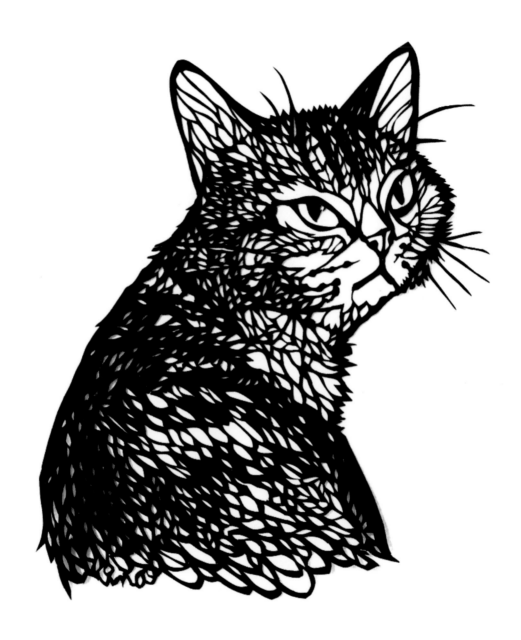

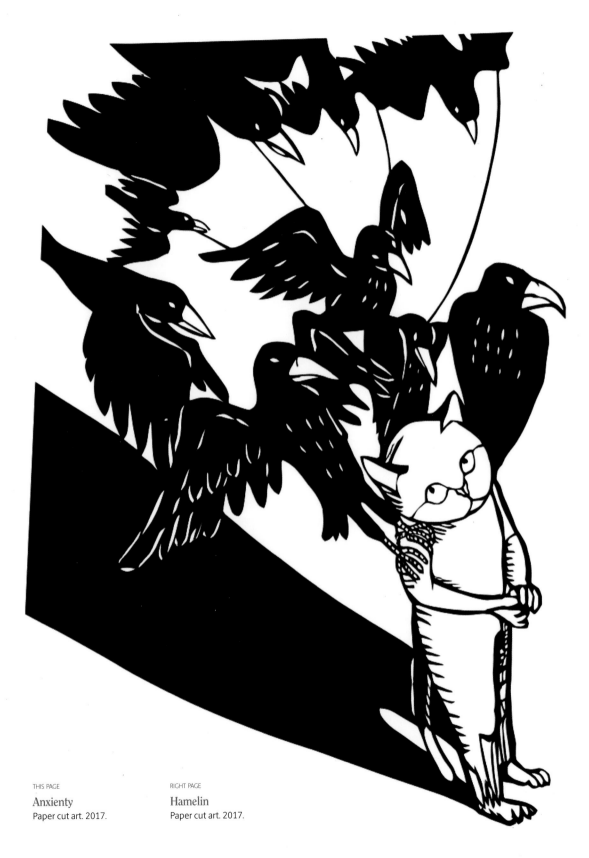

THIS PAGE

Anxienty
Paper cut art. 2017.

RIGHT PAGE

Hamelin
Paper cut art. 2017.

234

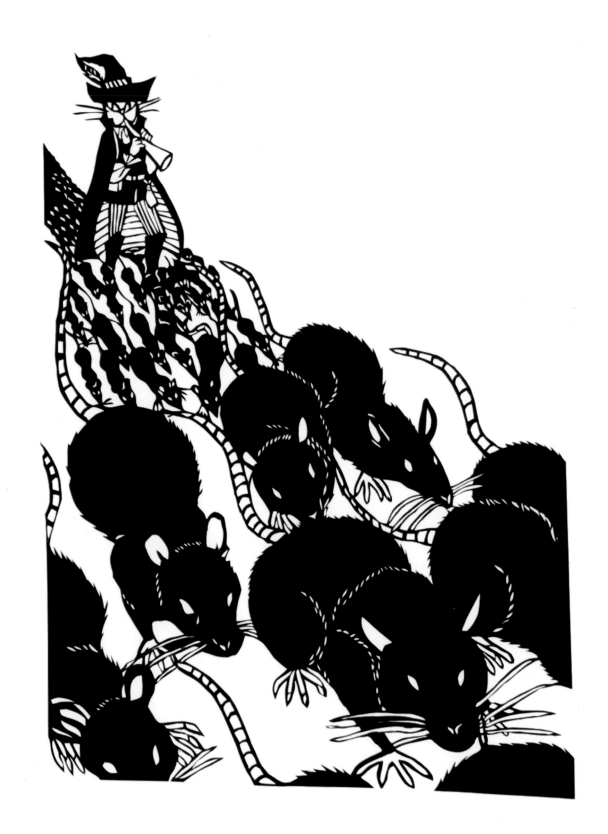

YUKO HIGUCHI

Yuko Higuchi is a professional painter who lives in Tokyo. She has collaborated with various companies such as Gucci. She has been participating in exhibitions around Tokyo since 1999 and has recently published several books, including *Yuko Higuchi Artworks, Two cats, Yuko Higuchi Postcard Book, Museum, BABEL Yuko Higuchi Artworks* and others. Now she has her own shop, Boris Zakkaten, in Tokyo.

www.higuchiyuko.com
Instagram: @yukohiguchi3
Twitter: @nekonoboris

What inspires you?
Familiar things, natural objects.

How did cats come to be in your work?
I have a cat, and I usually spend time at house.

Why did you decide to depict cats with so many different emotions?
Because my cat is very emotional.

Since you are an artist who creates images of many different animals, do you think different animals have different qualities?
Yes, they do. Not only cats are special.

Do you have any pet cats yourself? If so, can you tell us about them?
Yes, I have a cat named Boris. He is very violent and jealous.

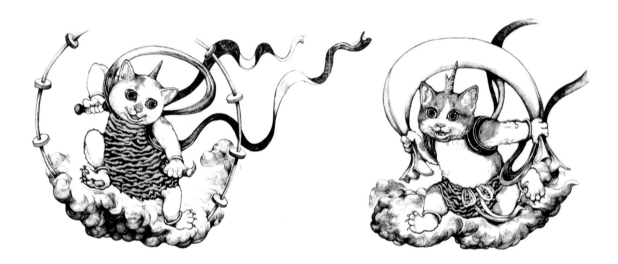

THIS PAGE

Fujin Raijin (Wind-God and Thunder-God)
Watercolor and pen on Japanese washi paper. 2015.

RIGHT PAGE

Jakuchu-Ito's Cock vs Yuko Higuchi's Gustave-Kun
Watercolor and pen on Japanese washi paper. 2016.

THIS SPREAD

Koharu Snail
Watercolor and pen on
Japanese washi paper. 2014.

NEXT SPREAD, LEFT

Pierrot
Watercolor and pen on
Japanese washi paper. 2018.

NEXT SPREAD, RIGHT

Strange Plants
Watercolor and pen on
Japanese washi paper. 2016.

strange plant

CAT COMMUNICATION

Her conscious tail her joy declared;
The fair round face, the snowy beard,
The velvet of her paws,
Her coat, that with the tortoise vies,
Her ears of jet, and emerald eyes,
She saw; and purred applause.

"*ODE ON THE DEATH OF A FAVORITE CAT, DROWNED IN A TUB OF GOLD FISHES,*" THOMAS GRAY, 1747.

For as long as cats have existed, they have served as symbols. Cat hieroglyphs persisted across ancient cultures, and symbols remain within modern pictorial languages. In the past, artists used cats in their work to symbolize femininity, evil or even good luck. Even the double entendre of the word "pussy" is rife for use by artists. Pop artist Andy Warhol's book, *25 Cats Name Sam and One Blue Pussy*, (1954) functioned as both a cheerful colorful study of cats and a tongue-in-cheek dirty joke. Words for "cat" have a similar double entendre in many languages. Rarely is a cat just a cat. This makes the image of a cat perfect for communication.

In 18th-century Japan, the popularity of the Maneki-neko, a beckoning good luck cat, took hold. The small cat statue is often white or gold and can today be found bringing luck to Chinese and Japanese restaurants alike. She is thought to have inspired the 1974 Sanrio character Kitty White or Hello Kitty, a pioneering cat communicator created by Yuko Shimizu. Hello Kitty waves. She doesn't have a mouth or need words to communicate, and hence, her iconic image is as easily translatable as it is comfortably vague. People of all nationalities and ages are free to project their own emotions onto Hello Kitty, and in her wordless state, she "speaks" for everyone, communicating exactly what they want her to.

Since the days of witchy woodcuts, cats have been iconic. In more modern times, they have appeared as renowned communicative anthropomorphized cartoon characters such as Felix the cat (1919), Sylvester (1939) and even Garfield (1978). More recently, with the advent of the Internet, cat images have acted as stand-ins for myriad human emotions. Nearly every emotion in GIF format has a corresponding cat-based image. The emoji keyboard, which comes with many cellular phones, highlights cats as the only animal to be given their own expression-based emoji. From Grumpy Cat to the meme cats of *I Can Has Cheezburger?* to Pusheen, the popularity of cats as totemic characters shows that we are often more comfortable expressing our feelings through anthropomorphized cats than in any other way. The cats in this section are extremely expressive and often larger than life. These cats interrupt scenes and environments and generally make their presence known.

CLAIRE BELTON

Pusheen™
THE CAT

Pusheen is a sweet, curious, lazy and plump tabby cat that loves to have adventures. Her hobbies include blogging, snacking, taking naps and being a unicorn, mermaid, dinosaur, various wild animals and even a trio of pastel aliens on occasion.

She is represented by Pusheen Corp., an Illinois-based company dedicated to bringing smiles to the faces of fans around the world. Founded in 2010, Pusheen Corp. develops Pusheen content and products, working with more than 100 licensees globally. Pusheen made her first appearance online in a short series of comics by creator/founder Claire Belton written together with co-founder Andrew Duff in 2010. That project, Everyday Cute, spun off into the original Pusheen.com Tumblr blog. The comics and GIFs posted to Tumblr quickly became a viral sensation, with images of Pusheen being shared across the Internet hundreds of thousands of times every week.

In 2013, a comic compilation *I am Pusheen the Cat* was published by Simon & Schuster and was translated into more than 12 languages. That same year, Facebook's "chat sticker" feature launched and Pusheen images became licensed emoji-style graphics, available to over one billion users, launching the cute kitty into super stardom overnight. It is estimated that Pusheen images and GIFs have been sent between friends more than 20 billion times across popular social media platforms since her creation.

Today, the Pusheen brand is a global phenomenon with a growing cast of characters, tens of millions of fans worldwide, and licensed merchandise available in more than 60 countries.

Instagram: @pusheen

THIS PAGE
Winking Pusheen with Sparkles
Digital media, 5 x 5".

RIGHT PAGE
6 Reasons to Be Thankful for Your Cat
Digital media, 10 x 10".

6 Reasons to be thankful for your cat

warms your heart

warms your seat

cuddle buddy

alarm clock buddy

beautiful friend

beautiful paper weight

ABOVE LEFT

Pusheen Character Purse
Faux leather, mixed media,
8.5 x 6.5 x 4".

ABOVE RIGHT

Pusheen Squishy
Mixed media,
dimensions vary.

RIGHT

Dinosheen Blind Box
Textile, mixed media,
dimensions vary.

LEFT PAGE

Purrmaid Tea Party
Digital media, 10 x 10".

Have you noticed a change in the portrayal of cats in art since you started creating Pusheen? What have you noticed and why do you think it is?

Over time I've noticed a trend away from more traditional "just cute" cat art and toward more work focusing specifically on the humor and unique weirdness of cats. If I had to attribute it to anything, it would probably be meme culture in general. After all, if something makes you laugh, you're more likely to share it (or have someone share it with you).

Why do people love Pusheen so much in your opinion?

When you look at Pusheen's humor, sometimes you'll see your cat in her and sometimes you'll see yourself. I think people really connect with her because she's so relatable. Also, she is round and has a small face. What's not to love?

Does Pusheen make it easier for people to communicate through stickers? If so why do you think that is? What role does Pusheen play in this visual communication culture?

From what I've seen, people are really creative (and very funny) with how they use Pusheen stickers. The designs themselves are very simple, so they're often open to some level of interpretation. You can use the same Pusheen sticker to express a variety of emotions depending on the context of your conversation. They also make it easier for people to express things

that might be difficult to say with words (such as affection or annoyance) in a humorous, less vulnerable way.

What is your favorite Pusheen and why?

My favorite Pusheen is probably this one:

So small, so sassy.

THIS PAGE

Pusheen Line Sticker
Digital media, 1/2 x 1/2".

RIGHT PAGE

Pusheen Tied on Balloons
Digital media, 10 x 10".

248

CHRISTINE SHAN SHAN HOU

Christine Shan Shan Hou is a poet and artist based in Brooklyn, New York.

www.christinehou.com

LEFT
The Wisest
Collage on paper,
6.75 x 10". 2012.

RIGHT
Cat and Nuns
Collage on paper,
6.75 x 10". 019.

RIGHT PAGE
Around the Fire
Collage on paper,
6.75 x 10". 2012.

LEFT PAGE

Guardians
Collage on paper,
6.75 x 10". 2013.

THIS PAGE

Parade Cat
Collage on paper,
6.75 x 10". 2012.

When and why did you start incorporating cats into your work and what do you feel they bring to it?
I made my first cat collage about seven years ago. And I basically started incorporating them into my collages because they made me smile and filled me with joy. I write poetry, which can feel really heavy at times. I started collaging as way of introducing fun or lightness into my art-making practice, and then introduced cats in them to make it more fun and a little silly.

Is there any work of art featuring cats that has inspired you? Where did you encounter it, and how did it make you feel?
The only cat art that comes to mind at this moment is in 2007 at Bard College, where I received my undergraduate degree. For her senior project, the artist Eva Lewitt made a room-sized installation of gigantic, stuffed, abstract cat figures, called *Nine Cats*. I remember being in awe of its colorful immensity and sense of liveliness.

What do you make of the popularity of cats in our culture overall?
I think it's wonderful and brings a little bit of lightness during heavier times.

THIS PAGE
Holy Cats
Collage on paper,
6.75 x 10". 2012.

RIGHT PAGE
Train Cat
Collage on paper,
6.75 x 10". 2012.

DECUE WU

Diyou Wu a.k.a. Decue Wu was born in
Shenzhen, China. She earned an Illustration
Practice M.F.A. degree from the Maryland
Institute College of Art. Wu has more than eight
years of experience as a freelance illustrator.
Her work focuses on fashion and lifestyle
illustration, editorial illustration, info-graphics,
advertising and other graphic arts. Her work
has been featured by several brands and
publications including Louis Vuitton, Armani
Exchange, Airbnb, *The New York Times*, *Time*
magazine, *Vogue* and many more. She lives in
California with her cat, Sashimi, who is often
the focus of her creative work, which has
shown at exhibitions around the world.

www.decuewu.com
Instagram: @decue_wu

ABOVE

Cat Art
Digital painting,
2.78 x 3.6". 2017.

RIGHT PAGE

Cat Vase
Digital painting,
8.5 x 11". 2018.

THIS PAGE
Cat Plants
Digital painting,
10 x 10". 2018.

RIGHT PAGE
Cat Illustrator
Digital painting,
14 x 18". 2016.

When and why did you start incorporating cats into your work and what do you feel they bring to it?
I started to include cats in my artwork when I adopted my first cat, Sashimi. Sashimi is my muse. She brings my work joy, fun, cuteness and a stronger connection to my personal life.

Is there any work of art featuring cats that has inspired you? Where did you encounter it, and how did it make you feel?
I saw a book called *Cats Cats Cats* by Andy Warhol. I liked the way he drew cats super whimsically and very vividly, in many different poses. I really enjoyed it. Cats are the most mysterious and adorable figures. I can stare at my cat all day.

What process do you go through to create your work? What inspires you?
I usually collect photos of my cat, images of her weird poses and cute moments. I have an illustration called *Cat Mountain*, because when Sashimi likes to sit on the record player and stare outside at birds, the shape of her back really looks like a mountain.

What might people be surprised to know about you (or your work)?
When I am working on my freelance or commercial projects, I like to secretly add a cat. That makes me feel like the work is more personal and connected to my heart.

What question do you wish I had asked you?
What Sashimi's personality like?

What is your answer to that question?
Sashimi is very curious about everything, very independent, she likes her privacy and a little bit of space from the humans. She is smart, energetic, super playful, cute, and irresistible.

Cat Mountain
Digital painting,
10 x 7". 2018.

CHRISTIAN GUÉMY

Christian Guémy, also known as C215 is a
Parisian street artist focused on stencil graffiti.
Born in 1973, C215 started spray painting in
2005 and is today one of the finest and most
productive stencil artists on the street art scene.
According to artist Shepard Fairey,
"C215's art captures a light, depth and
humanity that is difficult and rare, using
stencils, his chosen medium. Stencils tend
to flatten images and make them static, but
C215 has developed a style of illustrating
and stenciling that yields an impressionistic
illumination of his subject's character. Even
though his technique is meticulously refined,
C215's work transcends the formal and seems
to get to the core of compassion and belief in
the human spirit. Encountering C215's pieces
on the street always makes me happy."

SHEPARD FAIREY / OBEY GIANT

www.c215.fr/C215/HOME.html
Instagram: @christianguemy

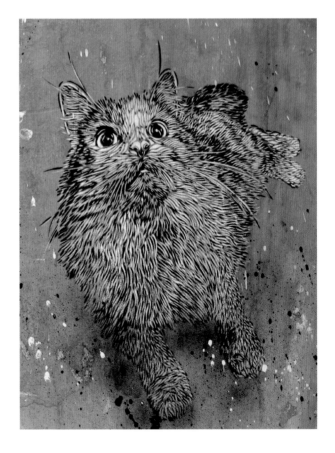

THIS PAGE
Fès
2009.

RIGHT PAGE
Paris
2012.

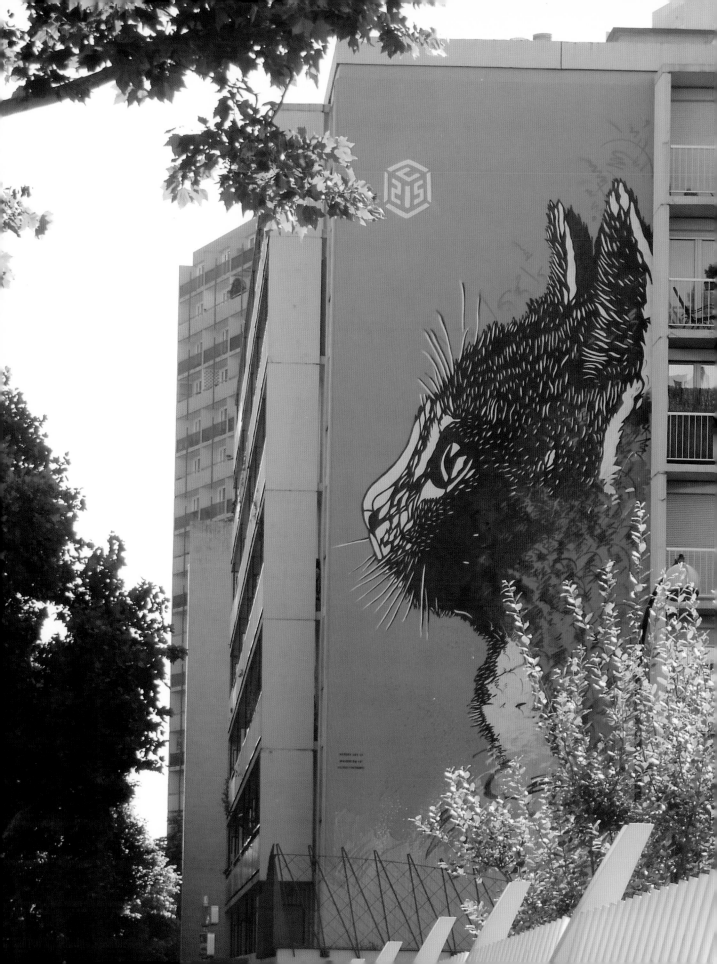

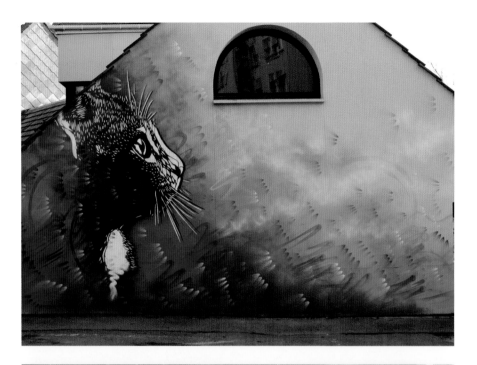

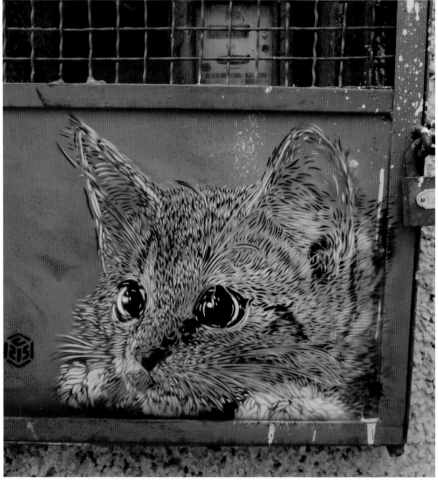

STEPH MARCUS

Steph Marcus grew up with her two brothers in Natick, Massachusetts. She studied history in college and fled to Venice, Italy to learn printmaking. She attended grad school at Lesley University while teaching elementary school art in Boston. Steph currently lives in Cooperstown, NY with her cute husband Jon and baby son Theodore.

www.stephmarcus.com

THIS PAGE
The Morning
Watercolor, ink, graphite and marker on paper, 22 x 30". 2014.

RIGHT PAGE
Working
Walnut oils on wood, 8 x 10". 2018.

NEXT SPREAD
Kitty Raccoon
Monoprint on paper, 15 x 22". 2017.

LEFT PAGE, TOP

Kitty TV B
Mixed media -gouache, acrylic,
ink, gesso, colored pencil- on
paper, 20 x 24". 2018.

LEFT PAGE, BOTTOM

Kitty TV C
Mixed media -gouache, acrylic,
ink, gesso, colored pencil- on
paper, 20 x 24". 2018.

THIS PAGE

Kitty TV A
Ink, marker, acrylic, colored
pencil, and gouache on
gessoed paper, 30 x 42". 2018.

When and why did you start incorporating cats into your work and what do you feel they bring to it?

I've been drawing all kinds of animals since I was little, and we always had a cat to squeeze at home. But in all these pictures, the subject is somebody special: Kitty T. Tuxedo Cat. She was in my life for 18 years, and in my work she has become an alter ego, a comely lady, a knight/princess/dragon, a mountain, a mighty steed, a Tibetan snow lion and a ceramic trinket. I draw her because she's beautiful and ridiculous and always around, and observational drawing calms down my anxious brain and helps me appreciate the world. She's starred in a thousand adventures. We actually had to say goodbye to Kitty this February and it felt like losing an arm and a huge chunk of heart.

Is there any work of art featuring cats that has inspired you? Where did you encounter it, and how did it make you feel?

My mom had some Steinlen prints hanging in the house and a French drawing in red pencil of a windswept girl by a window petting a cat. I must have stared at those a lot. What I like best now are wonkier renditions of kitties, where they've got slightly crazed expressions, like Rousseau's tigers, ink drawings of Japanese house cats and Chinese lions, and folk art that's very precious and detailed.

What process do you go through to create your work? What inspires you?

I'm attracted to extremes: either very ordinary moments, or epic and fantastical themes. Mundane/extraordinary. Cats are that way too: simultaneously commonplace and super weird. Sometimes I borrow compositions from painters I admire, like Matisse or Heironymus Bosch, and substitute Kitty for demons and my living room for a French parlor. I usually try to make a picture, mess it up, get annoyed, stick it out, and end up with something much more interesting. Whenever I can I'll incorporate recycled materials: Amazon boxes, pencil shavings, dried up paint. Perfection makes me uncomfortable.

What might people be surprised to know about you (or your work)?

Let's see— I've got the same interests as a 12-year-old boy (ninjas! Dinosaurs! Comic books!). Also, I do all my drawing and painting on the floor. Kitty liked to help by sitting in the middle of everything. I've wiped a lot of paint off her white paws.

What question do you wish I had asked you?

I liked the question you asked earlier—"what do you say to the haters?"

What is your answer to that question?

There are no haters! I've always expected people to say that it's cheesy or "not high art," but the worst criticism I've gotten has been, "Not really a cat person, but there's something okay about THAT one." Cats are "edgycute"— they embody anarchy and provide exquisite cuddles. At the same time. It's amazing.

RIGHT PAGE

Temptation of St Kitty
Mixed media -gouache, gesso, ink, marker, graphite, dried up paint, collage- on cardboard. 20 x 24". 2014.

1506: WILDLY IMAGINATIVE ARTIST HEIRONYMUS BOSCH DUMPS SAINT ANTHONY INTO A TRIPTYCH OF TERRIBLE TORMENTS!

OVER 500 YEARS LATER: IN A CURIOUSLY FAMILIAR HELLSCAPE, A THIRTYSOMETHING ART TEACHER/STUDENT POSTER LANGUISHES, OVERWHELMED BY A BEVY OF DEMONS MOST FOUL! UNOPENED EMAIL... FACULTY MEETINGS... UNSTRUCTURED LEISURE TIME...

BOSCH HIMSELF WOULD QUAIL AT THE THOUGHT OF SUCH SINISTER FIRST-WORLD IRRITATIONS!!

I AM EELCO

Eelco van den Berg was born in Uden, the Netherlands in 1974 and is a painter, muralist and illustrator based in Rotterdam and sometimes in New York City. In elementary school, he became mesmerized by hip hop and graffiti. He grew up to be a multi-disciplinary street artist creating psychedelic landscapes with a unique color palette developed primarily on the streets. His work is mainly hand drawn and stands out due to its strong use of color and surrealistic pop art style. I AM EELCO is honored to be named one of 15 must-know Dutch street artists by *Street Art Today*. He is not just living the dream but painting it as well! His bold award-winning graphic works and paintings have been commissioned by numerous major brands and galleries, including a recent feature at Jonathan LeVine Projects in New Jersey.

www.eelcovandenberg.com
Instagram: @iameelco

ABOVE

Opperclaes XL
Spray-paint.

RIGHT PAGE

Chicago
Spray-paint.

When and why did you start incorporating cats into your work and what do you feel they bring to it?
I've been painting graffiti since the mid-80s and in 2013, I decided that instead of letters, I would paint something without words. In the train on my way to Berlin for an art fair, I sketched a cat and painted it in Berlin on a mural. As a kid I used to draw a lot of animals. Changing from commissioned illustration work to more free work, animals have been my main theme. I always liked cats for their social and stubborn behavior.

Is there any work of art featuring cats that has inspired you? Where did you encounter it, and how did it make you feel?
The inspiration came from having cats myself. I liked to observe them.

What process do you go through to create your work? What inspires you?
I'm an observer. Certain things get stuck in my mind. During my creative process, they pop up instinctively I guess. Nature itself has been my biggest inspiration since I was young.

What might people be surprised to know about you (or your work)?
I am not sure. My work shows my passion for bringing nature back into the 'concrete' world we are living in. I like to observe little birds, flowers, the changing of the seasons.

Rotterdam Netherlands
Spray-paint.

276

SHAG

Josh Agle, also known as Shag (a combination
of the last two letters of his first name and the
first two letters of his last name) is a painter,
illustrator and designer based in Southern
California. Shag has had numerous gallery
exhibitions in the United States, Europe, Japan
and Australia. While Shag's work might easily
be dismissed as retro-kitsch, the influential
New York Times art critic, Roberta Smith, has
called his painting catchy and witty, saying
"the eye is snared by Mr. Agle's economic use
of saturated colors—sharp greens and warm
lavenders, smoldering reds, sour ochres—and
the tinted-gel space created by his thin-on-
thin paint handling." Interest by museum
curators and academics has led to his work
being featured in museums such as the Laguna
Art Museum in California, The Andy Warhol
Museum in Pennsylvania and the Naples
Museum of Contemporary Art in Italy. His
work is also in the permanent collection
of the Los Angeles County Museum of Art.
Shag's distinctive imagery can be found on
merchandise and products worldwide. He
has created work for Coca-Cola, MGM's *Pink
Panther*, *Star Wars*, and *Playboy*. In 2005,
he was chosen to be the official artist for
Disneyland's 50th anniversary.

www.shag.com

Too Many Cats
Three color printed rayon
fabric, 12 x 38". 2006.

When and why did you start incorporating cats into your work and what do you feel they bring to it?
I painted cats in art school, and continue to paint them today. It's hard to resist painting a creature that is so aesthetically pleasing. To me, cats represent the feminine and wild side of the human species. Almost every cat I paint is accompanied by a woman, much like a witch with her familiar. There are a few exceptions, where I have painted men with cats. I'm in the middle of a series of celebrities and their cats, and many of the humans are male.

Is there any work of art featuring cats that has inspired you? Where did you encounter it, and how did it make you feel?
The cats in my paintings were inspired by a bubble bath bottle that I remember from my childhood. It was a long-necked plastic cat that came in black or pink, and the head screwed off to open the bottle. At the time, only little girls would have used this bubble bath, as boys had containers shaped like Superman or Yogi Bear. This was before Google Image Search, so I had to recreate the cat bottle from memory. Years later, when I actually saw one, I was surprised at how different it was than I had remembered.

What process do you go through to create your work? What inspires you?
My early work was aspirational. I was painting places, people and things I wanted to be a part of. The world I was trying to depict was based on my childhood perception of what it meant to be a grown up. Going to bars and cocktail parties, hanging out in a bachelor pad playing records, or speeding down a winding road in a Jaguar E-Type were the rites and rituals of my imaginary adulthood. As my career progressed, my life began to increasingly resemble my art. The inspiration for my work turned towards real experiences, people and places and relied less upon an imagined world. I am constantly drawing.

I produce rough little sketches and throw them in a file drawer, and when I need inspiration, I go through those drawings, pulling out bits and pieces and combining ideas to create a composition that will become a painting. I redraw and refine my sketches until I'm satisfied with the line, shape and space of the work, and then produce a painting based on that.

What might people be surprised to know about you (or your work)?
I'm much more of a dog person than a cat person in real life. Until recently, dogs have seldom appeared in my art. Cat aficionados have a magnetic attraction to felines in art. Any painted cat is a representation of the viewer's own pet. A well-rendered cat walks, sits and arches its back in a reflection of how a real world cat behaves, projecting the aloofness and icy cool nature of the animal. But dog lovers are different. If I paint a beagle and you own a chihuahua, you feel no real connection to the dog in the painting.

What question do you wish I had asked you?
I wish you had asked me about the whale I saw yesterday.

What is your answer to that question?
I was surfing near Crystal Cove (between Laguna Beach and Newport Beach) looking toward the horizon yesterday morning. I heard it before I saw it. The rapid expulsion of breath happens right before a whale surfaces and sounds a bit like a semitruck bleeding its brakes. Then it appeared about ten yards from me, directly in my line of sight. I could see the individual barnacles and scars on its back. As quickly as it appeared, it was gone. But the smell of its breath lingered; it was the odor of fresh shrimp and crab, not fishy smelling but sweet. I didn't know what kind of whale it was, so I did a little research when I got back to my studio and discovered that the California Gray Whales are migrating now.

RIGHT PAGE, TOP
The Crack Up
Acrylic paint on panel,
17 x 24". 2011.

RIGHT PAGE, BOTTOM
Tiki Cats and Kittens
Fifteen-color silk screen print
on paper, 23 x 41". 2017.

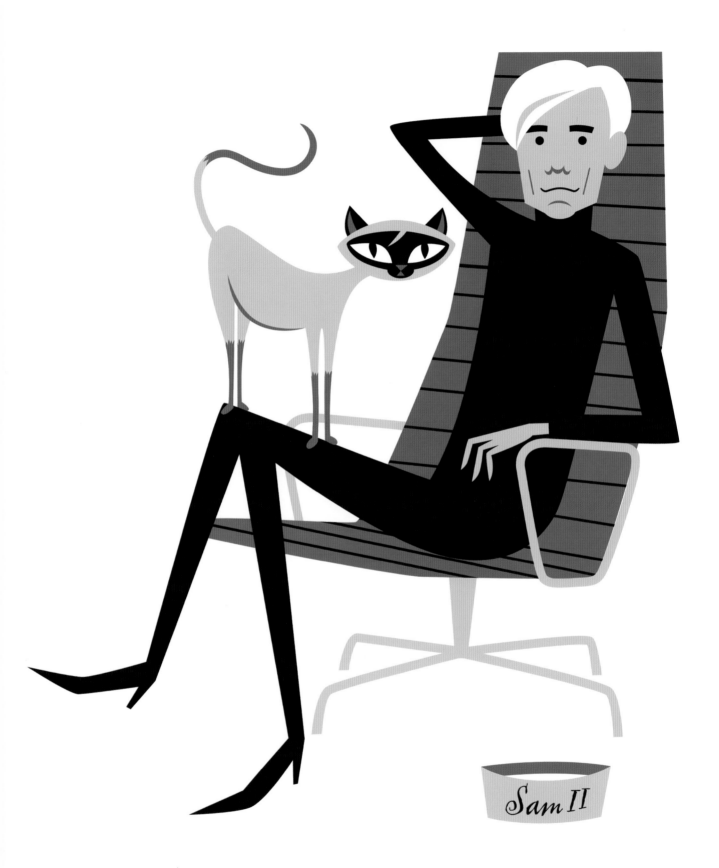

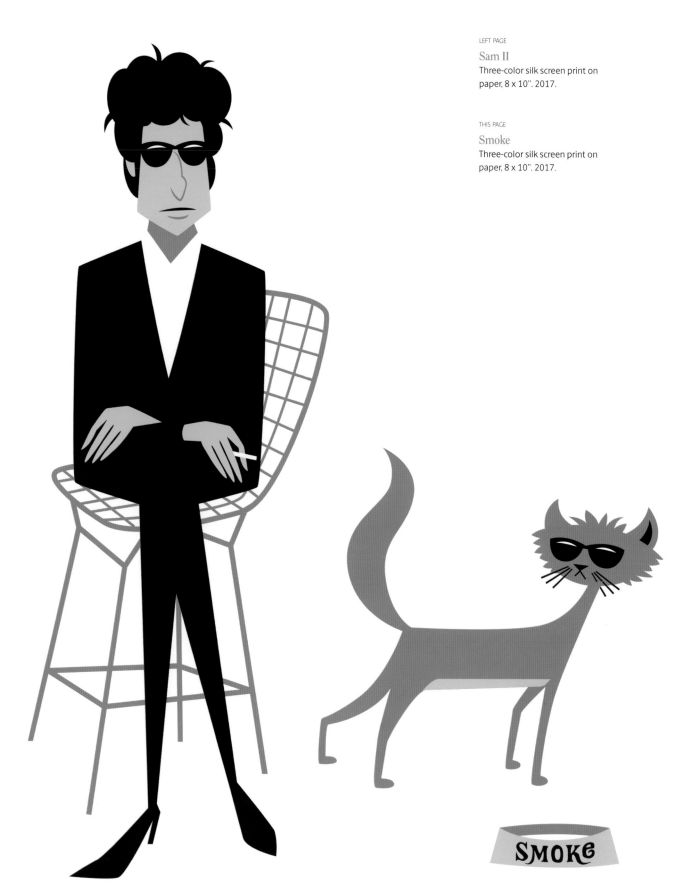

LEFT PAGE
Sam II
Three-color silk screen print on
paper, 8 x 10". 2017.

THIS PAGE
Smoke
Three-color silk screen print on
paper, 8 x 10". 2017.

SMOKE

NATHALIE LÉTÉ

Nathalie Lété was born in 1964 in France. She lives and works in Paris. She works in many ways, mixing different techniques and mediums: painting, ceramic and textile. She is inspired primarily by nature, animals and vintage toys. Her work is colorful, naïve, poetic and sometimes strange, tending towards Art Brut. Her world is nurtured by popular and folk art, from her two origins (her Chinese father and her German mother). She produces children's toys and books, rugs, ceramics, dishes, patterns for fabrics, wallpapers, stationaries, fashion accessories and furniture. Her commissions include fashion brands, logos, and advertisements. She exhibits her art all around the world and has appeared in Korea, Japan, China, the United States, Germany, England and France.

www.nathalie-lete.com

ABOVE
Chat Vert
Acrylic on paper,
8.24 x 11.69". 2018.

RIGHT PAGE
La Chatte et
sa Poupée Lapin
Acrylic on vintage wall-
paper, 10x14". 2009.

NEXT SPREAD, LEFT
Dame Chat
avec sa Boîte
Acrylic on paper,
8.24 x 11.69". 2019.

NEXT SPREAD, CENTER
Monsieur le Chat
Dandy
Acrylic on paper,
8.24 x 11.69". 2019.

NEXT SPREAD, RIGHT
Minette
en Robe Rose
Acrylic on paper,
8.24 x 11.69". 2015.

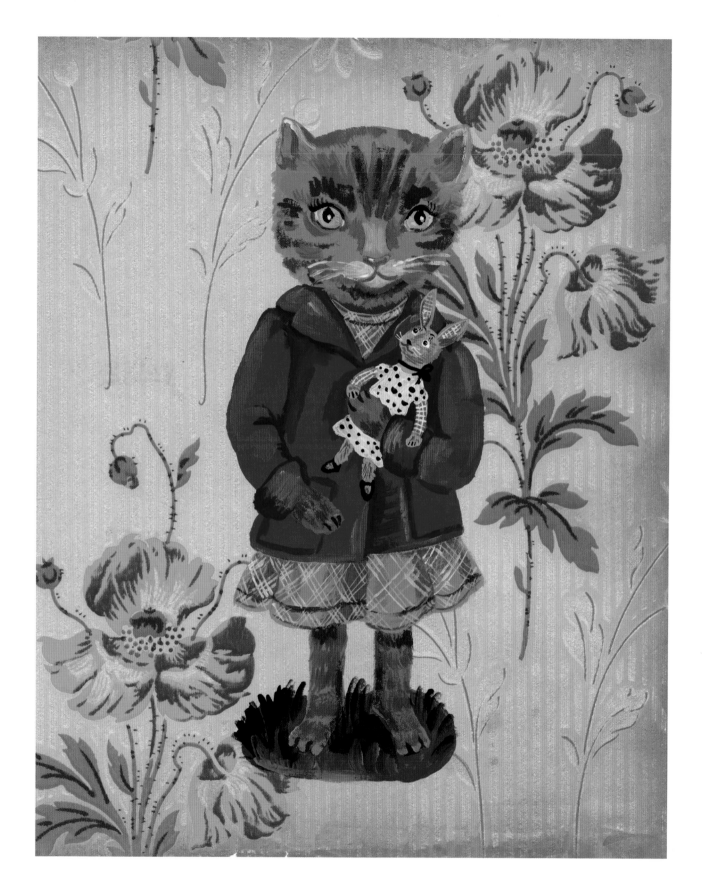

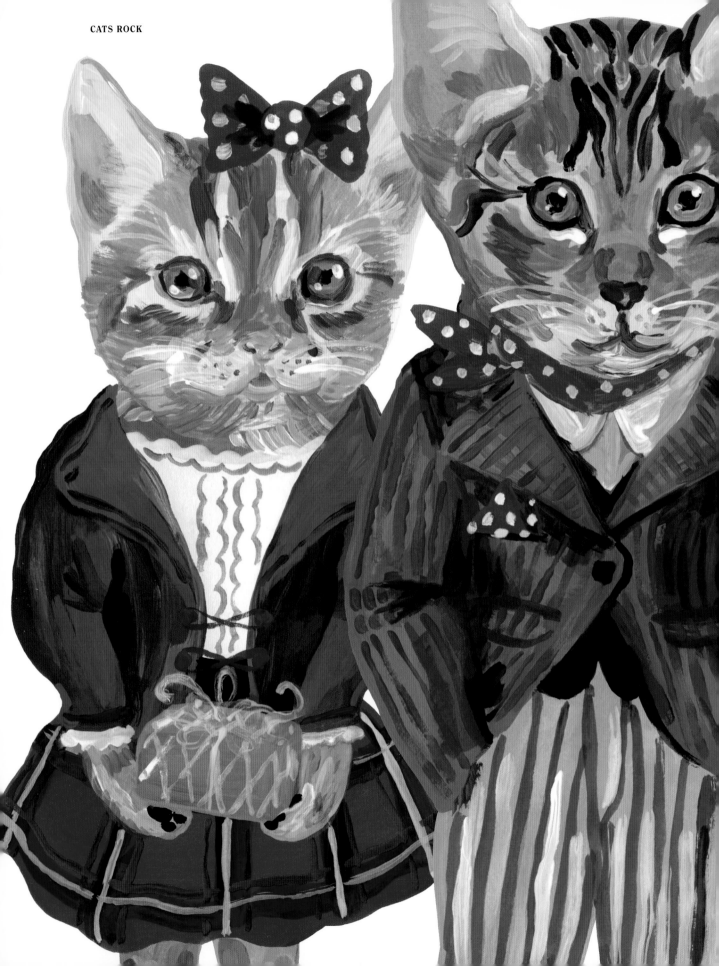

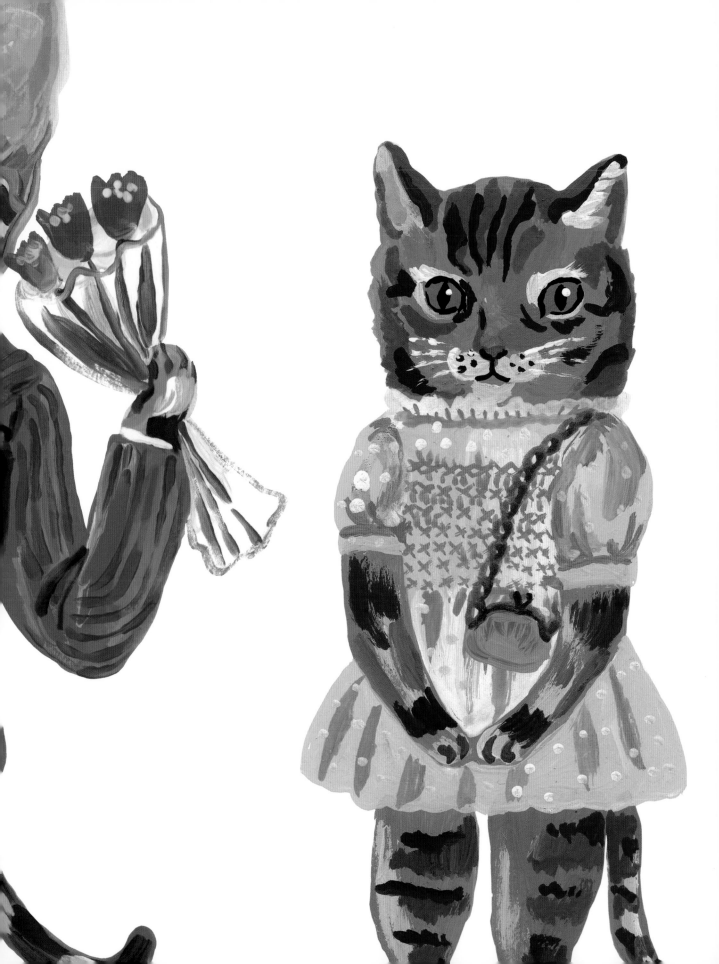

THIS SPREAD

La Vie des Chats
Acrylic on paper,
27.5 x 27.5". 2017.

NEXT SPREAD

Quatre Chats
Acrylic on paper,
13.8 x 20". 2016.

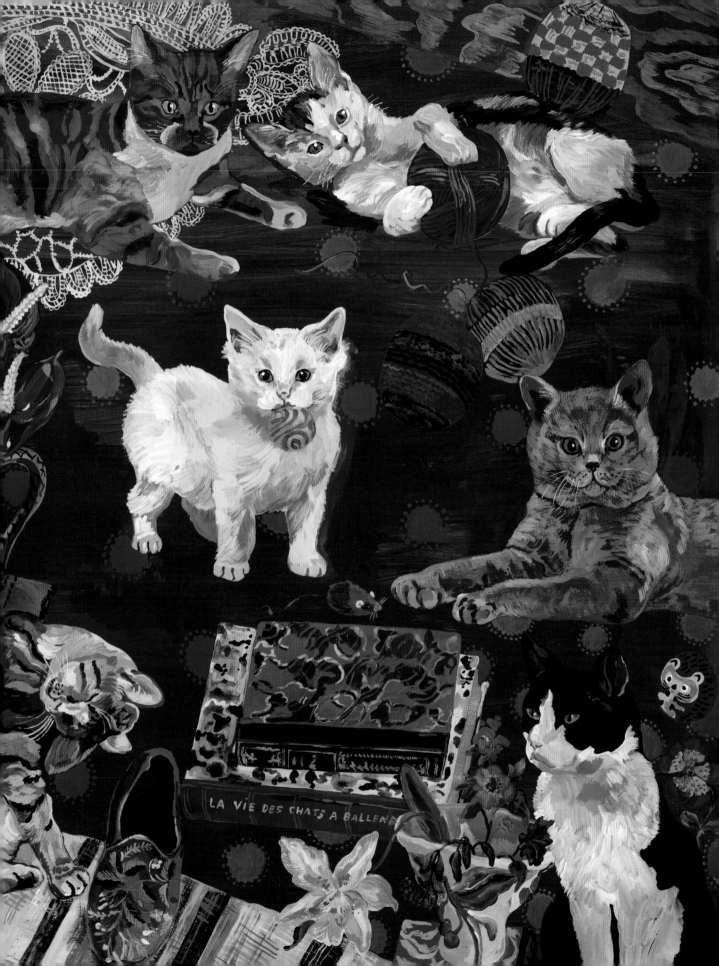

LA VIE DES CHATS A BALLEN

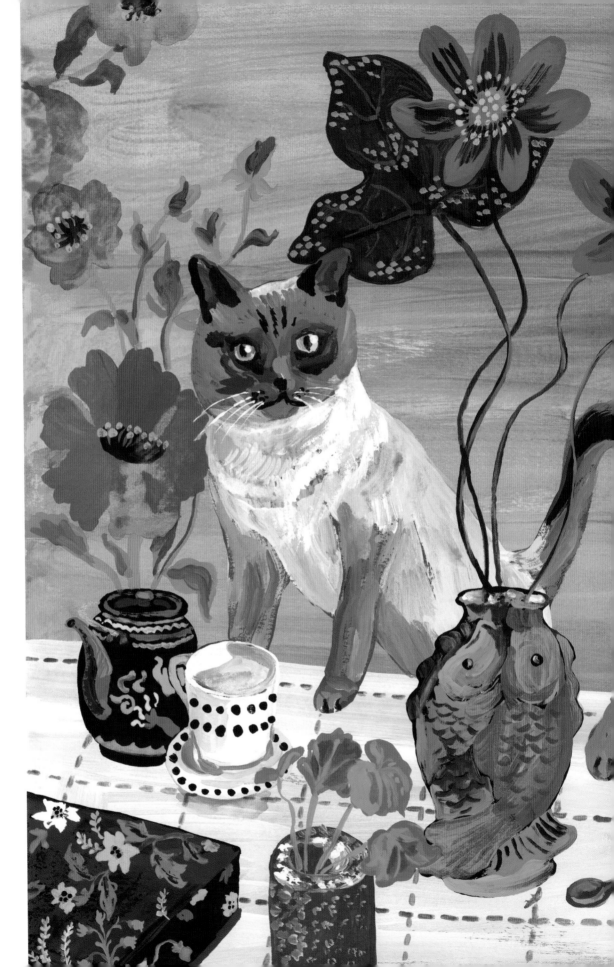

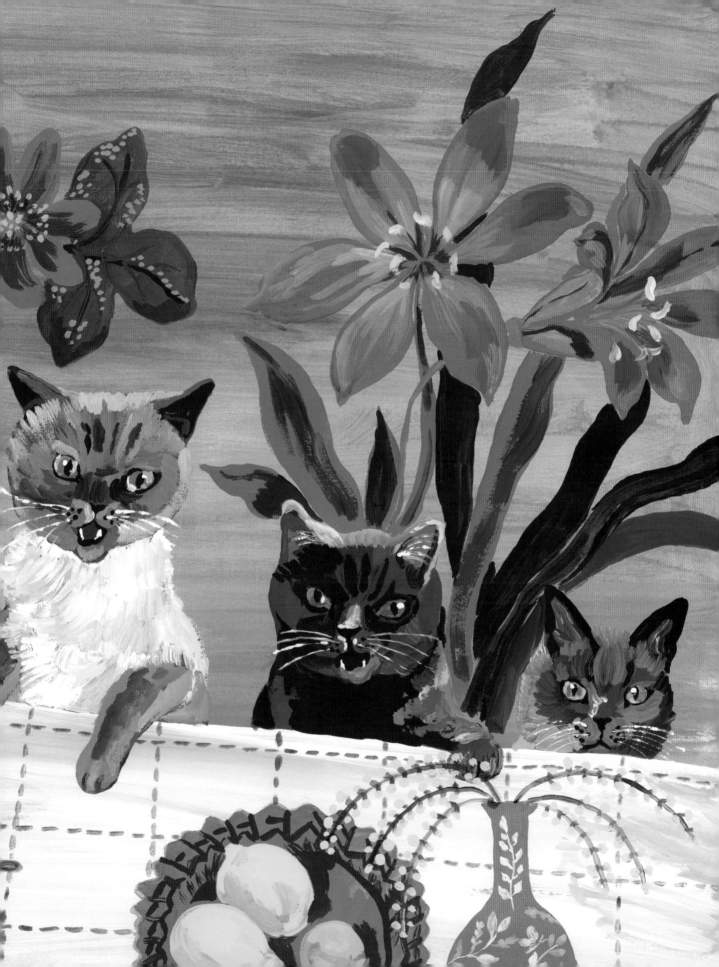

When and why did you start incorporating cats into your work and what do you feel they bring to it?

I started introducing cats in my work about 20 years ago, when Japanese customers offered me the opportunity to create a license in Japan. In my mind, cats and dogs represent the characters of humans and I wanted my products to be suitable for both cat and dog people. And as it has always been difficult for me to represent humans, through animals I could illustrate different daily situations, using cats and dogs to replace humans. Little by little, I drew more and more caricatured cats, but also some more and more realistic ones. You may like or dislike cats, but as an animal, they always represent the other, or yourself.

Is there any work of art featuring cats that has inspired you? Where did you encounter it, and how did it make you feel?

I remember very much how I liked reading Charles Perrault's *Puss in Boots*, but also the postcards from the 30s with cats dressed as humans. There are also the drawings Balthus drew when he was 12, to tell the story of his cat Mitsou. I always liked telling a story through drawings or paintings. I also love Foujita's paintings, and he often painted cats in his portraits, nudes and self-portraits. I feel the tenderness, the comfort, the sensuality, the softness, the happiness of everyday life in these paintings.

What process do you go through to create your work? What inspires you?

I am inspired by vintage and kitsch images as in postcards of the 70s, or the French Post Office's calendars. They presented pretty photographs of cats, often kittens, in front of baskets full of flowers, playing with balls of wool. But I'm also inspired by the chromos that I collected to stick on my letters. I use a similar process in a way. I paint images that supply my image bank, then I play with these visuals to create new compositions, new images for my clients. I also like the small objects that I collect and that I like to repaint while observing them carefully to bring them back to life. I love to try to make my painting as realistic as possible, it gives me a lot of pleasure. I also caricature, simplify, illustrate, play and the final image becomes more naïve. Folk art or outsider art are also great inspirations for me.

What might people be surprised to know about you (or your work)?

People often think I love cats because I draw them very often, but in truth I prefer dogs by far. Cats scare me! I like watching them from far away, sometimes caressing them, but I'm not totally confident with them. I dread their claws. To the question: rather cat or dog? I love a good dog every time!

RIGHT PAGE

Le Chat au Chapeau
Silk screen in 4 colors,
12 x 17". 2014.

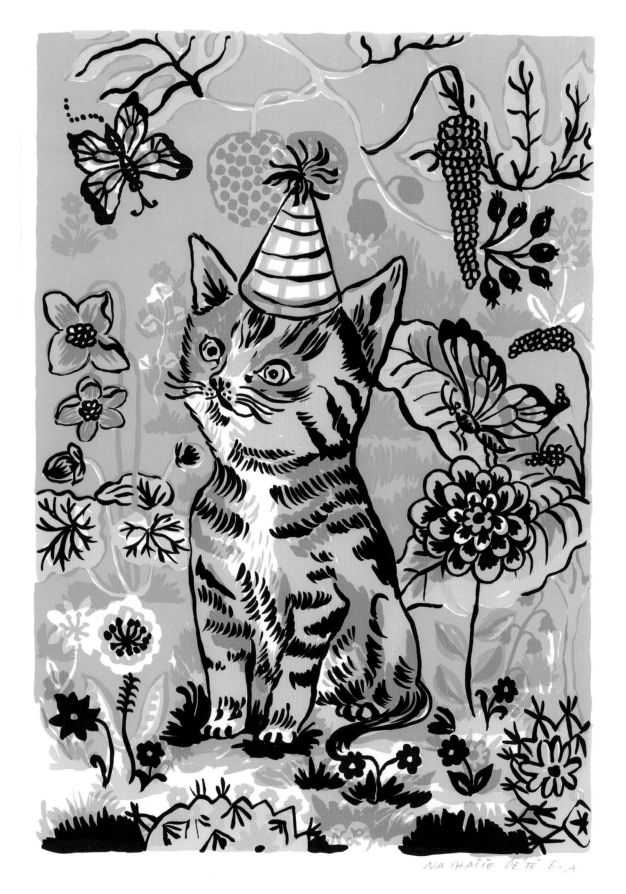

NATHALIE LÉTÉ E.A

CREEPY CATS

Gary Baseman
Scratch and Bite (detail)
2014.

The Cat

There is no man now living anywhere
Who hates cats with a deeper hate than I;
I hate their eyes, their heads, the way they stare,
And when I see one come, I turn and fly.

— Pierre Ronsard as translated by Edmund Gosse.

Everyone knows that if a black cat crosses your path, it's supposed to signify bad luck. However, throughout history cats were more likely to suffer from "bad luck" than the humans they encountered. While it was illegal to kill cats in ancient Egypt, those glory days were short-lived. For centuries after, cats were gutted and used to make potions. They were eaten, skinned for coats and violently tortured by humans as part of rituals to ward off evil. Cats are associated with dark magic and thought to have the ability to see demons according to the Jewish holy book, the Talmud. In Chinese and Japanese folklore, cats have been associated with positive things like wealth and cuteness, but also with reanimating the dead. As anyone who owns a cat knows, they tend to be active at night and it often does sound like they are haunting attics and hallways. It has also been theorized that some of the "bewitching" supposedly undertaken by cats, such as making it hard for certain people to breathe, may actually have been the result of allergic reactions cats are known to cause. Aside from all this, cats can be creepy. Sometimes they stare off into space, seeming to see something invisible to the naked eye. These natural tendencies, in combination with the fact that the worship of cats was originally associated with pagan traditions, made felines easy scapegoats at the dawn of Christianity. While cats later became household pets, to this day they have not rid themselves of negative associations. One author noted that it is much more socially acceptable for people to hate cats and proclaim it than to hate dogs.

Black cats are harder to find homes for and will forever be witches' best friends. Even today, nothing says Halloween like black cats and pumpkins. The artists in the following section are haunted by cats. They follow in the footsteps of early modern European woodcut artists, who warned the public of the danger of witches in the 1500s. They take after such creepy creators as Arthur Rackham of England (1867-1939) who illustrated *Grimms' Fairy Tales* with the famous panel "By Day She Made Herself into a Cat." They take after Francisco Goya (1746-1828) of Spain, who at times depicted cats as wild symbols of death and evil in his etchings. They are inspired by folk tales and by Tim Burton, known best for his Halloween-themed animated films including *The Nightmare Before Christmas*. Some of these artists treasure Halloween ephemera in the form of Beistle decorations, which hung all over the United States beginning in the 1920s. Unlike much of today's cute Halloween ephemera, the decorations back then were as scary as much of the art that follows.

CASEY WELDON

Casey Weldon was born in southern California, where he spent the majority of his life until his graduation from the Art Center College of Design in Pasadena. After starting his career in Las Vegas, Nevada, and spending many formative years working in Brooklyn, New York, he relocated to Seattle, Washington, where he now lives and works as an illustrator and fine artist. Using the iconography of today and yesterday's popular culture, his work aims to awaken feelings of nostalgia within the viewer, often along with a sense humor, melancholy, and longing for times lost.

www.caseyweldon.com
Instagram: @caseyweldon

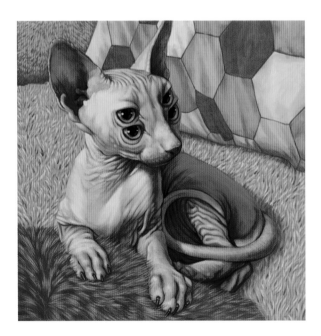

ABOVE
Gilly
Acrylic on wood,
16 x 16". 2014.

RIGHT
Chewie
Acrylic on wood,
16 x 16". 2013.

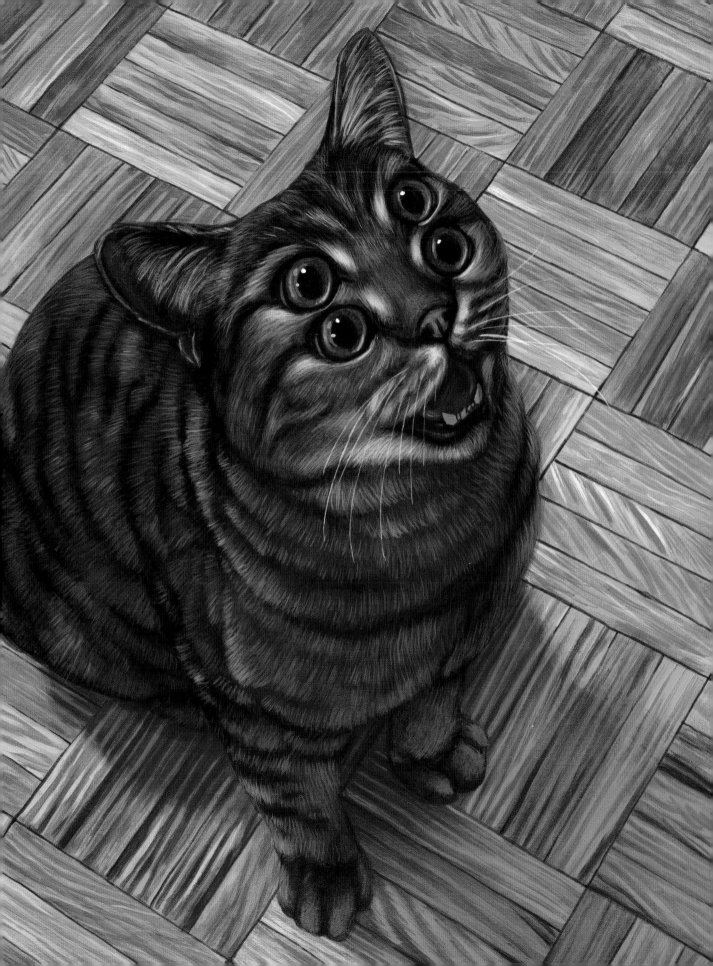

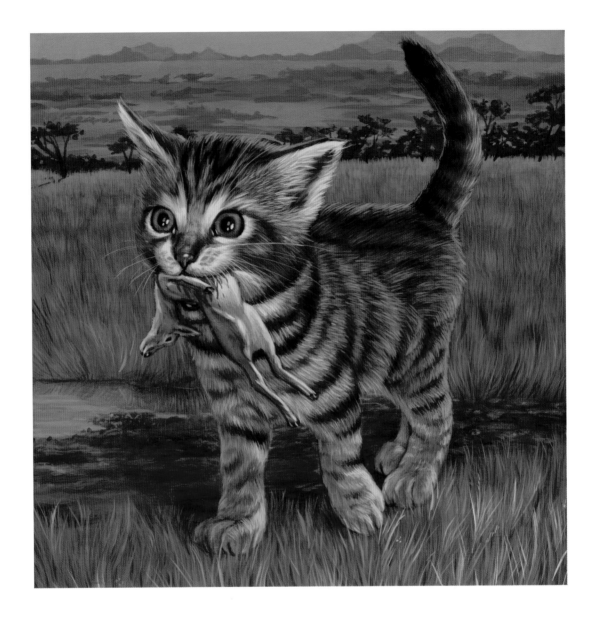

THIS PAGE

The Kill
Acrylic on wood,
12 x 12". 2014.

RIGHT PAGE

La Purrsh
Acrylic on wood,
20 x 24". 2017.

NEXT SPREAD

Go Away
Acrylic on wood,
24 x 48". 2017.

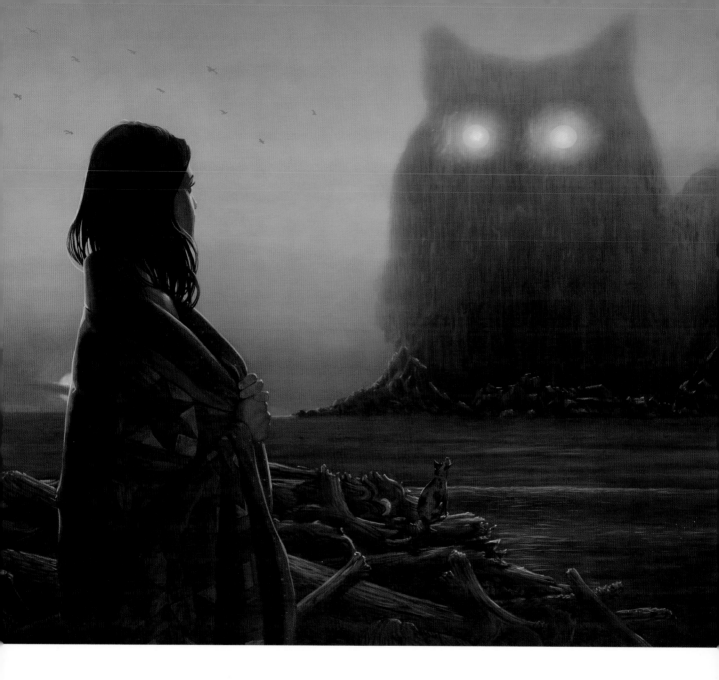

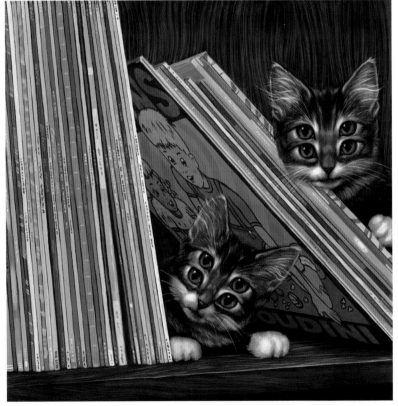

When and why did you start incorporating cats into your work and what do you feel they bring to it?

Honestly, I'm not sure how it started. They began creeping into paintings here and there and everytime they did, I really enjoyed painting them and how the piece came out. I think there is just something inherently funny to cats, maybe because they often seem like they are always trying so hard to play it cool. They can be cute. They can be frightening. They are the perfect model for when your intention is to be adorable and creepy simultaneously, which I feel my work strives to be most of the time.

Is there any work of art featuring cats that has inspired you? Where did you encounter it, and how did it make you feel?

Louis Wain, hands down. I think my grandparents had a book of his work in their house, and I have very early memories flipping through it and being both amused and totally disturbed by these cats that were well-drawn and performing anthropomorphic activities in strangely victorian fashions. It wasn't until very much later did I realize who the artist was and grew to fully appreciate his work.

What process do you go through to create your work? What inspires you?

It always starts with an idea, which really resembles a punchline more than anything. "Wouldn't it be funny if a cat was like this, or weird if a cat was like that?" Then I just try to sketch it out from there. I'm not really sure where these things come from other than just joking with my friends over drinks or laying in bed alone at night trying to go to sleep.

What might people be surprised to know about you (or your work)?

That it's all acrylic paint. I'm not sure why, but most people seem to be quite incredulous about that. I think it's a compliment, and I will choose take it that way!

What question do you wish I had asked you?

Do I even have cats???

What is your answer to that question?

I don't! I grew up always having cats in my life, but unfortunately I have been reluctant to adopt one in recent years as I feel like I don't have the time and commitment to bring a new kitten or rescue into my household. Art life can be a little unpredictable, and I'd hate to subject that frantic schedule to another being that doesn't know what they are getting into. Cats are notoriously independent, which is what I love about them, but it does take a certain amount of face time to make them comfortable and loved in a new environment. But soon, I'm sure.

LEFT PAGE, TOP

Toxoplasmosis I
Acrylic on wood,
14 x 14". 2017.

LEFT PAGE, BOTTOM

Louie & Nico
Acrylic on wood,
16 x 16". 2013.

GARY BASEMAN

Los Angeles-based artist Gary Baseman explores the "beauty of the bittersweetness of life" through painting, performance, illustration, toy design, film and fashion. Known for his raw style and humor, he created the Emmy and BAFTA award-winning series "Teacher's Pet," and designed the visual identity for the best-selling boardgame Cranium. Recent projects include a collaboration with Coach, a documentary film *Mythical Creatures* about his family heritage, and exhibitions of his fine art around the globe. Baseman's longtime pet companion Blackie has been inspiration for many of the artist's iconic characters, representing love, compassion, and the healing power of purr.

www.garybaseman.com

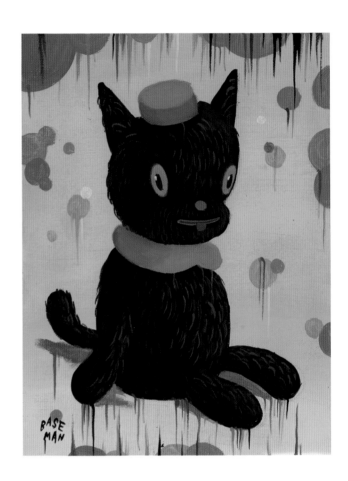

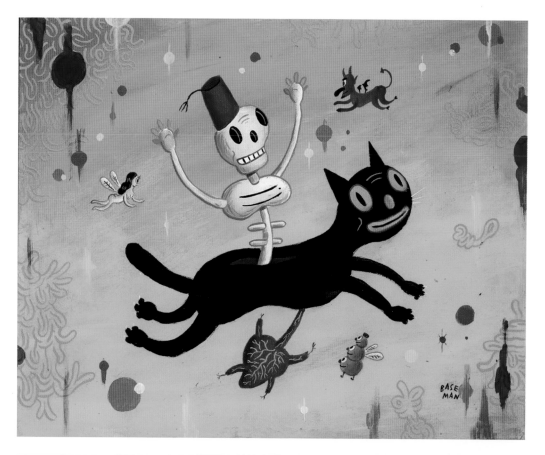

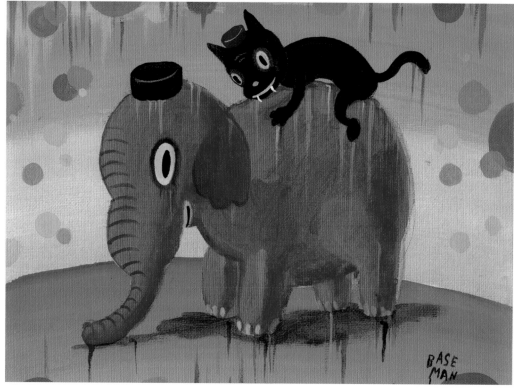

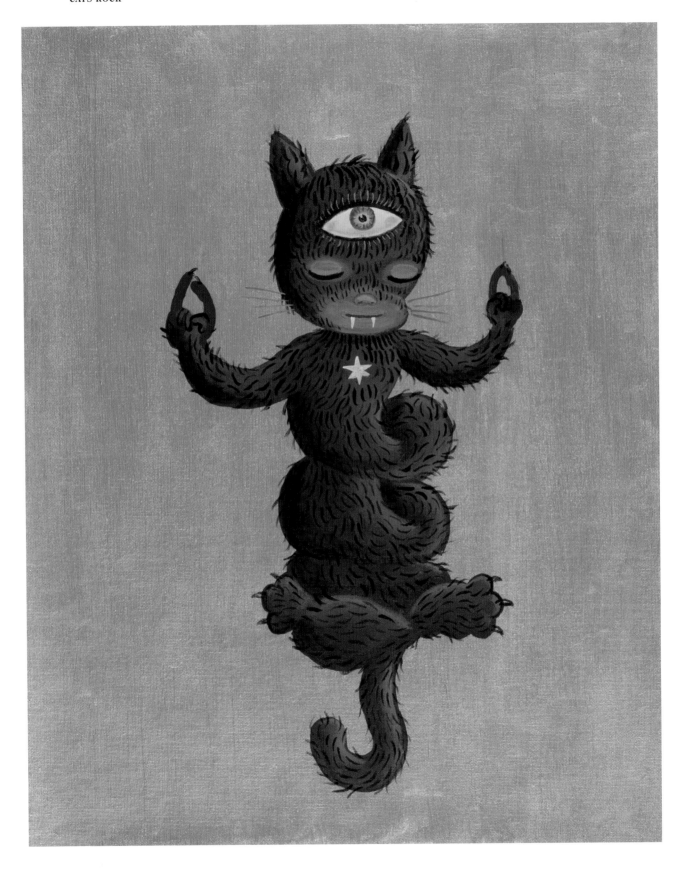

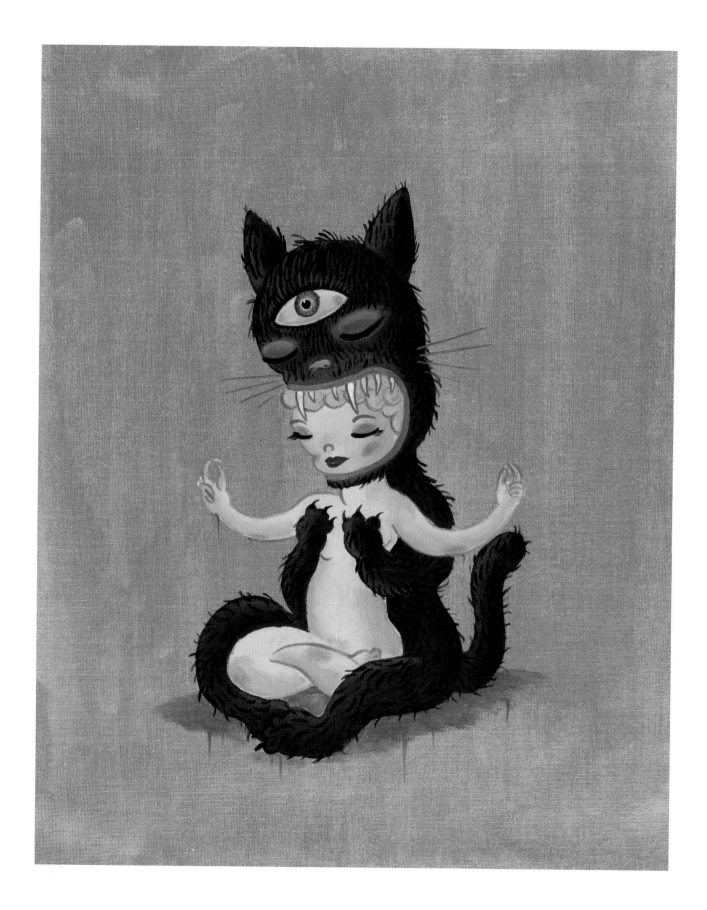

When and why did you start incorporating cats into your work and what do you feel they bring to it?

Cats have probably been featured in my art since I was a kid, and became more prevalent in the 1990s, especially when I produced editorial and ad campaigns. I started drawing an early version of my character Toby, who is a cat in the early 90s. He has always been a sort of alter ego for me. A trustworthy best friend who keeps secrets and also takes more risks than I do. Cats are clever and adventurous, and in so many ways more honest than humans..

Is there any work of art featuring cats that has inspired you? Where did you encounter it, and how did it make you feel?

The first artist I respect that comes to mind featuring cats is Balthus. His paintings are disquieting and beautiful, often with girls in curiously provocative poses and with cats. I remember seeing *Girl with Cat* from 1937 at the Art Institute of Chicago, and feeling both disturbed and intrigued. The sheer candor he has with his subject matter is bold and daring. I also like the photographs of Marc Chagall in his trademark robe holding a cat. He, too, includes cats in his brilliant and colorful works.

What process do you go through to create your work? What inspires you?

I am inspired by daily life and personal interactions, whether with my pet companion Blackie or with people I dine with. I'll make videos or draw in my sketchbook, capturing in my own way what's going on. Much of my work reflects the human condition, the themes of love, longing, and loss. I want to celebrate the beauty of the bittersweetness of life, meaning that there is good with the bad. Nothing is really perfect, but we have to keep trying to do good. We have to keep trying to find and share compassion and kindness. That's what my cat Blackie has taught me.

What might people be surprised to know about you (or your work)?

People often assume that because my work looks like cute cartoons that the images are sweet and funny and meant for children. But there's always something deeper and darker going on: pain, blood, open wounds. I make art for many audiences, for different ages (but not necessarily for all ages at the same time). Each series usually starts with an inspiration that is from a specific moment, based on what's going on in my own life or what's happening in the world.

What question do you wish I had asked you?

What is the "Power of Purr"?

What is your answer to that question?

I learned the healing Power of Purr from Blackie the Cat who saved my life over a dozen years ago. He found me during a traumatic time in my life, and inspired me to create many characters that reflect his personality and powers. I created "The Purr Room" with Blackie in 2018 as a reaction to my country's widespread chaos and anxiety due to the current White House occupant. This immersive sound bath installation features Blackie the Cat's triple purr that amazingly relaxes people, making stress and anxiety go away. May the power of purr be with you.

RIGHT PAGE, TOP LEFT
Self-Portrait as Blackie
Colored pencil on paper,
7 x 5". 2018.

RIGHT PAGE, TOP RIGHT
The Purr Room
Colored pencil on paper,
7 x 5". 2018.

RIGHT PAGE, BOTTOM
The Demon Nymph
Acrylic on canvas,
18 x 24". 2018.

NEXT SPREAD
Nightmare and the Cat
Acrylic on canvas,
18 x 24". 2011.

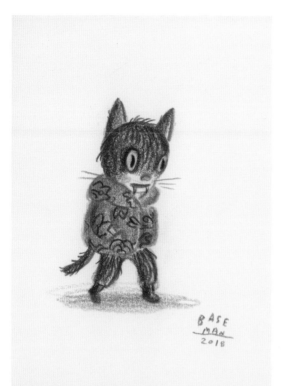

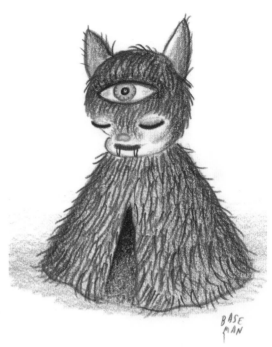

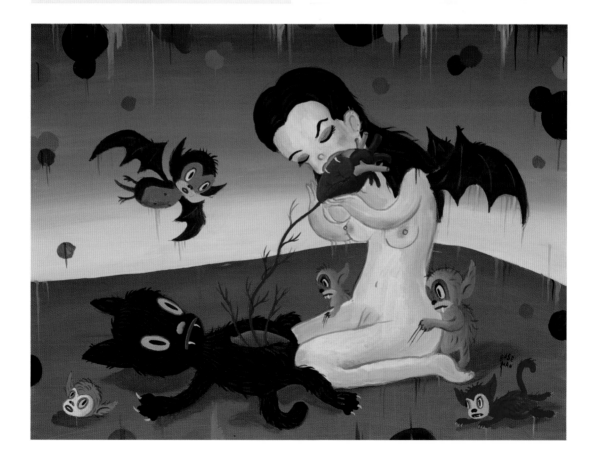

MATT BOBER

Matt Bober was born in 1978 and grew up in New Jersey, just outside of New York City. He currently lives in Williamsburg, Brooklyn, where he also maintains a studio. Bober began his artistic training at 16 at the National Academy of Design and The Art Students League of New York. He studied subsequently at the School of Visual Arts. After a brief career as an illustrator, Bober worked for over a decade fabricating artwork for Jeff Koons. Bober's current paintings explore his ideas about contemporary art and religious iconography; he enjoys employing recurring objects that have a visual personal symbolism. Bober shows his work at various galleries in New York City, Los Angeles, and at his main gallery, Robert Lange Studios in Charleston, South Carolina.

www.matthewbober.com

What if anything do cats symbolize to you and/or in your work?
In my work, cats have an observer status, reacting to and altering the meaning of other objects in the painting.

What is your favorite work of cat art by another artist and why?
When I was younger I would go to the Metropolitan Museum of Art constantly and one of my first stops was a painting by William-Adolphe Bouguereau called *The Proposal*. The painting was hung high and it was hard to study the surface of the people. I've spent many hours looking at the cat in the bottom right. Its expression was painted so perfectly.

When did you first decide to incorporate cats into your work and how did that come about?
It isn't a conscious decision. When they fit the design and emotional note I want to convey for the specific painting, I incorporate them.

Why is cat art so popular right now, in your opinion? What is it about cats?
I think cat art is popular because there is very little in this world that can bring a joyful emotion to many people as quickly as a cat. Especially after the presence of online meme culture, it would be strange to not see that represented in fine art as well.

RIGHT PAGE

Three Cats
Oil on panel, 16 x 20". 2018.

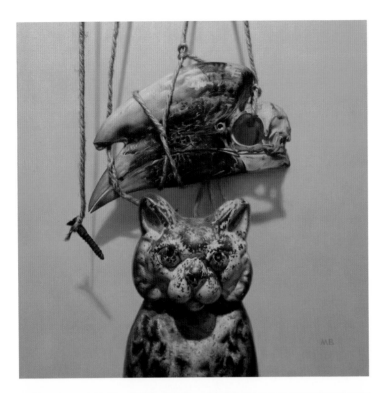

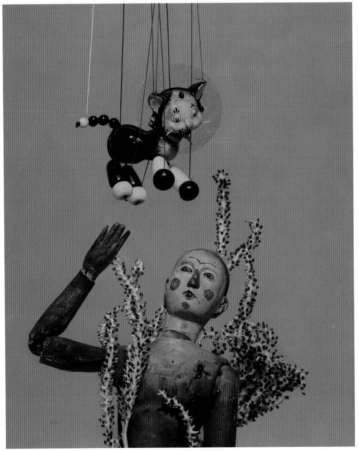

Cat Bird
Oil on panel, 10 x 10". 2015.

Drowning
Oil on panel, 16 x 20". 2018.

Visitation
Oil on panel, 17 x 28". 2019.

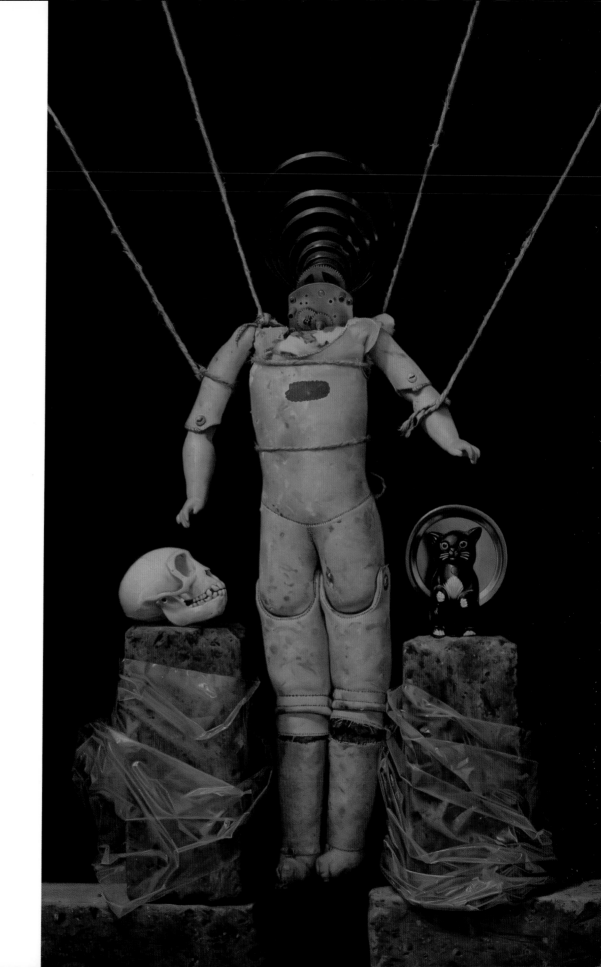

ANDY KEHOE

Andy Kehoe was born and raised in Pittsburgh, Pennsylvania, and lives there today with his wife, Ash, along with their furry family of three cats and Gizmo the dog. Kehoe explored a number of different art schools before finishing up at Parsons School of Design in New York City with a degree in illustration. After dabbling in commercial illustration for a short time, he began exhibiting his work in galleries and he has continued doing so for the past 12 years. Kehoe's work has shown the world over including at such prestigious galleries as Jonathan LeVine Projects in Jersey City, New Jersey, Thinkspace Gallery in Culver City, California, Roq La Rue in Seattle, Washington, Copro Nason Gallery in Santa Monica, California, Outré Gallery in Melbourne, VIC, Australia, as well as at Scope Miami during Art Basel in Miami, Florida.

www.andykehoeart.com

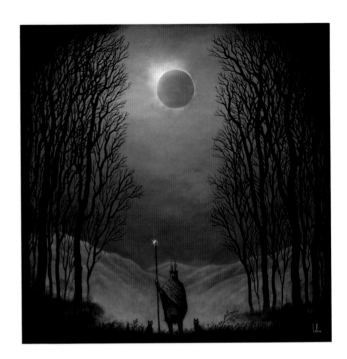

ABOVE

Under the Glow of Anomaly
Oil on wood panel,
24 x 24". 2018.

RIGHT PAGE

Ubiquitous Little Joys
Oil on wood panel,
12 x 16". 2018.

316

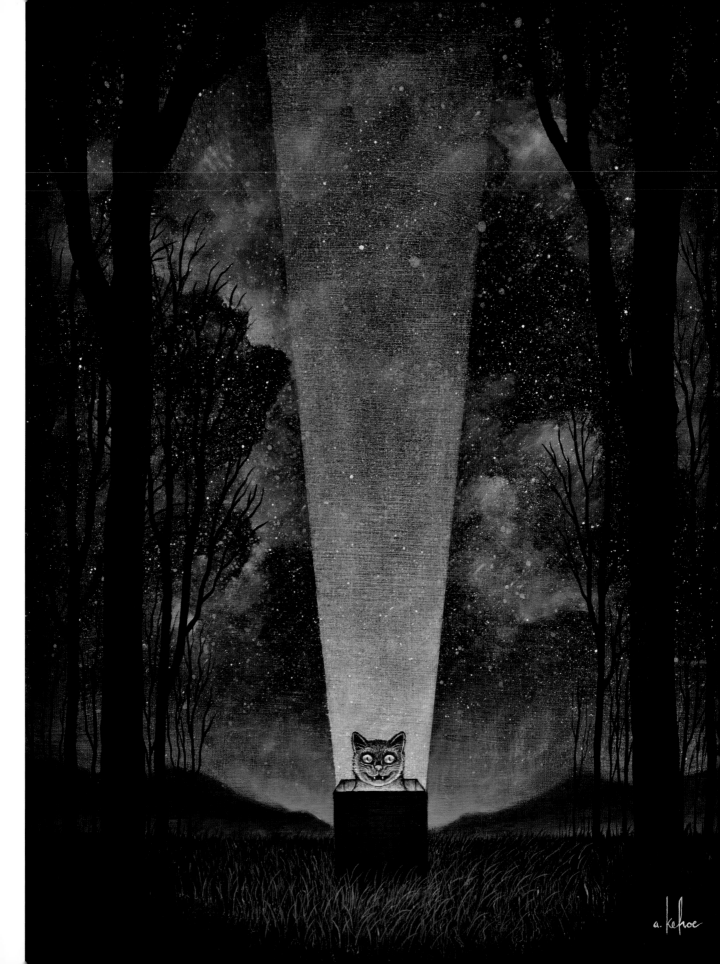

When and why did you start incorporating cats into your work and what do you feel they bring to it?

After art school, I started to make my own work and I wanted to create my own fantastical and imaginary worlds. When I started crafting these imagined worlds, I also began to create the creatures that would inhabit them. The cats just kind of showed up, as cats tend to do. I see cats as very magical creatures. I appreciate their sneakiness and overall mischievous way of life. They always seem privy to some unseen truth but are either indifferent, or they keep it to themselves, reveling in quiet amusement to our ignorance. When I see my own cats running around, chasing who knows what, I want to know what is rattling around in that cat brain. A tiny glimpse into the imagination of a cat would be amazing. Of course, that imagination most likely revolves around hunting, killing, and probably torturing imaginary prey, which are also weird cat things, but it is an imagination nonetheless.

The world in my work is comprised of multiple universes and cats bring a constant to those worlds. No matter what universe it is, a cat will be there and they will be up to something. Amongst other things, they travel with other creatures, commune with the dead, trick people, help people or just silently observe all the strange happenings. Some of the cats are more fantastical in appearance, but most are the familiar felines we know in our reality. I like the idea of a singular creature roaming our known world, alien worlds, and nonchalantly traveling between multiple universes.

Is there any work of art featuring cats that has inspired you? Where did you encounter it, and how did it make you feel?

I'm not sure why or when cats became such a symbol of magic and mystery to me as I didn't grow up with cats. I never lived with a cat until I was well into my thirties, well beyond when I started incorporating them in my work. So something along the way lead me to see cats as magical, so I'm sure artistic influences, lore, and tradition were involved. Halloween was always a special time for me, so the images of black cats definitely influenced me. My grandmother had a Margaret Keane print hanging in her house, featuring a large-eyed Siamese cat. That print now hangs in my parents' home. Henri Rousseau paintings and the large cats he hid in the foliage also made an impact upon me.

What process do you go through to create your work? What inspires you?

Each piece I make comes together a little differently, particularly in the beginning stages. Sometimes I have a very clear visual idea of what I want to create, and I can jump right in, having a definitive direction to the piece. There are other times where I have a more abstract idea and it's more about evoking a particular emotion. In those cases, the beginning stages are about being loose and experimental to figure out the best way to demonstrate that emotional response. Despite the initial stage, as the work progresses and starts to take shape, I always give myself breathing room to assess the piece. I take time to decide if I want to keep going in the same direction or if I want to pivot and change course. I've never been one to sketch a whole piece in concrete detail. I like a more chaotic and organic process that allows me to improvise and allows the elements to morph and change into something I could have never intended. Another reason I like to work this way is because most of my inspiration comes to me randomly. It could be from anything, such as a piece of art I stumble across online, a film that emotionally resonates with me or something I observe in the world, like an amazing sky or an old, lonely tree in a field. I want the freedom to allow these random and unpredictable inspirations to influence my paintings as I'm working on them.

RIGHT PAGE

Eyes of the Wild Wonder
Oil and acrylic on wood panel,
18 x 36". 2016.

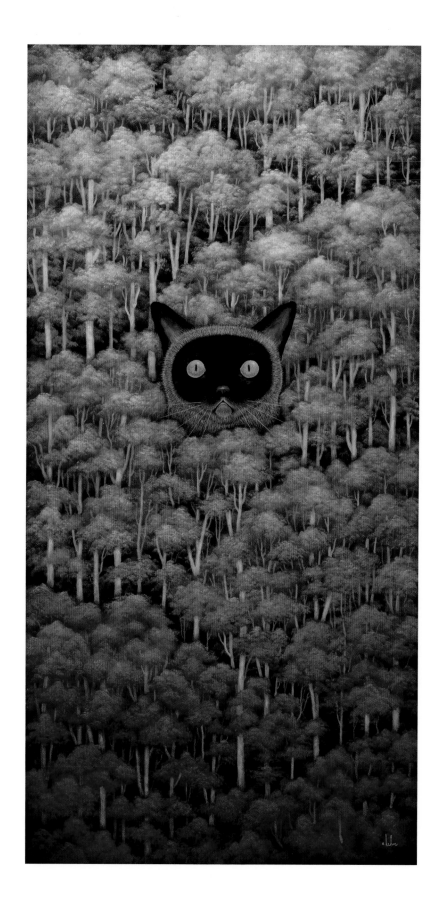

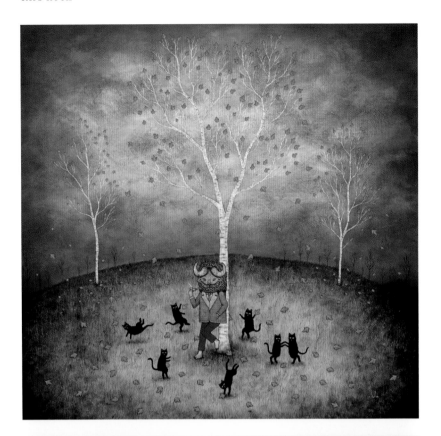

What might people be surprised to know about you (or your work)?

I've had a good number of people tell me they thought my pieces were done digitally and were surprised to know they are actual, physical paintings, which in turn, surprised me they thought my work was done digitally. It's a classic surprise loop. But, just to muddy the waters and blur the lines even more, I'm learning to paint digitally and I want that work to resemble my physical paintings. If all goes well, it'll be anyone's guess. Including mine.

What question do you wish I had asked you?

Who is the most perfect cat across all universes that does no wrong?

What is your answer to that question?

Gremwald Goggins Kehoe a.k.a. Gremmy
This last answer is in reference to my cat and obviously kind of a personal joke, but I really do think he is the best.

LEFT PAGE, TOP
Revel in the Wild Joy
Oil, 30 x 30". 2011.

LEFT PAGE, BOTTOM
Exodus of Youth
Oil, 20 x 20". 2011.

THIS PAGE
Riding a Dream
Resin, mixed media in wood box, 24 x 18". 2013.

ROB REGER

Rob Reger lives in the San Francisco Bay Area and is most famously known for introducing the world to Emily the Strange – a *New York Times* Best Seller and international icon for empowering people of all ages. Reger has been designing Emily and her cats for over 25 years and has generated millions of fans of the character. Reger received a master of fine arts degree from the San Francisco Art Institute and his abstract and figurative oil paintings, printmaking, watercolors, sculptures, and collage have been exhibited in galleries around the world, including: Tokyo, Paris, Los Angeles, Miami, San Francisco, Berlin, Milan, Hong Kong, Sydney, Sao Paulo, and Worcester.

www.robregerart.com
www.emilystrange.com
Instagram: @emilythestrange_official
Instagram: @robreger

Cat Nap
16 x 20". Originally designed
for a 16" x 20" screen print.
2014.

When and why did you start incorporating cats into your work and what do you feel they bring to it?

I started drawing my cat when I was in college back in 1991 and had a full exhibition with paintings and prints of my cat called *HUMES* in 1995. This art show told the world I was crazy about my cat, who was in many ways a best friend - or confidant that witnessed and was there for me more than any other living thing up to that point in my life... I printed my first Emily the Strange T-Shirt in 1993 which incorporated a black cat of mine (Sabbath) and came from a woodcut print I did at the time. I think having the cats with Emily shows that she has companions, but prefers them not to be human.

Is there any work of art featuring cats that has inspired you? Where did you encounter it, and how did it make you feel?

I've always enjoyed vintage cat art in general—especially from the 60s. I like the stylized (sometimes kitsch) versions of cats that came from that era, and they have greatly informed and inspired my style. No one artist comes to mind, but in terms of cartoon cats— Felix, Garfield, Hobbes, the Aristocats, Pink Panther, and Tom (from *Tom & Jerry*) all have styles in the drawn form and attitude that have influenced my cat-related artworks.

What process do you go through to create your work? What inspires you?

I generally just doodle sketches first, and look for the new design or style that I like from that, which will inspire me to do a new painting, or perhaps an ink wash or watercolor or sculpture. Often the drawing comes first, then the story comes after.

What question do you wish I had asked you?

How many cats do you have?

What is your answer to that question?

I currently have two cats, an orange tabby named Country Boy, and a Russian Blue named Flash. In the past I had a fluffy white cat named Human Cat (Humes), a black cat named Sabbath, and a Tortoise Shell named Lupa.

LEFT PAGE

40 Cats In 4 Directions #3
Acrylic on canvas (with wall mounted rotational device), 30 x 30". 2017.

NEXT SPREAD

Stranger and Stranger
Acrylic on canvas, 20 x 36". originally painted for a spread in the novel *Stranger and Stranger* published by Harper Collins. 2010.

CIOU

Ciou is a French artist and illustrator who holds a unique place place in the world of lowbrow art. She obtained international visibility at the Flux Factory gallery in New York City in 2004 by participating in the exhibit *Cute and Scary* with other lowbrow artists. Since then, she has shown her work around the world including shows in Japan, the United States, Europe and Australia. She is represented in the Netherlands by Kochxbos in Amsterdam. She has held several solo shows, including one at Vanilla gallery in Tokyo. Diverse, excessive and firmly alternative, Ciou's world is a visual compendium of fantastic themes and styles. She has a taste for the odd and folkloric, and approaches the subjects of nature, death, metamorphosis, paganism and beauty in her work. She defines her work as Necro Kawaï art (Necro for the dark side, Kawaï for the cute side). Her style is the result of a massive hybridization of European, American, Mexican and Japanese graphic styles. A large part of Ciou's world can be described as a strange carnival parade where tattooed ladies, charming freaks and outsiders are the norm. She composes acid-colored farandoles with attractive nymphs, phantasmagorical animals and anthropomorphic plants.

www.ciou.eu

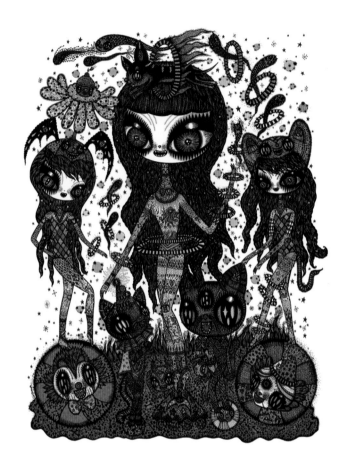

ABOVE

Space Circus
Acrylic and ink on paper,
16 x 12". 2017.

RIGHT PAGE

Tribute to Mary blair
Acrylic and ink,
11 x 10". 2019.

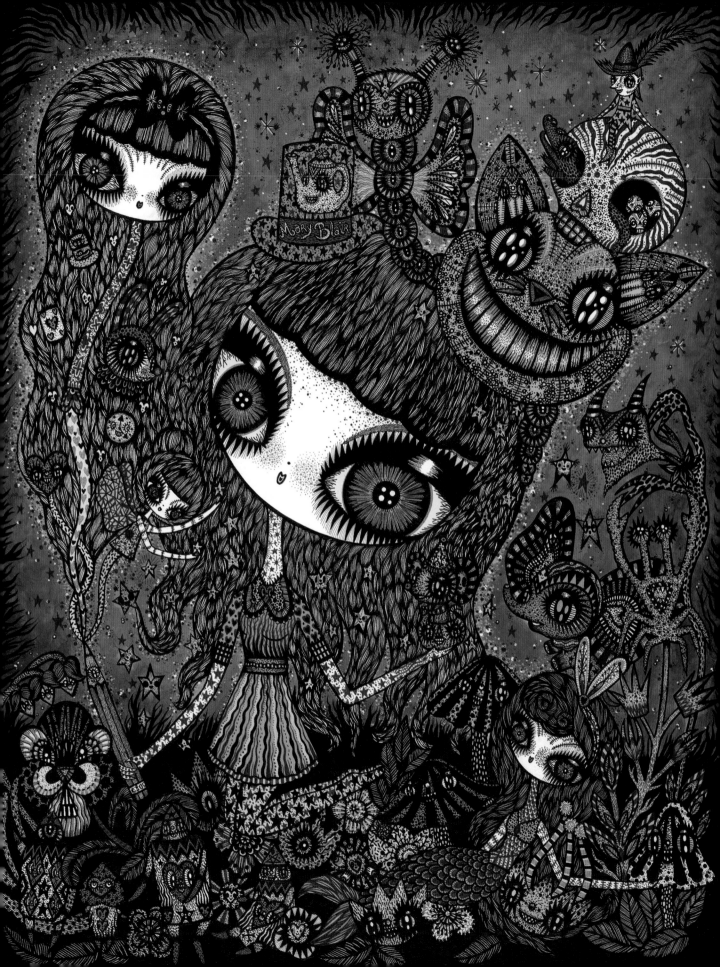

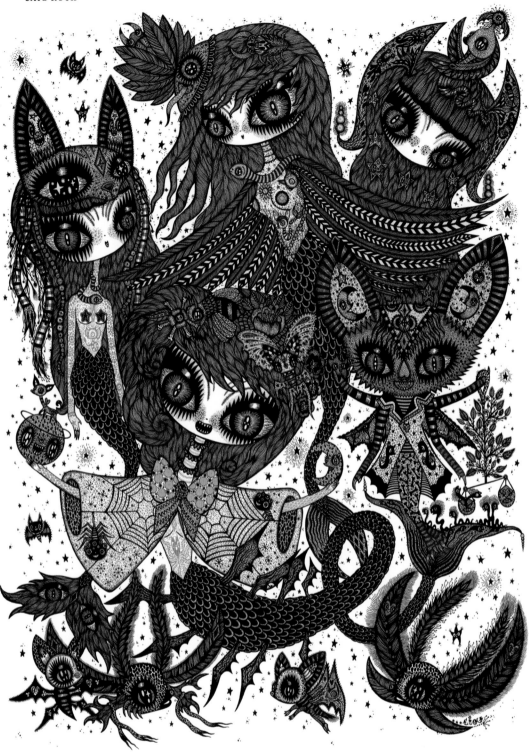

THIS PAGE

The Saturne Sisters
Acrylic and ink on paper,
16 x 12". 2019.

RIGHT PAGE, TOP

Girls just want to have Fun
Ink on paper,
16 x 12". 2017.

RIGHT PAGE, BOTTOM

Burlesque Meeting
Ink on paper,
9 x 7". 2011.

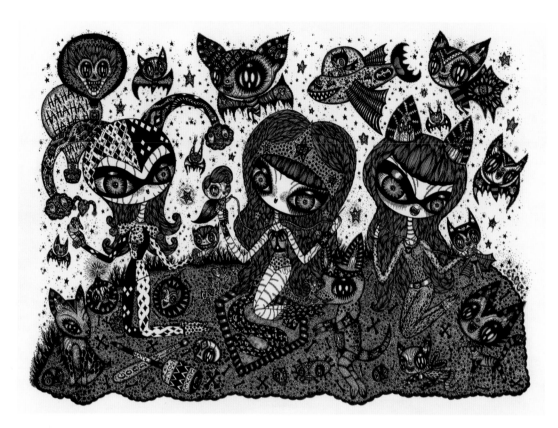

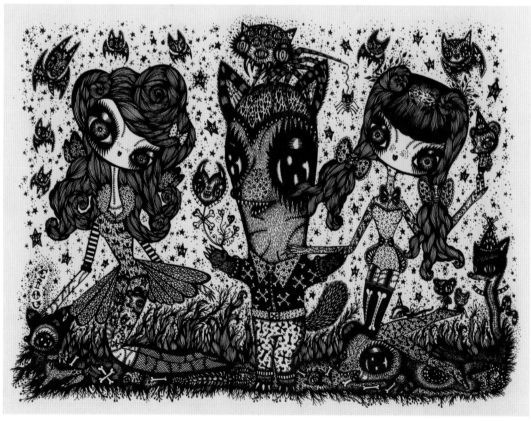

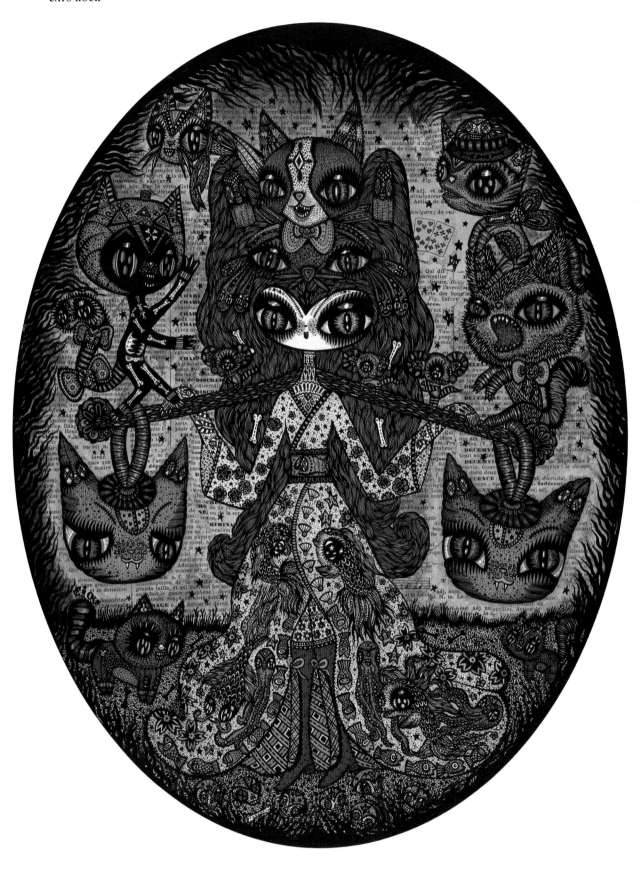

When and why did you start incorporating cats into your work and what do you feel they bring to it?

For as long as I can remember, I have drawn cats. I drew them since I was a little girl because I was so in love with Hello Kitty! Then I never stopped drawing cats. I made my first illustrated book, *Siamese Twin Cats* in 2009. It is a strange story about a witchy little girl and her cat. I love to draw them because they are so mysterious, beautiful and so funny to draw. They have magical eyes, you can fall into their cat fantasy. They also are very addictive. When you start to love them or draw them, you can't stop.

Is there any work of art featuring cats that has inspired you? Where did you encounter it, and how did it make you feel?

There are so many artworks with cats that I really love. The first artist is Utagawa Kuniyoshi. I love the way he draws cats wearing kimonos and playing cards. It's so great! He is one of the best artists from the 19th century in Japan. My biggest inspiration comes from Japanese culture and artists that I discovered at a very young age. The second artist is a French illustrator named Grandville who has a book, *Scène de la vie privée et publique des animaux*. He drew beautiful cats as ladies wearing Victorian clothes. He is the master of personification of animals and surrealism. The third artist is Femke Hiemstra, a Dutch contemporary artist and friend of mine who loves cats. She makes beautiful paintings with cats and other animals. She makes beautiful colored scenes. She helped me discover the cat museum, Cat Cabinet, in Amsterdam. It is a small museum filled with cat art! She is one of the best living artists I know and I had the chance to visit her studio which was inspiring.

What process do you go through to create your work? What inspires you?

I start to work in my sketch book. The inspiration comes from nature, museum visits, travel, etc. Then I start to work on the final piece, using acrylic, watercolor or gouache, and of course ink. I am a traditional artist. I don't work on digital artwork. I really need to work with sensitive tactile materials.

What might people be surprised to know about you (or your work)?

I am a workaholic. I can't stop until I am totally exhausted. So when I am not travelling for my shows and events, I am drawing and painting all the time. I always travel with my sketchbooks so I never forget anything. Also, I am a crazy toy collector. I collect everything from vintage toys to new ones, so I have a few Japanese and American cat characters. They surround me in my studio and are very inspiring.

What question do you wish I had asked you?

What is your favorite animated movie with cats?

What is your answer to that question?

Totoro by Hayao Myazaki of course! The Catbus is just the best creepy and funny cat. I had the chance to see the short animated movie about the Catbus dynasty, which was only on view at the Ghibli Museum. It was so poetic and fantastic! Also *The Cat Returns*, directed by Hiroyuki Morita of Studio Ghibli and *The Aristocats* by Disney are also good cat animated films.

LEFT PAGE

Empire of Cats
Mixed media,
9 x 7". 2013.

FIREXIA DOLLS

Alexandra Popova is a self-taught artist, born
and raised in Russia, in the city of Murmansk.
Many call it the outskirts of the world. It's very
cold there, but bears don't walk in the streets,
she says. Popova has drawn and engaged
in creative activities for as long as she can
remember. She has participated in various
exhibitions and many years ago she started
making artistic toys, but they were mostly scary
monsters. Now she has returned to creating
toys again, but they have become nicer and
friendlier. Each toy is created from scratch.
All parts are made by hand, painted and
stitched, therefore, each of them is unique.

Instagram: @firexia

Witch Cats -
The Magic Trio
Living doll, artificial fur,
synthetic winterizer, granulate,
acrylic paint, glossy varnish,
2018.

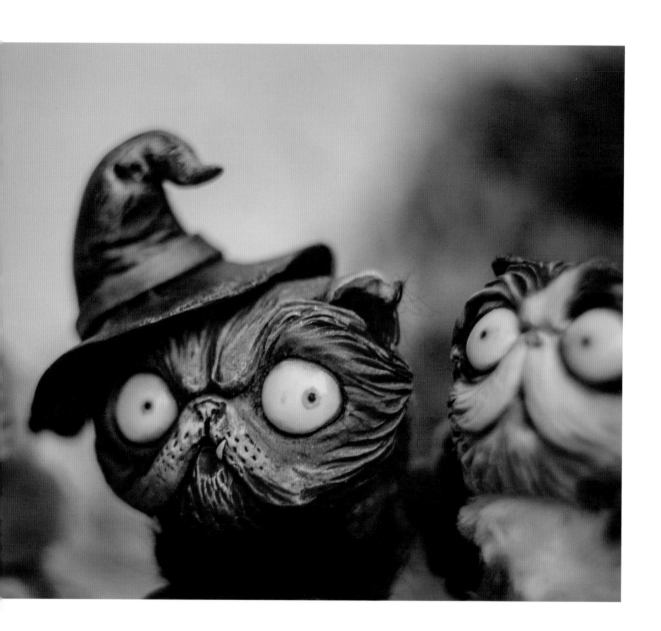

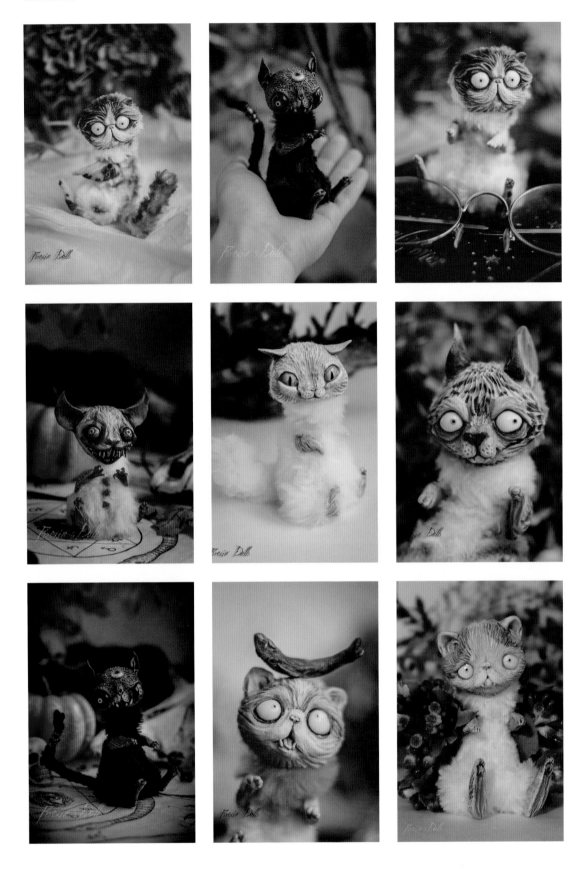

When did you first include cats in your work?

I began to include cats in my work as soon as I resumed the creation of toys. Cats have surrounded me since childhood, and I love them very much. My mother and I are volunteers at a local shelter, so there are more cats in our environment and all of them are completely different. Each one has its own immaculate character and appearance. I consider cats to be very charismatic animals and I try to reflect this in my works.

What inspires you?

One of my idols and main inspiration is Tim Burton. I'm crazy about his style. My friends say that they notice the resemblance, recalling his cartoon *Frankenweenie*. There was a white cat with big crazy eyes.

How do you make your work?

I rarely create sketches for a future toy. Usually, I open some photos with cats and immediately begin to sculpt. I improvise. In the process, the image may change or be supplemented with details. Cats that live with us at the moment are my main source of inspiration.

Do you have any cats in your life?

At this moment in our care there are 6 cats of different breeds from the shelter and two dogs. We usually do not have fewer than five cats in our house.

What question do you wish I asked and what is your answer to that question?

Usually they ask: "What advice would you give to readers and beginning artists," and I answer: "Always be yourself and do not be afraid to change. You are unique and your works are also unique."

FROM LEFT TO RIGHT, AND TOP TO BOTTOM

Moon Cat Insomniac

Witch Cat

Granny Weatherwax Cat
(Witch Cat and Wizard hat)

Pennywise Horror Cat

White Cat With
Heterochromia

Tabby Cat Who Considered
Himself A Tiger

Witch Cat

Red Cat Who Was Friends
With Fish

Tricolor Persian Cat
Bringing Good Luck

Living doll, artificial fur, synthetic winterizer, granulate, acrylic paint, glossy varnish, 2018.

GRETCHEN LEWIS

Gretchen Lewis grew up in the rural foothills of northern California. She spent a lot of time reading, talking to animals and wandering around the woods earnestly searching for fairies or the secret portal to some other world (as promised to weird quiet kids like her in books like *Alice in Wonderland* or *The Chronicles of Narnia*). When she wasn't doing these things, she was drawing, painting, or otherwise creating something feverishly and obsessively. She now lives in Sacramento, California, where she works as a painter and freelance illustrator.

www.gretchenlewisart.com

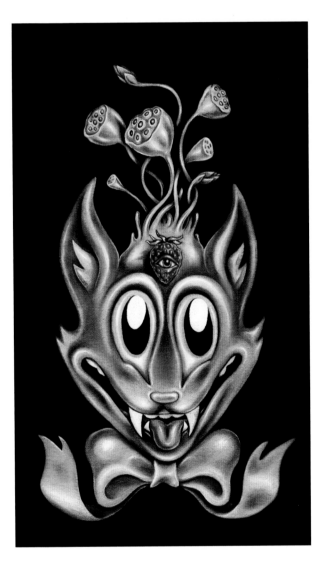

LEFT

Feed Your Head
Oil, acrylic, house paint and silicate paint on panel,
10 x 8". 2017.

RIGHT

Earthly Pleasures
Oil on illustration board,
6 x 10". 2019.

RIGHT PAGE

Mitosis
Oil and house paint on panel,
12 x 12". 2018.

TOP
Esmie
Oil and house paint on wood,
6 x 6". 2017.

BOTTOM
Mask 1
Oil and house paint on panel,
5 x 6". 2018.

When and why did you start incorporating cats into your work and what do you feel they bring to it?

I've been a cat fanatic since I was a little kid. My family always had cats around, and I was pretty much obsessed with them. When I was 4 or 5 years old, I would insist that I could "speak cat" and that I was definitely a cat in a past life. So, I've probably been drawing cats forever, but the first of the black cat characters that are in a lot of my work now were initially conceived in 2014. By 2015, they began to grow extra heads and sprout third eyes.

I always see my cat characters as shapeshifting tricksters. Folkloric traditions from around the world have their own stories of cats and catlike creatures, and often they are shapeshifters and tricksters. Sometimes they are benevolent, sometimes malevolent, but there are so many similarities in these mythologies, which really fascinates me.

Is there any work of art featuring cats that has inspired you? Where did you encounter it, and how did it make you feel?

I grew up watching a lot of old cartoons, and *Felix the Cat* was a favorite. I think it's easy to see the influence Felix has had on my work. I also have collected antique Beistle Halloween die cut black cats for a while, which are another big inspiration for my cats. Besides those, there are so many artists I could mention whose depictions of cats make me really happy. Takeo Takei and Arthur Thiele, both among my favorite illustrators, come to mind in particular. Takei stylized cats in a way that is really odd and charming, and the series of anthropomorphic cat postcards illustrated by Thiele in the 1910s are really wonderful.

What process do you go through to create your work? What inspires you?

My creative process usually starts with a lot of small doodles and scribbled words in my sketchbook, which I try to spend time with for an hour or so early every morning. I collect a lot of visual inspiration and sometimes I will create little collages of cut out images to figure out a composition that I like. However, often my paintings will pop into my head, suddenly and almost fully formed. Then it's kind of a race to put it onto paper before I lose it.

When I'm not painting, I'm usually out hunting for treasures at flea markets and antique shops. I love old things that have a story to tell, and the dusty old toys and bits of ephemera I bring home influence a lot of my work. Lately, I've also begun to incorporate a lot of found objects from these hunts directly into my work, and have been creating paintings on old books, suitcases and glass bottles, among other things. I love the almost magical feeling of transforming an object.

What might people be surprised to know about you (or your work)?

I guess something that might not be obvious upon looking at my paintings is the ways I work personal meaning and symbolism into a piece, and really, I guess that is pretty intentional. I often use my paintings as a place to explore personal fears, anxieties, or obsessions, but I also like to leave the interpretation up to the viewer. I like creating work that is accessible and fun, and that doesn't take itself seriously. I'm never bothered if a viewer takes away a different meaning from my paintings than what I intended, or even if their takeaway is just "that's cute/funny/weird" etc.

What question do you wish I had asked you?

Oh, I don't know. I suppose something like, "What is your cat's name, and is he a good boy?"

What is your answer to that question?

My cat's name is Bosco, and he is the very best boy.

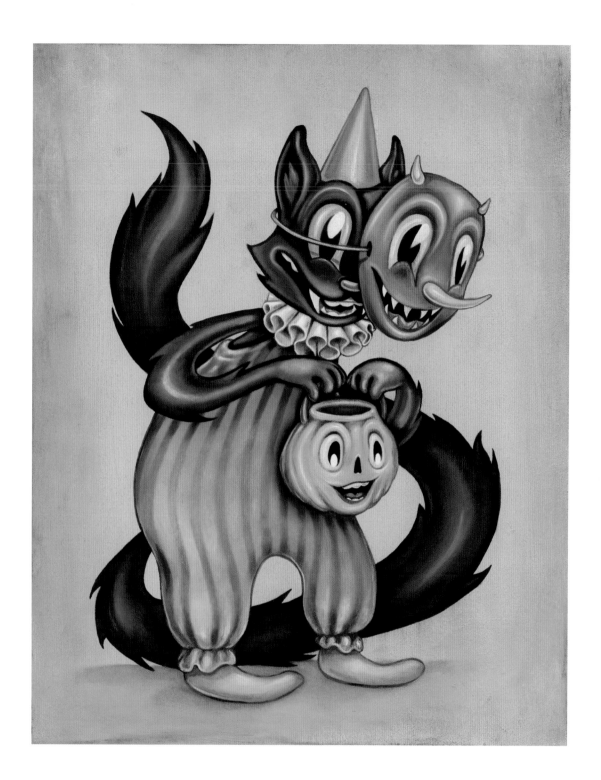

LEFT PAGE

Treat
Oil and house paint on panel,
8 x 10". 2018.

THIS PAGE

Trick
Oil and house paint on panel,
8 x 10". 2018.

KAMWEI FONG

Kamwei Fong is a Malaysian Artist based in Kuala Lumpur. His animal-themed art centers on a series of furry animal illustrations known as *The Furry Thing*. His creations are often described as poetic, humorous, imaginative, playful or dream-like. Using only black micro pigment ink, Fong has created a menagerie of playful kitties, puppies and other animals. Despite their contextual isolation and uniform style, each of Fong's cats display unique personalities: some are fluffed and puffed into self-contained balls; others look with curiosity or wariness at fish that dangle, or waves that crash from the animals' own tails. The artist builds each feline form using innumerable short thin lines, varying the density of the marks to create volume as well as a palpable sense of furriness.

Instagram: @kamweiatwork

THIS PAGE
Kitty No.25
Micro pigment ink pen on
paper, 12 x 17". 2018.

RIGHT PAGE
Kitty No.21
Micro pigment ink pen on
paper, 12 x 17". 2018.

Kitty No.9
Micro pigment ink pen on
paper, 12 x 17". 2018.

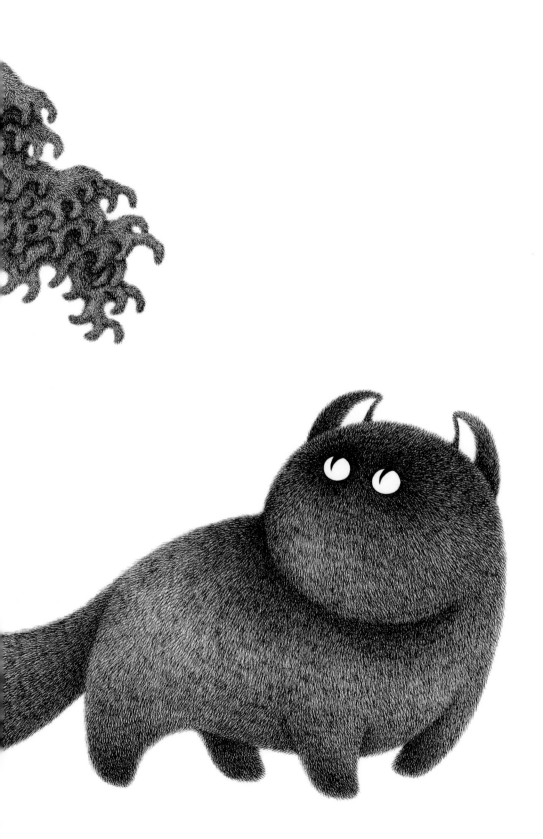

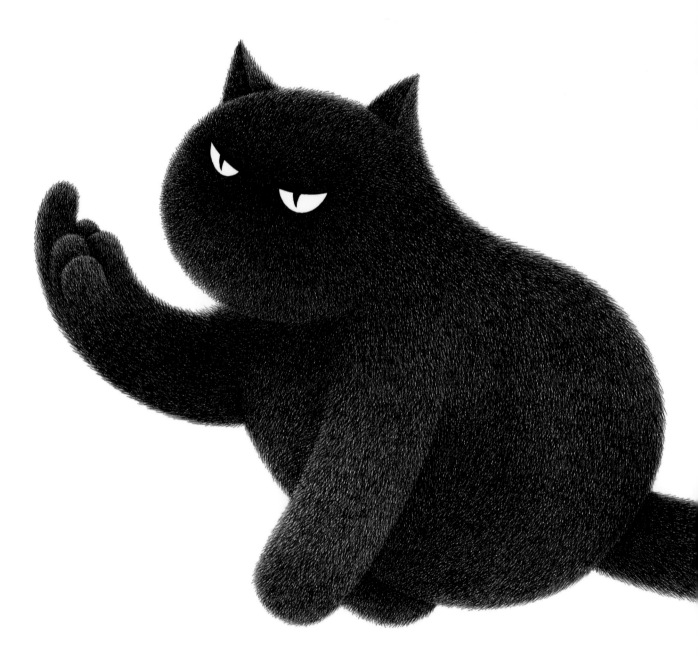

When and why did you begin making cat art?

The first piece of *The Furry Thing* series – Kitty No.1, was inadvertently created in 2009. I was working for a brand consultancy back then. I was doodling on some recycle papers while waiting for a client's feedback on a branding project I was working on. I was happy with what I scribbled so I did it again patiently on a piece of good quality drawing paper. I find the process therapeutic and enjoy it very much. Cats seem to be the perfect matching subject for my style, which is why I created different kinds of kitties in this style. I stopped this project for quite some time until I revisited and expanded the series further in 2017.

Why do you seem to focus mainly on black cats?

In this series, I explored other animals too, but cats seem to be the heroes. Cats give me lots of space for imagination, they are quirky, they are adorable, they are like ghost sometimes, mysterious and secretive, and their bodies are very flexible in real life too. That's how I imagine cats from a distance as I'm not a cat person and I've never kept a cat as pet in my life. Black looks fine in my style: it's simple, it's minimal, and I prefer something less complicated. It's like Chinese and Japanese calligraphy and black ink painting. It's about the balance of positive and negative space. One day I'd probably explore other monochromatic compositions, like red or blue against white.

What inspires you to create your work—where do you get your ideas?

Nature inspires me a lot, giving me room for imagination. I've got tons of ideas from things around me, plants, cats, dogs, birds who came by my house, the books I read, the movies and dramas I watched, the conversations I had with someone, the sceneries I saw while driving, they spark ideas.

What do you want viewers to feel or experience when looking at your work?

I never really thought about that and I don't have the exact answer. I quit my advertising job to become an artist because I want happiness. I do hope that everyone who viewed or purchased my work would be happy or be delighted as well. Many audiences said they find it therapeutic looking at my drawing process, many enjoyed the process when they did the drawing themselves in the same style.

Kitty No.38
Micro pigment ink pen on
paper, 12 x 17". 2019.

CONCLUSION

She sights a Bird - she chuckles -
She flattens - then she crawls -
She runs without the look of feet -
Her eyes increase to Balls -
Her Jaws stir - twitching - hungry -
Her Teeth can hardly stand -
She leaps, but Robin leaped the first -
Ah, Pussy, of the Sand,
The Hopes so juicy ripening -
You almost bathed your Tongue -
When Bliss disclosed a hundred Toes -
And fled with every one –

"SHE SIGHTS A BIRD - SHE CHUCKLES -"
POEM BY EMILY DICKINSON (ABOUT 1862).

Throughout history cats have been said to have nine lives. Whether this is because they always land on their feet or because of some ancient proverb is not entirely known. The expression could have many different cultural origins, though by the time of Shakespeare it was well enshrined, appearing in *Romeo and Juliet* and *Macbeth*. The expression "nine lives" may not only be a statement regarding the ability of cats to persevere, but also perhaps a statement on their diverse personalities. They may be cute, cuddly, creepy, friendly or shy. They can be aloof and alluring, the most charming of pets, but forever their own masters. The artists in this book have depicted cats in a variety of ways—anthropomorphized, as objects, as pets and even as other animals. They show that there is no singular way to view the feline, and even nine different ways, one for each life, may still not be enough.

My father with our cat, Pumpkin.

My Cat Artichoke!

Dedication

This book is dedicated to my father, Richard Daley, 1943-2018, an architect and the original cat man. During my childhood, I forced him to get a total of six cats: Pumpkin, Patch, Wizard, Monkey, Shi-Shu and Mi Tu, whom he owned simultaneously at one point. When our cat Shi-Shu became injured, we had to decide whether to amputate her leg to give her a chance at life, or allow her to die naturally. We decided to intervene and she survived. During my father's illness, I made many similar decisions about his life. We put our faith in medicine, however he wasn't as lucky. He ended up on a ventilator tethered to his bed. As a result, I also want to dedicate this book to those prevented from leaving hospital beds due to ventilator use. All humans desire and deserve to feel the sun and air on their skin. All humans deserve the dignity of basic communication, routinely denied patients on ventilators. I know my father would have been proud of me for delivering this message and finishing this book and I hope he is with our cats now, enjoying whatever the afterlife has to offer.

Acknowledgements

Thank you to my friends and family who have supported me in writing this book. Particularly Amanda Lowe, my best editor and biggest fan. My mother, who has supported me in following my dreams (both wittingly and unwittingly). My brother who inspires me by thinking about the world differently and my friend Heather Clarke who was very thoughtful in buying me some research materials. Special thanks as well to Emma Zurer who always believes in me, and to Jennifer Jones without whom this project would not have been possible. And especially to my sweet pet and catspiration: Artichoke!

Author Biography

Elizabeth Daley is a writer from New York City. Her articles have appeared in *Guernica*, *USA Today*, *The Christian Science Monitor*, *New York Observer*, *Belt Magazine*, *Quartz*, *GOOD Magazine*, *Public Source*, *Advocate.com*, *Patek Philippe*, *Narratively*, *Al Jazeera*, *Alternet* and numerous publications globally through her work with Reuters. She was arts editor of the *Queens Chronicle* (weekly circulation of 160,000) and holds a bachelor's degree from Bard College and a master's from Emory University in American Studies. Her writing tends to take a broad view of artistic, historic and cultural phenomena, exploring why particular works matter in the present moment. She dreams of being a Floridian and possibly writing a book about death.
To contact her about this or other work, email iconoclassy AT gmail.com

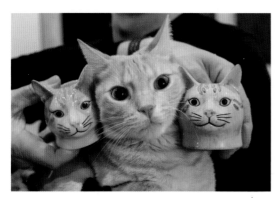
Bison, graphic designer's cat <3

NOTES

Introduction - Cats Rock, but Why? (page 6):

1. Ottoni, Claudio & Van Neer, Wim & Cupere, Bea & Daligault, Julien & Guimaraes, Silvia & Peters, Joris & Nikolay, Spassov & Prendergast, Mary & Boivin, Nicole & Morales-Muñiz, Arturo & Balasescu, Adrian & Becker, Cornelia & Benecke, Norbert & Boroneant, Adina & Buitenhuis, Hijlke & Chahoud, Jwana & Crowther, Alison & Llorente-Rodriguez, Laura & Manaseryan, Nina & Geigl, Eva-Maria. (2017). The palaeogenetics of cat dispersal in the ancient world. Nature Ecology & Evolution. 1. 0139. 10.1038/s41559-017-0139.

2. https://www.reuters.com/article/us-egypt-archaeology-discovery/ancient-egyptian-tombs-yield-rare-find-of-mummified-scarab-beetles-idUSKCN1NF0KY

3. Rogers, Katharine M. 1998. *The Cat and the Human Imagination: Feline Images from Bast to Garfield*. First Edition. Ann Arbor: Univ of Michigan Pr.

4. https://www.stripes.com/travel/belgium-s-cat-parade-once-cruel-now-just-playful-1.50470

5. https://lithub.com/the-oldest-american-picture-book-still-in-print-is-obviously-about-cats/

Cats as People, People as Cats (page 179):

1. https://archive.org/stream/annalsofenglandt00stow?ref=ol#page/n1079/mode/2up/search/hanged+a+cat

CERNUNNOS ROCKS

In the same collection:

Rodolphe Lachat (editor) – *Anatomy rocks: Flesh and bones in contemporary art*
Collective – *Anatomy rocks: The coloring book*
Collective – *Anatomy rocks: 30 deluxe postcards*
Sarah Daniel – *Beards rock: Facial Hair in Contemporary Art and Graphic Design*

First published in 2019 by CERNUNNOS an imprint of Dargaud
57, rue Gaston Tessier
75019 Paris, France

www.cernunnospublishing.com

ISBN: 978-2-37495-046-4

© 2019 Cernunnos
Texts and images: respective authors
Texts by Elizabeth Daley

2019 2020 2021 2022 2023 / 10 9 8 7 6 5 4 3 2 1

Director of publication: Rodolphe Lachat
Copy Editing: Melisse DunLany
Cernunnos logo design: Mark Ryden
Book design: Benjamin Brard

Front cover: Midori Yamada, *The White Camellia*, watercolor, 8x8", 2010.
Back cover: Train, *Spot*, digital painting, 13x17", 2019.
Front cover of the dust jacket: Michael Caines, *Gus*, oil on canvas, 40 × 30", 2016.
Flaps: GaAs, *Pattern Cat Box* (detail), digital, 2018.

P.4 © Manuel LAGOS CID/PARISMATCH/SCOOP ; p. 8 © 2010 Joan Marcus ; p. 9 The Louis E. Stern Collection © 2019 Estate of Pablo Picasso / Artists Rights Society (ARS), New York ; p. 10 photo by Warner Bros. Pictures/Sunset Boulevard/Corbis via Getty Images

Dépôt légal: November 2019
Printed in China